Looking for Texas

Essays from the
Coffee Ring Journal

Rick Vanderpool

Republic of Texas Press
Plano, Texas

Library of Congress Cataloging-in-Publication Data

Vanderpool, Rick.
 Looking for Texas : essays from the Coffee ring journal / Rick Vanderpool.
 p. cm.
 Includes index.
 ISBN 1-55622-826-0 (pbk.)
 1. Texas—Description and travel. 2. Texas—Pictorial works. 3. Texas—Social life and
customs. 4. Vanderpool, Rick—Journeys—Texas. I. Title.

 F391.2 V36 2000
 976.4—dc64
 00-062764
 CIP

Republic of Texas Press is an imprint of Wordware Publishing, Inc.
No part of this book may be reproduced in any form or by
any means without permission in writing from
Wordware Publishing, Inc.

Printed in the United States of America

ISBN 1-55622-826-0
10 9 8 7 6 5 4 3 2 1
0011

All inquiries for volume purchases of this book should be addressed to Wordware Publishing, Inc., at 2320
Los Rios Boulevard, Plano, Texas 75074. Telephone inquiries may be made by calling:

(972) 423-0090

Raison d'etre

The project is called *"Looking for Texas,"* and it exists because God allowed me to persevere. It came about because I dreamed it and did it, in a series of hastily planned (as time and finances permitted), quick trips to visit all 254 counties in the state, photographing the word "Texas." The project is unique, and I did it first. So to all of you out there who might have had the same idea but, for one poor excuse or another, left it on the back burner—na, na, na, na, na.

With that out of the way, there are just a few folks I'd like to mention and thank:

I dedicate this book to the following people:

Judy—my favorite partner, always; for better or worse...

Mary Helen Spencer—she got me to Texas as quickly as she could; for always being a best friend and staunch supporter.

Lola Hope Borchers—the best co-pilot and traffic re-router a "retired roadkill photographer" could hope to have; for other trips, "looking."

Otha Spencer—my favorite author and critic; for your inspiration, thanks.

Eddie Smith—how can a person seriously look for Texas without a pickup truck?

Duncans— "not no, but . . ." I know I was covered every mile.

Bishops, Millers, Latsons, Jameses, Kings, and Roberta—for all those bon voyage and welcome home celebrations.

Commerce Tigers—the best reason to be home on a fall Friday night. You rule!

. . . and especially to

Dad—for an ordered mind and eye.

Mom—for endurance and a positive outlook on life.

Grandmother and Granddad—for nurturing my wonder and wanderlust.

Reggie and Sue—for all the laughs and love, dearest brother and sister.

Evan, Jason, Jennie, Jessica, and Shay—something to remember; Love, Dad.

Madison Amelia Brown—your first road trip was to Texas . . . Love, Granddad.

There are far too many other dear Commerce, Athens (GA), and Columbus (USA) friends, fans, and extended family to list here, but if I thought that doing so would ensure they'd buy a copy of the book, well, they know who they are . . .

Contents

Foreword

This Rick Vanderpool fellow is certainly an enterprising dude. When I first got acquainted with him, he was in charge of a festival in his home town of Commerce, Texas. The festival was called the Bois D'Arc Bash (pronounced bo-dark bash) to honor trees by that name that grow around Commerce. The whole town was celebrating a type of tree. He had people on a big flatbed trailer singing songs about the bois d'arc tree. And people were out in front listening. Most amazing.

A couple of years later I learned he had traveled once upon a time to all the towns in America named Columbus. He would go to these places at his own expense and take some pictures with the idea of making an exhibit of photos to honor the 500th anniversary of Columbus discovering America. He did it— 30,000 miles of pictures and stories. Rick is a festival and anniversary-celebrating, traveling type of guy.

In 1997 he became publisher of the *Commerce Journal*. About the time he started working for the paper he was nearly half finished going to all 254 counties in Texas to take pictures of anything with the word TEXAS on it. He left the *Journal* in 1999 to finish *Looking for Texas* that year—another 20,000 miles of pictures and stories. He thinks of the neatest things to do.

Rick needs lots of money to pay for his ideas and excursions. He gets a wild idea and doesn't just sit around thinking of it. He starts laying out his own cash to pay for getting things done. It's a good thing he's married to an understanding woman who provides funding for his enterprises from the couple's Prairie Rose Studio, located on the square in downtown Commerce.

Rick is an accomplished photographer. His black and white photos depict the variety of life found between these shores. He and his wife, Judy, have found a way to color black and white photos with an artistic touch, and their work hangs in galleries and public buildings all over the place.

Rick is an original. There's no telling what he might come up with next. You know he could use the cash, so buy his book.

Tumbleweed Smith

Introduction and background/history

In this corner

Howdy! My name is Rick Vanderpool, and I will be your faithful scout, interpreter, and tour guide for the next several pages—pages that distill into roughly 50,000 words, nothing short of a labor of love. I hope you read all of these pages. If you do, they might inspire you to invent your own travel adventure. And if you keep a journal, write a poem, or take a picture or two, I couldn't be prouder to imagine that I had a little something to do with it. If I may say so myself, all these pages are worth a look. I'll even go so far as to suggest that you might find your own inspired version of *Looking for Texas* to be the adventure of a lifetime. It truly was for me—so far . . .

How about some background? I have worked as an artist/photographer and journalist for the past twenty-five years, since graduating from the University of Georgia's then Henry W. Grady College of Journalism in Athens, Georgia. Judy Breitlow joined my studio in 1983 as framer, hand-colorist, right arm, then wife. Over the years we've created original, photographic art and silk-screened prints for a wide range of Fortune 500 clients and federal and state governments, most often through contacts in top architectural and interior design firms across the country.

In 1989-1991, prior to the 500th anniversary in 1992 of Christopher Columbus' first voyage to the western hemisphere, I undertook a largely self-funded (Kodak provided 400 rolls of film and Days Inns of America provided lodging) 30,000-mile project to visit and photograph every town (living, dead, or renamed—seventy sites in all) in the U.S. named Columbus. A unique collection of over 15,000 images and 50,000 words resulted. Approximately fifty articles were published in newspapers in the Columbus towns large enough to have one. An exhibit of fifty of the photographs was curated by the Georgia Museum of Art and traveled widely to more than twenty-five Columbus towns and other venues. Little did I know what kind of precedent I had set for myself. Actually it was more like discovering an addiction to huge travel projects.

Judy and I moved to Commerce, Texas, with our then seven-year-old daughter, Jessica, in 1994. We established Prairie Rose Studio on the downtown square and took up residence in an apartment above the studio. Many of our clients were then, and still are, in Dallas and Fort Worth.

To be perfectly honest, *Looking for Texas* almost didn't happen. You see, my girls hated to see me leave, and I hated to make them feel bad when I had to go away.

Take Judy—please (I've always wanted to say that); she started getting all teary-eyed and clingy-like a couple of days before my scheduled departures. I knew she was just miserable, but she went about her business as normally as she could manage, what with calls to our insurance agent and packing like I was going to be gone for weeks instead of a day or two. Then at the last minute she was a basket case, hanging all over me, begging me not to go. **Aside:** Funny, I never remembered loading the truck for a trip, but it always got done...

And little Jessica absolutely broke my heart. Why, she started crying the minute I told her I was going to be gone for a few days. **Aside:** In truth, she acted the same if I suggested she come with me... She had this way of holding out her little hand while she sobbed into the other one, held close to her face. The first couple of trips I tried to give her Kleenex, and the sobbing increased in intensity. I discovered that a five-dollar bill worked better. The little angel could even manage a smile and goodbye hug for a ten or a twenty.

For a while it got so bad I tried being really mean to them a week or two before I was to leave, but it didn't seem to make any difference. Finally, I convinced them to just have fun while I was gone, go shopping, have friends over (Jessica, not Judy; I believe a little solitude and misery is good for a mature relationship), and eat out often.

Wouldn't you know it, those dear girls of mine finally managed to put their true feelings aside and act is if they weren't the least bit sad to see me go. Sometimes they weren't awake or even at home for my departure. And I know that those times when no one answered the phone, when I'd call home late at night, those sweethearts were probably unable to hide their grief and just wanted to spare me from worrying about them while I was looking for Texas.

How I pictured Texas

To paraphrase a quip attributed to James Barnes, "You can always tell a Texan, but you can't tell him much," I never imagined being able to *tell* Texans anything new and different about their state—its history, myths, or geography.

I'd seen many of the books on Texas, shelf after shelf in libraries and bookstores, and came to believe that Texans certainly do enjoy the telling and do not mind in the least the retelling of almost anything about their state.

So it was that I awoke one morning convinced I just might be able to *show* Texans something new and different. Several friends and clients encouraged the idea, as did information from the crunchers of travel and tourism numbers at the Texas Department of Economic Development; information supporting the fact that Texans and non-Texans alike feel that the Lone Star State is worth at least a second look.

In 1994 I began a series of trips that would eventually total over 20,500 miles and fifty-four days on the road—several roads, actually—to visit all 254 county seats in the state. And while I photographed anything else that caught my interest, from road kill and wildflowers, to grand views and tumbleweeds (all captured, coincidentally, as Columbus had been, on roughly another 400 rolls of Kodak film; Judy and I paid for these, however), I was mostly looking for Texas—simply the word—as part of an old sign on the side of a barn, on a once bustling storefront, now closed and crumbling, or on a brand new sign welcoming visitors to a revitalized Main Street. Tiny or huge. Fashioned from neon and glass, metal, wood, stone, or plastic. On T-shirts and banners, jackets or caps, leather belts, boots, and saddles. On buckles, badges, patches, tattoos, or you name it. Anywhere. Any material. And with character—as in worn, weathered, carved, etched, painted, stitched, tooled, scrawled, scratched, or sculpted.

The word is everywhere, and not always visible at first glance around a town square. One Saturday morning I had to lie flat out on a downtown sidewalk to photograph it as part of the foundry plate on the base of an iron support for a building in Henderson. I found it faded nearly away on the side of an oil tank in Perryton. I often wonder how many I missed. Of course there were the countless times the word literally jumped out at me, like the dozen or so Texas Theater signs; the word literally up in lights in Hillsboro, Raymondville, and Seguin, or once-upon-a-time in Sherman, Marfa, and Burkburnett.

Looking for Texas was more of an experience than I ever could have imagined in 1994, and when Kathy Straach wrote a very nice article on the project for *The Dallas Morning News* (January 31, 1999—Super Bowl Sunday, no less), she noted that I had been to 191 counties so far. By mid-July 1999 I had visited the last four counties (Liberty, Chambers, Harris, and Galveston—capped by a celebration with Jessica, and Lance and Jennifer

Gammill at Joe's Crab Shack in Kemah), but I still look for Texas everywhere. Probably always will. Judy tells everyone that I've never stopped looking for Columbus.

A unique collection of more than 400 black and white and color photographs show how I pictured Texas—that and several pages of notes, stories, and sketches in my *Coffee Ring Journal*. More than one editor has agreed that the images might make a worthwhile book, validating my premise that there is a place where a thousand pictures are worth one word—Texas. Finally one editor at Republic of Texas Press decided that in addition to my pictures, I had indeed written a thing or two I could *tell* a Texan. Thank you, Ms. Bivona . . .

On the following pages, amidst a sprinkling of a couple hundred photographs, are some stories, sketches, and whimsy from my journal —a few words to share what I didn't picture while I was looking for Texas.

Coffee Ring Journal

Just as the rings within a tree
yield the riddle of its age,
so coffee circles, cup by cup, mark nearly every page;
to underscore what's written while
my life was passing, mile by mile.

And end-to-end, each plastic frame,
etched in silver, no two the same;
to hold what caught my practiced eye,
as I passed lots of Texas by . . .

Musings

Knit one, purl two

For now, Texas is one state, under God, but hardly indivisible, as we shall see...

"Disunion, thy name is Texas..."
Virgil Race

Sometime after *"In the beginning..."* God divided all the land and the water that humans would later call Texas into four physical regions, each with one or more subdivisions or features (twenty-four total); humans also did label these regions as follows: Basin and Range Province (Upper Rio Grande Valley, Davis Mountains, Big Bend, and Guadalupe Mountains), Great Plains (Toyah Basin, Stockton Plateau, Edwards Plateau, Balcones Fault, Llano Basin, and Llano Estacado), Interior Lowlands (North Central Plains, West Texas Rolling Plains, Western Cross Timbers, Eastern Cross Timbers, and Grand Prairie), and Gulf Coastal Plains (Rio Grande Plain, Lower Rio Grande Valley, Coastal Prairies, Blackland, Post Oak Belt, Pine Belt, and Blackland Belt).

Later, other humans, called authorities, further divided Texas—physical regions and subdivisions and all—into nineteen additional major subdivisions, called Major Land Resource Areas. These are based on similar or related soils, vegetation, topography, climate, and land use.

After later, other humans, whom we'll call bureaucrats (another name for authorities, but employed by a branch of government) divided the state into sixteen regional water-planning areas.

A growing number of other humans (well-meaning authorities, perhaps, with the aid of bureaucrats) have divided the state into 10 principal plant life areas, 7 principal forest and woodland regions, 5 state forests, 122 state parks, 17 national wildlife refuges, 13 national parks, 4 national forests, and 5 national grasslands. The Nature Conservancy of Texas's divisions of the state (called "preserves" by these well-meaning humans) number 4.

Further, by its own bureaucratic hand, the state of Texas has divided itself, amoeba-like, into 254 counties—largest (pop.) Harris/largest (area) Brewster; smallest (pop.) Loving/smallest (area) Rockwall. The counties are further divided into four precincts each, and beyond that, into no fewer than 1,194 incorporated municipalities, ranging from the largest, Houston (Harris County), to Belcherville (Montague County), which is

1

the smallest, populated, incorporated place in the entire United States (34)—*yahoo!*

Is it okay to use that word here these days without fear of litigation?

There are literally thousands of unincorporated, populated places in the state, three of which have only one inhabitant—Arden (Irion County), Elton (Dickens County), and Pueblo (Callahan County). For local election purposes, each town or city (with the probable exceptions of Arden, Elton, and Pueblo) is further divided again into an indeterminate number of precincts.

For reasons of legislative manipulation, Texas is divided into 31 senate districts and 150 house districts; for judicial stuff, the state is divided into 9 judicial administrative districts, 14 districts for courts of appeal, and 411 state court districts.

To keep track of and manage all things educational in Texas, it is divided into 1,062 school districts.

If you have been keeping a running total, up to this point, Texas has been divided into a total of 4,438 entities. Just a few to go...

The Texas Department of Transportation (TxDOT—no com) promotes the Texas Department of Economic Development (TDED)'s Tourism Division's division of the state into seven travel regions, based on largely geographical criteria, for marketing purposes. But get this, TDED uses another ten regions, called Uniform State Service Regions (yes, USSRs), for the purpose of reporting data from the seven travel regions. On top of that, TxDOT, no com, divides Texas into 18 divisions and 25 districts for purposes of planting wildflowers, highway and bridge building and maintenance, and whatever else it can do to disrupt the orderly flow of traffic in our state.

And finally, Texas is divided into two time zones, central and mountain.

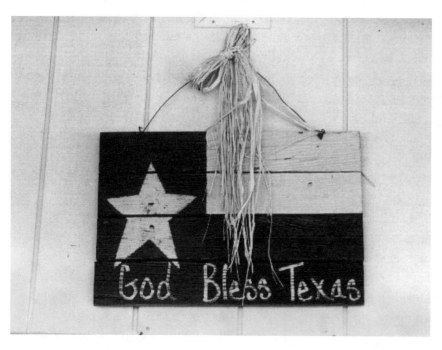

That makes a grand total of 4,500 official divisions of our state (and goodness knows my overworked research team over-looked at least one or two dioceses); add the further statewide division into acres (171,057,280—total, land and water), plus the smaller parcels of varying size for individual homes, and an accurate picture of the state, showing every line of demarcation,

would resemble a 267,277-square-mile mirror, dropped from no more than waist height onto a sizeable marble floor.

But never fear, those farsighted Texas Tourism marketing folks have united all those itty bitty pieces of our disjointed state, cleverly packaged it, and make the proud claim, "It's like a whole other country."

Was I just dreaming, or did I read once that the state of Texas can be divided into five separate states? Someone had better call the Texas Tourism folks...

I must have been dreaming in 1994 to think I could travel all those miles, through all those parts of Texas, but no. Thankfully, I only talked myself into tackling 254 of the parts—each county—while looking for Texas.

When Texas humorist and state treasure Tumbleweed Smith claims that he is "part owner of Texas," one can but wonder, which part?

My favorite Texas

Ask almost any Texas resident or visitor what his/her favorite Texas image is and you will get answers like: "bluebonnets in the Hill Country"; "Mission such and such, or the Riverwalk in San Antonio"; "the Dallas or Houston or Llano skyline"; "the beach at South Padre or Galveston"; "Big Bend"; "Austin"; or "a lonely windmill, some longhorns and cactus, with some tumbleweeds snagged in a section of fence on the High Plains in the Panhandle."

All those other images of Texas are great, and a bunch more to boot, but my favorite Texas image (and I get asked constantly) would have to be my first one: a photograph I took in 1980 as part of an art collection for Citizen's Bank of Denison. It's an image of a very old, broken neon on wood sign, leaning against a breezeway wall of the old icehouse at the Katy Railway Station in Denison. The entire sign read "Denison, Texas" and was on its way to the dump. The icehouse was demolished several years later when the station and grounds were renovated and landscaped. I've always regretted not rescuing that sign.

Back then I was just beginning to work regularly in Texas, in Dallas and San Antonio mainly (from my studio in Athens, Georgia),

but something told me that shooting the word "Texas" separately would come in handy. And indeed it did, as countless Texas and Texas-loving clients, over the next dozen or so years, purchased the Texas image that I produced most often as a silkscreen print and titled "Old School of Thought."

In 1993 my wife and studio partner, Judy, after teaching herself to hand-tint, chose the Texas image as her first to seriously color using her new skills. It was a big hit and we titled the hand-tinted version "Bright Spot."

When we relocated from Athens and opened our new studio in Commerce, Texas, in 1994, the image was proudly displayed and served as an inspiration as I began to photograph the word in black and white (no color

until mid-1995) for Judy to color. We had in mind to complete a modest collection of the hand-tinted images as our personal recognition of the 150th anniversary of Texas statehood on December 29, 1995. By the end of December 1994 I had pretty much decided to travel to all 254 counties in the state, "looking for Texas."

Day-trips to Dallas and to a handful of county seats near Commerce, in northeast Texas, provided several exciting images that Judy colored, framed, and frequently sold to clients of The Spencer Company, mostly in Dallas. In early fall 1995, GTE agreed to exhibit a collection of the work (twenty-five framed 16x20 prints) for the month of December in the corporate gallery at its Las Colinas headquarters. We sold six pieces from the exhibit, and shortly thereafter Reunion Arena and The Ballpark in Arlington purchased some of the work. Word began to spread among clients and friends (nearly at a pace with my excitement) that we were going to travel to all the Texas counties.

Looking for Texas was not without some interesting variations on the theme. For a wildflower photography trip one spring, I borrowed a shiny, white, metal Texas sign (salvaged from an old service station) from Debby Ridgway and placed it in a patch of bluebonnets in Burnet. Over the next several months, the same sign traveled with Judy and me to St. Louis (shot at the base of the arch); Wyoming (shot at Flaming Gorge and Fire Hole Canyon); Santa Fe (shot with a typical Santa Fe architectural feature); Georgia (shot at the base of Tybee Island lighthouse); and Washington, D.C. (shot at the base of the Jefferson Monument). The sign also has been the subject of several shots closer to home. We've had great fun "creating" other Texas images over the span of the project.

Judy and I were both captured by that first photograph of Texas. With no way of knowing in 1980 just how important working in this state would be to my development as an artist/photographer, the image and the word certainly made a lasting impression on me. And Judy's selection of the image has come to symbolize not only our strong partnership, but also the bond between our work and a new home that we've discovered and shared; a place where a thousand pictures are worth one word—Texas . . .

My way or the (cyber) highway

If given the choice, what kind of person would take the so-called "Information Highway" rather than a concrete, blacktop, gravel, or dirt one? Not me. Give me a V-8 over a search engine any day. I happen to believe there is far more worthwhile information to be had on the road than on-line.

Perhaps the major difference between roaming cyberspaces and driving through wide-open ones is that real trips are much less organized than virtual ones. Sure, both routes are more or less marked (both, sometimes very creatively), but nothing along the way of a trip that begins with a key in the ignition has been so well organized, categorized, and labeled for easy reference as a trip that starts by pressing a key.

There is another difference. If a journey in cyberspace has been anticipated and pre-visualized by someone else in order to navigate a traveler effortlessly (as in "user-friendly") to some point, what is there to discover by accident on such a journey? Except, perhaps a bug. Think about it, the last time you encountered a bug on a real-highway trip was pretty much the same as the first time and all the times in between, right? You either plucked it from your grille (your teeth, perhaps, if you favor a two-wheeled conveyance, sans helmet con visor) or washed it from your windshield. No crash, just a pang of sadness for those of us who hate to see a tiger swallowtail reduced to a spot of dust and yellow goo.

Even with real trips, we are often too narrowly focused by the time we determine a destination and mark a route on our maps. Thanks to brochures, ads, and the like, we might feel as if we knew the place before we arrived. What a pleasure to find that, on the contrary, the experiences en route, the unplanned, unknown, and unexpected discoveries (with the exception of the study in tiger swallowtail anatomy) were as often as not even more meaningful and just as memorable as the destination. Ever take a side-trip that becomes the vacation?

For the guys: There is nothing you can find on-line to match a real-road experience—at least not until Ms.'s Hill, Twain, Fuentes, Electra, Judd, Berry, McCarthy, Lopez, Aniston, Diaz, and Veda-Jones do a feature-length music video together on their new

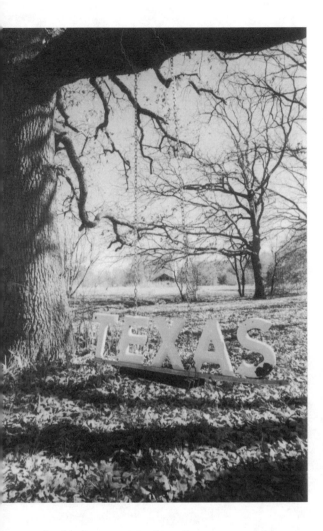

all those virtual stores and still driving to get in line at the real ones—sometimes both at once. And if you had to choose one over the other (as if you could be honest about giving up any shopping opportunity), you know that you are not going to trade a trip to Neiman Marcus, Dillard's, Saks, or even Target to let your fingers do the walking through iVillage or other e-anyplace.

To look at travel from another perspective, a character in Garrison Keillor's *Lake Wobegon Days* complains that his upbringing "...taught me the fear of becoming lost, which has killed the pleasure of curiosity and discovery."

Even though every human being strives in his/her own way, consciously or un-, to make the statement "*I am here*" with their lives, the real message is always the same. Whether it is whispered in the form of a poem, written and tucked away on a closet shelf; spoken confidently as a novel by a noted expert on some aspect of the human condition; or screamed as a four-foot high, garishly colored obscenity on

web site as your monitor dispenses cold beer and hot pretzels. When was the last time you encountered a gaggle of buzzards, gagging over some sun-cured road kill on any virtual highway? Can you pull your mouse into the gravel parking lot of an out-of-the-way BBQ joint, and 30 minutes later come out smelling like a smoked brisket, feel as if you ate half a cow, and have sauce stains on your T-shirt for life? No way.

Hey, ladies: Statistics, schematistics, everyone knows you are shopping on-line at

the side of a building or railcar, the real message is, "Help me, I'm lost."

There's that kind of "lost," as in "directionally challenged in life," and then there's lost, as in not being able to find your backside with both hands, as in not knowing where on earth you are. I'm talking the kind of lost that has not only "killed the pleasure of curiosity and discovery," but probably ruined a vacation as well. The "up the creek, without your geography" kind of lost. Yep, I said geography, as in maps with latitudes, longitudes, continents, and oceans and stuff. Remember? Sadly, most of us don't. And with what we don't remember, one could fill several classrooms. Hold that thought . . .

We don't remember, for instance, how many planets are in our solar system or in which order they all spin around the Earth. That might be forgivable. It is not forgivable,

however, to look at the weather map, day in and day out, on our TV's made in Japan (that's somewhere off the coast of California, right?) and not know which states touch the one we live in. A show of hands, please, how many people think the smog in Los Angeles is San Andreas' fault? San Bernardino's? Is Oklahoma among the seven states one can see from Rock City in Chattanooga, Tennessee? Come on, people, Willard Scott, on his widest days, can only block half the country at a time. Pay attention to the states he is pointing to and see if precipitation might apply to more than the weather. Try this:

Take a crayon (kids, you did not hear this suggestion from me) and mark on the TV screen your state outline, with some prompt such as "I am here." Start off slowly. No rush. Then determine whether or not you know if Willard is blocking your part of the country. Here's a clue: The crayon outline of your state will not be visible.

Historically, man has never really known where he was on this planet. Not totally. Not the "big picture," until recently. It was about the time that everyone in fifteenth-century Europe agreed on what the world looked like and what country was where, when a hardheaded sailor named Christopher Columbus more than doubled the size of the known world. And he only happened upon the "tip of the iceberg," as it were. For men like Columbus not to know where they were

was fine. They were explorers and discoverers. Thanks to them, we don't have to wonder where we are. Geographers, cartographers, surveyors, many other scientists, and even astronauts have added to the available knowledge of our whereabouts. We have no excuses for not knowing where we are. Well, no good excuses. And only some of the blame belongs to our educational system.

The importance of "where one is" is directly proportional to the importance of "where one is going." That concept is more difficult to grasp than it might appear, unless one considers this: 500 years ago Christopher Columbus brought the Old World together with the New World. Ever since that momentous "encounter," the resulting One World has been shrinking. Think about it. Knowledge and discovery began the Small World phenomenon even as it expanded the existing world. Faster and faster conveyances shrank the globe, almost literally. Until now we have faster knowledge, combined with faster conveyances, and the whole world is a block away, give or

take a chip or two. Please pay close attention here.

The easier it becomes to go anywhere (the less thought and effort, i.e., trips via telephone, radio, and television; or mindless excursions to job, market, school, or the same old vacation/recreation destination) the less important "anywhere" is. Thus, "anywhere" can be where one is or where one is going. The "anywheres" become blurred, obscure, and finally one and the same. Origin, interval (travel), and destination all the same. This is the ultimate and most serious manifestation of the Small World phenomenon. One's world shrinks to individual proportions. Therefore, one can be both where one *is*, and where one *is going*. Radical, huh?

Not really. We are spending more and more time within ourselves. Experts on trends in human social behavior have determined that this withdrawal of an individual—or the periodic need to protect oneself from the harsh, unpredictable realities of the outside world—is similar to "cocooning." And those experts predict that many of us will not emerge from the experience as beautiful butterflies; otherwise they would have called it "chrysalising." Ever see one of those lovely creatures caught in a ssspider ww*web*?

Who knows, by studying geography we might actually discover someplace worth going. It is, after all, "a science that deals with the earth and its life; esp. the description of land, sea, air, and the distribution of plant and animal life including man and his industries." And what if, by discovering someplace worth going, we were to discover that we, our very

selves, were already someplace worthwhile to be—as in a nice destination for another traveler?

So, about that fear of being lost. Simply dust off those atlases, globes, and encyclopedias while you're "cocooning," and you might just emerge one fine spring day with an urge to stretch your wings and flutter off to somewhere that no longer seems foreign, now that you know its name, latitude, and longitude. Next, wipe that outline off your TV screen. You've begun to revive your own interest in geography, why not share it with the family? Take a trip someplace brand new. Study the map together before you go. When you get back, see if you can discover why geography isn't so important in our schools these days. Maybe you can help fill a classroom or two. Nice thought.

Remember, being lost is one thing; not knowing where on earth you are is another thing entirely. Who knows? Learn where you are in the world and you just might find your place in it. At the very least you can point to your TV, hopefully without crayon aids, and say confidently, "I am here."

And by all means, don't be afraid of the unplanned—blushing is natural. Don't dread the unexpected. "Out of the blue" is where phone calls from old friends come from. Plan to get a little off-course, and pray to get delayed sometimes—for real, not waiting to log on or download. You never know what you'll discover.

Discovery

Discovery is a perfect shell on an early morning beach,
a penny on the sidewalk,
or an unexpected smile.
Discovery is treasure, rescued from spring-cleaning the attic,
tears after thinking you'd outgrown crying,
or a splash of wildflowers in the vacant lot
on the way to work.
Discovery is a sunrise for a "sleep-in" sort of person,
what you can see in your neighborhood
when the leaves are off the trees,
or a poem you wish you had written.
New worlds abound—even today—
awaiting the bold, the brave, the inquisitive;
they are just smaller and oftentimes harder to see;
they are under leaves in a wood, or in some obscure chromosome
that will make your son or daughter
smile just like you do.
So the continents all have names,
and the rivers, and most mountains;
any island or desert of note
has been noted—so what?
Find yourself a quiet, private spot,
a different author,
or a brand-new friend.
Finding that you take some pretty wonderful things for granted,
or merely at face value,
is what discovery is…

Second oil top to the left, past the big bois d'arc tree; you can't miss it...

I've often seen my grandfather and a crony or two engaged in the time-honored ritual of squatting in the dust or gravel or mud of a road or field to scratch directions to this or that hunting spot or secret cove. Of course in this situation my grandfather always observed another ritualistic practice and never gave accurate directions to his best spots or "honey-holes."

Old-time map makers are said to have put admonitions like "beyond this place there be dragons" or "over this way be some killer mead and dynamite haunch of venison" when they ran out of knowledge or names for those dots on their charts. Then there's the well-worn practice (now a fine art) of placing bogus names on maps to foil counterfeiters and completely Saran Wrap everyone else. I know, having chased one of those names all over north central Ohio one evening, looking for Columbus Park.

I only found myself directionally challenged once while looking for Texas, and it was my own fault, really. I should have known to abandon all hope when the giver of directions used the "as the crow flies" line—that being a quaint phrase, common in traditional direction-giving, but seldom used in modern, urban situations, where folks rarely, if ever, travel by crow.

When asked, most of us truly wish to help the disoriented visitor, but pride generally prevents us from being honest and admitting we don't have the slightest idea how to give

decent directions in our own town. I won't put anyone on the spot by asking if they have ever been on the giving end of poor directions. How about the other side of the compass needle? Ever get such poor directions that you had to go home and start your trip over? And you could swear you saw the local, either rolling in laughter on the floor of the filling station or hiding in his

shrubs with the lawn mower still running in the middle of his yard, as you retraced your route and passed by the scene of the misdirections seven times before you managed to find your way out of his town.

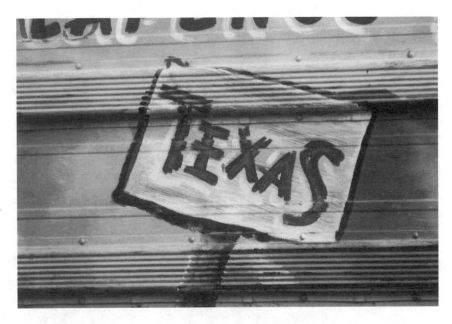

Note my gender bias. It comes from experience—from all points on the compass rose. Most of us men think we give good directions but rarely do, although we will look a total stranger in the eye and lead them off the edge of the earth. Giving directions to someone they perceive as desperate is an exercise of power for some men. Good men will attempt, though often in a condescending manner, to give good and accurate directions. They are proud of their community and happy to have you visit it. Bad men will look a total stranger in the eye and swear, "The sun sets in the east in my town, buddy." Or else, a man will respond with the standard, "You know, I could take you right to it, but I can't tell you how to get there."

On the other hand, most women give poor directions and they know it. They will generally defer to any male within a day's walk. If a woman does try to tell you where to go (not an ex-wife, that's different), the safe rule of thumb is to believe that you can't get there from where you are at that moment. Change your travel plans. Return home. Else, proceed

at your own peril, after calling ahead and telling whomever that you'll be late for supper.

But let's examine the situation fairly, shall we? Put the shoe on the other side of the mouth. Why would anyone take off to go anywhere without obtaining full and complete directions before departure? Do people really not do that? Of course, everyone cannot afford a global positioning system in their vehicle, but maps and markers are inexpensive and low

tech enough for all. Does anyone have the right to venture out there in unfamiliar territory, uncharted waters, unstomped (for them) grounds and expect to be given a get-out-of-lost-free card by the first person who makes eye contact with their

directionally challenged, not-from-around-here self? Of course not.

Sorry for all that; this was supposed to be a simple thanks to all the nice folks out there who helped me with directions along the way, not a lecture. I guess I kind of got off-course.

On the road
1994 – 1996

Follow the signs to Canton

On the outside chance that someone who will read this recently won a trip to Earth from outside this galaxy and therefore may not have heard, the biggest flea market, in this galaxy, at least (prove otherwise), is First Monday Trade Days in **Canton** (Van Zandt County), Texas. It takes place on 100 acres of land adjoining the town and involves over 3,000 vendors selling everything from dogs, Cowhill Express' frozen cappuccino, and you-name-it-Texana by the boatload to obscure treasures (one man's trash ...), priceless trinkets (but they are marked for sale), one-of-a-kind thingamajigs, and innumerable whatchamacallits.

Canton truly has something for everyone, and more choices of food to sustain a person while shopping than you can shake that authentic Incan rain stick at. My recommendations are to have an ear of roasted corn in one hand and a smoked turkey leg in the other, while you make your first casual pass through the prime

areas (this is somewhat akin to what Moses might have experienced had the waves not parted): the ones you've targeted from a series

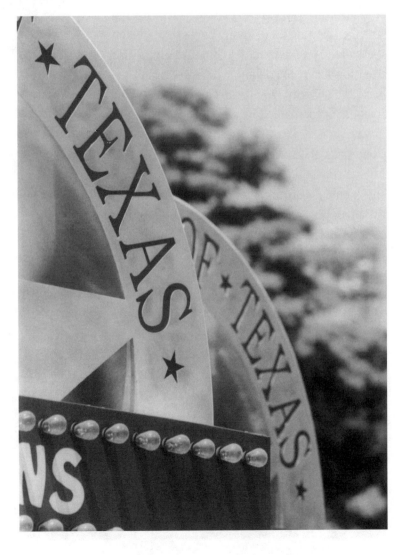

of earlier reconnaissance missions (helicopter fly-overs and/or Mir photos of the area—see vendor stall #BR549 for these), and marked on a laminated (sweat, drink, tear, mustard, ketchup, and tartar sauce repellent) map of the entire mind-boggling layout.

Just before you're ready to swoop down and make all those vendors' day, financially speaking, you'll want to set a spell and get your second wind and your second or third course, whichever the case may be. Gathering strength for this final buying burst demands a specialized intake of fuel, and nothing will gird a person for this grueling task like Clara Kirkland's Corny Dogs—three or four—which are best accompanied by a hot order of her Texas Twister 'Taters and washed down with a big glass of her freshly squeezed limeade. After a repast like that, you are ready to spread plastic around like there's no mañana. But au contraire, you can do the same thing next month, and the one after that, and the one after. During the intervening periods, you can visit the City of Canton's web site at

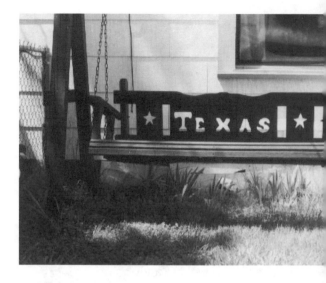

www.cantontx.com and make plans for your next assault on this haven of handiworks. (Everyone knows it is a poorly disguised cover for your monthly fix of Cuisine du Canton a la Clara.)

A trip to Canton never fails to impress me with the lengths that people go to in order to create a "favorable selling environment." That's an overblown, fancy term for place of business, otherwise referred to as the shop, the store, or as they call them in Canton, the vendor's "stall." Many structures resemble a hybrid version of a lemonade/fireworks stand. I always wonder how some of them got their start.

Anyone care to hazard a guess how many "Yard Sale" signs I passed in 20,500 miles, looking for Texas? When you consider there are never fewer than fifty signs posted all over a town the size of Commerce during the yard sale season (that's any month without

an "r" in it, plus the months when it's safe to eat raw oysters), I could claim to have counted a number approaching the speed of light squared and not be off more than one or two decimal places. You know I'm not kidding.

You also know that many yard sales are actually garage and driveway sales, and no one cares. But what everyone should know, that really should matter, is that there is actually only a handful of skillfully scheduled yard sales in every town, no matter what the size or location in the state, per season. That explains why all the same junk, I mean stuff, is at every single one.

Don't get me wrong, I hate the things. Yes, the selling of junk is often the first step in recycling, and I'm all for that, but the very next step always should be crushing the items beyond recognition. Personally, I'm in favor of that being the first step, but I know I'm in the minority in my thinking, especially in my own

home. Judy has orchestrated two yard sales in our time together, and both times my criticism nearly landed me in the yard...for the night...

Then there's those spurious Canton wannabes springing up all over the place.

"With a Second Thursday here, and a 247th Tuesday there; here a flea market, there a trashed up parking lot or converted mini-storage space—Texas has its share of junk, take it to the dump!"

Rumpledfriedporkskin, Grin Brothers Hairy Tails

Please. Don't you just want to stop and hand all those folks a map to Canton so they can see for themselves how it's supposed to be done? But then again, all those Cantonese have to get their training from someplace (admittedly, some have not progressed so very

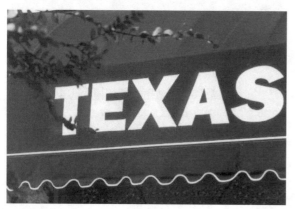

far from their yard sale roots). Jumping junk bins, Batman! Maybe we've discovered an evolutionary path no one has heretofore considered here before. Of course, it's logical; from lemonade stands as kids, to yard sales as whatever, to professional purveyors of all the stuff that has made First Monday Trade Days what it is—a legend.

Now all we have to do is find out where, and by whom, all that legendary stuff is being manufactured. There has to be some huge facility somewhere dedicated to the proposition that this planet needs literally acres of welded hand tool creatures; some factory making the makers of license plate-covered birdhouses; some plant turning out the turner-outers of painted, wooden, three-piece, slotted, cow yard ornaments. It's out there. And the next time I run across someone who may have recently won a trip to earth from outside this galaxy, I'm gonna get me some proper directions and boldly go...

Message in a bottle

My first trip, the first one that was actually planned—well, sort of—and devoted solely to looking for "Texas" (and wildflowers, of course), was on Saturday, March 30, 1996.

I had found and photographed the word often, in and around Dallas mostly—enough to have twenty-five nice images to hang in GTE's corporate gallery for the month of December 1995, an exhibit marking the 150th anniversary of Texas statehood and the true beginning of my commitment to find and

photograph every last "Texas" in the state. I was sober as a judge at the time I decided to do so; swear on a stack of Nanci Griffith albums.

Looking at any map of Texas, even the smallest one that can fit on a single page of a small atlas, those 254 counties, spread out over 262,017 square miles, make one huge parcel of real estate for any one person to imagine viewing through a windshield. Frankly, and I don't mind admitting it one bit, I was a tad intimidated. Yes, me, to this very day, the only person on earth who has traveled to every U.S. town, living, dead, or renamed Columbus (and as my wife, Judy, is always so quick to add, "the only person on earth who would want to do that")—30,000 miles and 100 days on a bunch of roads through 48 states for that little enterprise—daunted by another bit of driving and taking pictures.

Thus it was, laying my fear aside and girding myself for that first solo foray into Texas legend (one must gird oneself, in the absence of sponsorship cash, with self-proclaimed promises of fame and glory; actually, half a bottle

trip, as with most of those to follow, I simply saw an opening in my schedule (and a positive balance in my checkbook), gassed up, packed some clean underwear and toothbrush for a night or two

of Jose Cuervo works equally well), I set my sites on a modest goal, departing that spring day (Judy and Jessica were sound asleep, as I recall), without fanfare, and if I remember correctly, without breakfast. Such is generally the lot of all true discoverers—unappreciated and undernourished. This discoverer was also a little under the weather, having actually done the tequila girding thing the night before.

My modest goal was to see how many counties I could cover in one full day. I needed a benchmark for estimating and predicting a completion date for the entire project. Although I was to more than double that day's output two years later, by nightfall the counties of Wood, Upshur, Titus, Franklin, Camp, and Hopkins had been discovered. And not one resident of either had the slightest clue...

Speaking of fanfare, make no mistake, if I had had the time, there would have been press coverage of my departure to match Lindbergh's. I too would have painted some catchy moniker on my sturdy craft, but for this

away from home, grabbed camera, film, and notebook, and hit the road. Actually my first trip was only a one-day deal, and those rarely involve a change of clothes, so I simply headed out.

Notes from that first trip were sparse. It took another short trip or two to realize that it might be worthwhile to write more about each journey.

Hopkins Co.—Sulphur Springs; lovely courthouse; Mission Theater; Bodacious BBQ; buzzard 12:31 p.m.; sgl. to south. Grandmother

used to say, "Pass a load of hay, make a wish and look away." I did. Noted the lack of cabooses on trains (see story titled, "Train of thought").

Wood Co.—Quitman; Big Boy's BBQ on Lake Fork; Welcome to Quitman mural included an oil well with cowboy on horseback (saw the real thing later)—("Big Bass Capital of Texas"); Gateway to Lake Fork on Texas Forest Trail; ¾ town square on Goode Street; pecan, dogwood, azaleas, and wildflowers; lovely, rolling hills along TX154; buzzard 2:03 p.m.; sgl. to north.

Upshur Co.—Mary's Restaurant was for sale; met Mary, "what's left of me," she said, and offered me a cold drink; **Rhonesboro**, pop. 75, claims to be "Possum Capital of Texas"; Harmony School, the sign read, "Home of the Fighting Eagles"; so, is there harmony in Upshur County or not? Another sign for Harmony United Methodist Church; **Gilmer**—brick square; Buffalo Street; buzzard 3:22 p.m.; sgl. over Lily Creek to east.

Camp Co. 3:28 p.m.— **Pittsburg**; peach trees blooming; did not shoot Bo Pilgrim's mansion, but wow! The title for this picture I didn't take might be "Pilgrim's Progress"; NE Texas Rural Heritage Museum in old Cotton Belt RR depot; Holman Building has the oldest rope pull elevator in Texas still in use.

Titus Co. 4:17 p.m.—US271N—**Mount Pleasant**; saw first bluebonnets of the season; 5th and Jefferson—*East Texas Journal*; tulips; got several nice Texas shots near I30; buzzard 4:58 p.m.; 4 circling over I30 near mile marker 158.

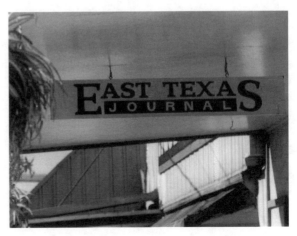

Franklin Co. 5:04 p.m.—**Mount Vernon**; lovely little square; shot faded and weathered sign on the side of an old building; must come back for a stroll with better light . . . and Judy . . . Home 6:ish; 165 miles total.

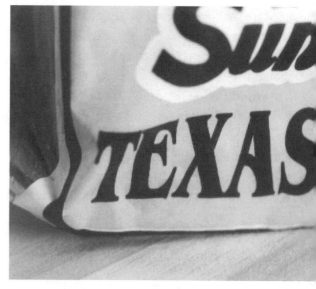

And just like that, six counties were behind me looking for Texas, for a grand total of 11 down (counting the five I had covered in 1994 and '95: Anderson, Dallas, Rains, Van Zandt, and Wichita) and only 243 to go. Between you and me, I was still a tad intimidated and sorely in need of additional girding.

But that first trip gave me lots of ideas, even as it convinced me that I truly had undertaken quite an enterprise in looking for Texas. I thought about doing a lot of stuff to commemorate my first "official" outing appropriately but have yet to manage more than this chronicle. No biggie. From what I have been able to discern, Admiral Columbus didn't get much of a send-off for his first voyage either.

Bertha missed East Texas

My real job, the paying one, required a trip to Arkansas to deliver some art to a site for a client we work with a great deal out of St. Louis, Missouri. On the return trip, July 10-11, 1996, with Judy, I covered three new counties and watched the weather.

A couple of days prior to our leaving for Arkansas, we had taken Jessica to Dallas and put her on a plane to visit Judy's sister on Amelia Island, Florida. Had we known that Hurricane Bertha was going to threaten that portion of the east coast, we would have kept Jess in Texas. It was difficult enough putting her on the plane for her first solo flight—no, not as the pilot, but as a very fragile-looking, ten-year-old little girl passenger—acting as if she were merely going out in the yard to play, not flying a thousand miles away, and seemingly oblivious to her mother crying and the longer than usual hug from her father.

Two margaritas later, Judy and I were in as good a spirits as what's-her-name we had just put on the thingamajig. Dinner brought our flight in for a safe landing before we had to make the unusually long drive back to Commerce in that huge, quiet

van. Going to Arkansas would get us out of that huge, quiet apartment.

US59S—**Cass County** 6:08 p.m.; green and lush for Texas, this hot, dry year; **Atlanta**—no 'lympics here... Texas Bar B Que! Buzzard 6:23 p.m. at US59/TX77 split; Judy had predicted the weather would clear

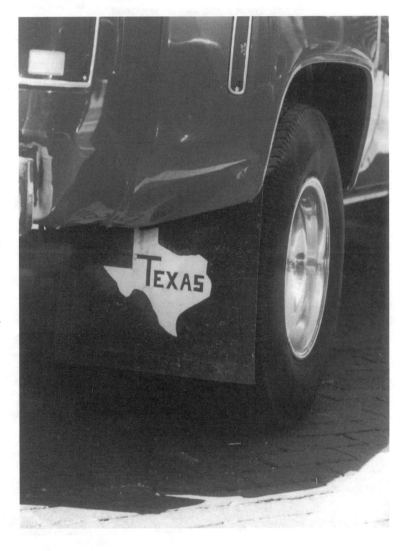

and just as the sun came out, we saw 6 buzzards circling to the west; TX11W to square (E. Houston St.) **Linden** 6:36-7:15 p.m.; Sweetgum Junction, Capital Florist, Carla's Corner (756-8017), On a Whim (756-7228), Linden Flower & Gift; Hurricane Bertha check; Jessica is clear (her Aunt Joan and she were safely evacuated from Amelia Island—another first).

US59S—**Marion County** 7:34 p.m.; **Jefferson** 7:42 p.m. ("Bed and Breakfast Capital of Texas"); self-guided, fast-fading-light, driving tour of town; excellent dinner at The Gallery Restaurant, 121 W. Austin, 75657 (903) 665-3641; watched "Lady Jane" (Gray), an outstanding PBS special; end of the day. We had made no arrangement for a B&B, so we promised ourselves, next trip . . .

7/11/96—we arose at 7:50 a.m. to discover that Bertha was bearing down on friends, family, and Georgia's coastal beauty . . . that information, thanks to the Weather Channel; buzzard sighting on the way to fetch Judy's coffee 8:55 a.m.; sgl. to the west; we ate

breakfast at Club Café, strolled around town, photographed, shopped, and visited the Chamber of Commerce; left town 11:40 a.m.

NOTE: "Crazy Quilt"—a life . . . ; I saw a huge patch of blue waterleaf; stopped and knelt to shoot the blossoms, and with that effort, every single pair of Levi's I own has a stained right knee . . .

TX49W "Texas Wildflower Trail"— **Cass County** 1:05 p.m.; **Avinger**; saw several new wildflowers; began "You only see the big flowers @ 70 mph . . ." **Morris County**—

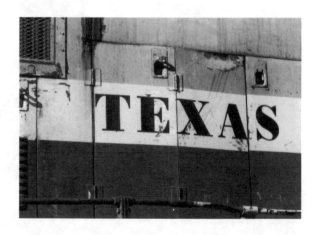

Daingerfield 1:15-1:49 p.m.; Morris Theater; lovely renovated office building; buzzard 1:51 p.m.; pair circling to south. Head for home.

Nothing relaxes a person like relief. A perfect delivery in Arkansas, a few more counties visited, and knowing our daughter and her aunt weren't getting any frequent flyer miles, courtesy of *Air Bertha*. My brother and friends in Savannah and elsewhere along the Georgia coast got heavy rain that Texas could have

used, and everyone went back to waiting for the next storm of the season—one beginning with the letter "C." With Jessica safely inland, Judy and I relaxed our weather watch and started counting days until our little flyer came home.

By the time the final days of 1996 had weathered away, I had stormed through a grand total of 40 Texas counties. Gee, *only* 214 to go...

You only see the big flowers

*"The wildflowers know
all the colors of the sky
and the taste of rain…"*

Virgil Race

On July 10, 1996, when I knelt to photograph a lovely patch of blue waterleaf, just outside Jefferson (Marion County), the collection was complete. Every pair of Levi's I owned sported a right knee that was either grass-stained or nearly white from treating for grass stains.

Looking for wildflowers was a passion long before I became smitten with looking for Texas. When one became a fortunate excuse for the other, I realized I could no longer keep a straight face whenever I used the word "work" in reference to what I do for a living. There are life lessons in looking for anything, but in my humble opinion, more are available for the learning in the gentle pursuit of wildflowers.

Did I say "gentle pursuit?" Only if one bears in mind that chiggers, ticks, fire ants, and an occasional snake often become the pursuers, while poison ivy, stinging nettle, and various burrs don't know the meaning of the term "gentle." But even though the wind and perspiration often conspired to take the "gentle" out of the pursuit, to date my life list of wildflowers captured on film is nearly 400. Here are some other scores just in: Chiggers 54-RV 0; Fire Ants 92-Vanderpool 1,999+ (I still lost that one); etc. etc. And here are some of those life lessons:

You only see the big flowers along the Interstate routes. At legal speeds or thereabouts, the colors merge and species blur, but real-life dramas do occur, just off the fast lane.

Whether traveling tourist or business class, we miss the little things we pass; from exit to exit, to fast food and gas, we whiz along in our overpriced, shiny, air-conditioned, mobile phone booths.

In midsummer's brew of asphalt, rubber, and hot exhaust, the fragrance of sweet white clover's lost; why the stench even makes brown-eyed Susan cross.

And it's a daring honeybee indeed, who chances a landing on some highway weed, buffeted by car or semi-load; if the insect can find even one bloom intact, its pollen's in some other area code. Even the sleekest Beemer's pass can blow the pistils off sassafras.

Relax and take the slower lanes—you know, the ones with pleasant names. And there you'll see lilies and chicory too, fleabane daisies and what have you; there to enjoy

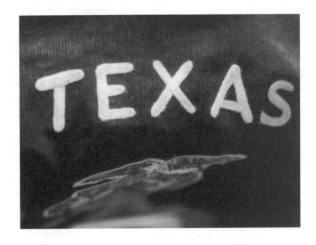

Mother Nature's thing, and liven your pulse to the measure of spring.

"Hey, you!" **won't get it**

Take a drive down a country lane
and count the flowers you can name;
no matter they be great or small,
showy, drab, or plain,
find a way to jog your brain
till you can name them all.
They're friends the same as Ed or Dan
a bouquet, fragrant, sweet;
each nods or waves as you pass through
so do your best to greet them too!

Blue-eyed grass gazes into Venus' looking-glass; henbit by the peck. Spring beauty, spring beauty out the kazooty. Stand in a spread of buttercup, up to your neck.

Flocks of phlox and crow poison mixed, till you can't stir either with a walking stick. Violets in every imaginable hue, from snowy white to violet blue. Mustard till you're flustered from so much yellow, then chickweed, indeed, a tiny, pale fellow.

The garlic is false, the dragonhead too; makes one wonder if bleeding heart's true. Hickory, chickory, dock; basket flower and four-o-clock. Only time will tell how many daisies. I think that I shall never seize a flower more nifty than zephyranthes.

How did Susan's eye get black? She ripped the Dutchman's breeches—smack!

We are blue flag iris—stop, get out, and admire us; thistle, thistle, common as a

whistle; plains and golden wave coreopsis, nothing tops us. You could fill a wheelbarrow with meadow pink and yarrow, and yucca elata, alive, alive-o . . .

More than a kettle, full of purple dead-nettle, and evening primrose for days, just at the stroke of paintbrush, when Her Highness, Queen Anne shows her lace.

Drink tea of yarrow; feel better tomorrow. And if you find you have an itch, you've learned there's chiggers in some son-of-a-vetch . . .

Watch out for that tansy as you view the field pansy, and scarlet pimpernel you may never see, unless you're prepared to genuflect and get some grass stain on your knee.

Red clover, red clover, red clover all over, and crimson and rabbit's foot too; and just when you think you've seen it all, the Lone Star State turns blue. As miles upon miles of Texas bluebonnets, inspire smiles upon smiles and occasionally, sonnets:

Bluebonnet songs

Bluebonnet songs whisper buffalo names
to coyote, quail, and deer;
with moonlit verse and sun-drenched note
(the likes of which man never wrote),
the blooms recall each bygone year.
Poets pen praises of prairie skies,
that match the *clover's hue;
stroked by the ceaseless prairie breeze,
are the endless waves of blue.
Mortals see, but do not listen,
or else they cannot hear,
bluebonnet songs whisper buffalo names
to coyote, quail, and deer.
Alas, man's memory is fragile,
and when the stories by firelight are gone,
pray the fabric of the wildflower's seed
holds all of our heroes and all of their deeds
wove secure in a memory as long
as spring and the bluebonnet's song . . .

*Bluebonnet is also known as buffalo clover.

Cuppa

Any true road warrior appreciates a good truck stop (the Flying J—as in **J**udy, **J**essica, and **J**ennie—chain is my personal favorite), if not for the coffee, food, and fellowship, then for the variety of services and amenities; all provided in a unique ambience one can only find at those welcome islands which beckon "your tired, your hungry, your huddled masses yearning to breathe fuel" (with apologies to Emma Lazarus and Miss Liberty).

> *Truck stop coffee, by any other name*
> *dark and strong and hot as hell;*
> *and every waitress, each the same*
> *tho' mid-west gal, or southern belle.*
> *But every trucker's different,*
> *characters etched by the road;*
> *from their handle to their hat—no matter where their heart is at,*
> *their lives are all the stories, load to load…*

Virgil Race

When I was younger and forgot for a brief time that I knew better, I considered becoming a truck driver. As a boy, I had eagerly wished my life away and counted off birthdays until I was old enough to work with my grandfather, moving furniture. I did that for two summers, one between my junior and senior years in high school, and another after graduating from high school, before I went into the Air Force. Granddad gave me a wonderful, priceless experience, teaching me valuable skills; but more even than that, he passed on to me his honest, blue-collar work ethic.

The last year I was in the service, stationed at Tullahoma, Tennessee, I worked for an agency, packing and loading as an antique handling specialist—Granddad treated his customers' property with care and respect, and he had taught me to do the same.

When I was discharged from the service, I worked part-time for an agency in St. Louis. Between a desire to attend college full-time,

and an unpleasant experience with the Teamster's Union, I decided to end my career moving furniture, and with that decision, pretty much laid aside any thought of driving a truck for a living. Little did I know at the time that I would later fashion a new career, stemming from an incurable wanderlust I also credit largely to my grandfather's influence, and that from my grandmother and gypsy parents as well.

Those summers I worked for my grandfather and lived with my grandparents, in a small town south of St. Louis, Missouri, were so full. In addition to working together, we hunted and

of stuff that has been warned out of our modern diets. She made three meals a day for as long as she had a kitchen of her own: real eggs and bacon or sausage for breakfast for Granddad and me—at 4 a.m. if we were going turkey hunting or fishing, 6 or 7 a.m. if we were going to work; an equally hearty lunch, promptly at noon if we were in town, or hearty sack lunches if we were in the woods or boat; a modest supper, many nights, often cookies and milk for Granddad (his preference) and some yummy, warmed-over leftovers for a growing grandson. She passed away in April 1997. What memories...

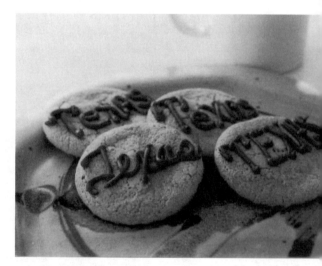

fished often. Granddad and I became best friends, which we remain to this day.

My grandmother was as all grandmothers should be—roundish, fun-loving, attentive to a fault, and one hell of a fine, nearly-everything-from-scratch cook. She came from the old-fashioned school of that nearly lost art; a pinch of this, a smidgen of that, and a whole lot

If Grandmother graduated with honors from the old school of cooking, keeping a neat house, and being a grandmother, Granddad always appeared to own a Ph.D. in helpless animal husbandry. Grandmother "ruled the roost" and waited on Granddad hand and foot. She wouldn't have had it any other way. Granddad doted on her, as well, and always

appeared totally incapable of surviving without her attention. I bought his routine until one trip he and I took to Kentucky Lake, crappie fishing, the spring before I went to Okinawa for the Air Force.

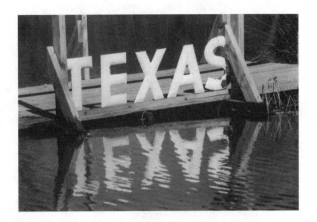

At home, Granddad had his wife convinced he couldn't boil water, much less make coffee, fry eggs and bacon, and prepare hash browns! Why, that first morning in the cabin, to my utter astonishment, the old boy even demonstrated complete mastery of canned biscuits. He fried extra eggs and bacon for sandwiches —he even packed our lunches—and would have done the dishes, had I not recovered enough to handle that chore.

When I found my voice and asked the obvious question, he replied, "I've had the best teacher a man could have all these years," he said, "but just because a feller knows how to do something, knowing when to do it is the real knowledge. And you tell me this, Grandson, what would your grandmother do if she couldn't cook and clean and launder for her family?" Knowing that's what she lived for, I shrugged and offered something to the effect of, "Dry up and blow away?"

"Sure as a feed mill's got a four-legged mousetrap," he replied.

Enough about my grandparents, this is a story about coffee. I never drank more than a sip or two of the stuff as a teen, or even later, in the service and college, but thanks to my grandmother, I always considered the unmistakable smell of it as part of breakfast—to this day, anywhere. And thanks to Granddad, it was always a necessary element of the wait for that first spring gobbler to announce his

whereabouts at the crack of a usually bone-chilling dawn; and often, a steaming cuppa was a basic survival aid for thawing out on a cold, rainy, windswept lake, or after sitting motionless for hours on a frosty, early morning, no-deer-as-usual hunt.

Alone, on roads I've not traveled before, early of a morning, with or without anything more for breakfast, that first cup of coffee brings reflections of so many others. There's just something comforting about clasping the warm cup, even when your hands aren't cold, and inhaling its familiar fragrance. It's like shaking the hand of a dear old friend.

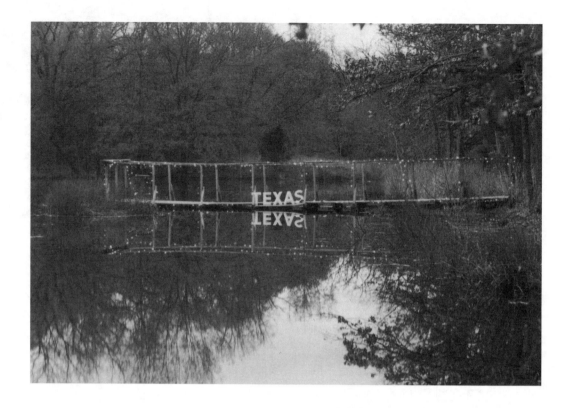

Alone on roads that deeply etch my character, my mind and spirit full from a day of looking and thinking, a cup of strong coffee never fails to coax a few extra miles from my tired eyes and body—always just enough to get me home, or anywhere safe for the night.

People whose job it is to warn all of us about the potentially harmful stuff that we might ingest, inhale, or otherwise put into our bodies have little interest in our spirits or our souls; that's someone else's department—preachers, therapists and other specialists, friends, and grandparents. So, as long as opinions on coffee's benefits or liabilities are divided equally, I will remain in the pro-coffee camp and enjoy a cuppa as often as I *need* one—not for the chemical stimulation it might provide, and really not so much for the smell, the taste, and the warmth, as for all those memories.

Sorry, I guess this wasn't a story about coffee after all.

Will act for a square meal

Besides the coffee at truck stops and small cafes around Texas, I noted the waitresses. And not for the reasons you might suspect. Young or old, they are simply books, walking around...

Connie feels like a leading lady. Working the breakfast shift at the only cafe in her small town, every morning serving dozens of the "most important meal of the day,"

she is noticed. She is pretty and polite, which helps, and she brings the steaming coffee to the bleary-eyed patrons promptly. Reading everything she can manage time for, her life has become a patchwork quilt of little plots and larger imaginings. Mostly she reads her customers. She is a very good waitress and an excellent actress.

All the orders are her lines and they are flawless;
placing napkin, fork, and knife, that is her art.
As each platter she does flourish,
and imagination nourish,
At each table she will play a different part.

She even got a quick and unexpected round of applause once when the oldest Stovall boy's eggs, toast, and coffee hit the only unstained spot on the relatively new indoor-outdoor carpet. Connie took it well and knew her audience wasn't being critical. She's a standout and she plays to that; flirting casually one minute, coolly distant the next, then almost, but not quite, one of the boys, laughing convincingly at some off-color joke or remark. She dresses creatively and as well as her meager income will permit.

She's tipped well, greeted cheerfully, and trusted.
She was fondled once but made her feelings clear;
The scalding coffee she did botch,
so's her message reached his crotch;
Connie bought his breakfast and the actress shed a tear.

Connie lives alone. She has a boyfriend in the service (or so she says) and her family is not from around here (or so she says). Connie senses there are light-years between her and the characters she serves, especially on those mornings when all the little tables with the honest smiles, the good-natured wisecracks, and the newspaper walls seem miles apart.

> *All the customers are fans—*
> *some fellow players,*
> *acting just as certainly as she;*
> *'though sick to death of where they are,*
> *none so fortunate as she;*
> *She can act like there's no better place to be.*

So every morning she plays the part of belonging here, amidst the eggs and toast and bacon, the hot coffee, and the breakfast crowd clatter; upstaging the news of the day at will and artfully easing the worries of the rest of the week. She has always known the way to her very best tomorrow, but for now she is needed and she is noticed, and she can always dream.

> *All her customers are friends and fellow travelers,*
> *each uncertain of the road to happiness.*
> *They are not much, but Connie needs 'em,*
> *perfects her craft each day she feeds 'em;*
> *Who needs whom the most is anybody's guess,*
> *as Connie feels like she is acting less and less.*

More musings

Getting it write

Writer's block:

Earnest Hemingway called it the "white bull." I remember reading that about the time I fancied myself a writer and determined I could avoid the problem by using a yellow legal pad.

Writer's cramp:

Avoiding this problem has always been as simple as waiting an hour after eating to write—that and getting out to stretch every 500 miles or so.

I mention these two problems that writers often encounter in order to illustrate how simple writing is. Writing is simple, but organizing is not. So I rarely ever organize: not my thoughts, my notes, the stuff I collect, and never, ever the things I write. Until recently, when I decided that a night alone in a motel room after a day spent looking for Texas was perfect for organizing the notes from all those miles. All I needed was a little discipline. Actually a great deal of discipline. Okay, make that far more discipline than I could ever manage to muster after a day on the road. So my notes remained intact until now. But they are very good notes—passed tenth grade geography for me and seven or eight of my classmates—and looking over them, I am able to precisely re-create every sight, smell, or sound I noted several months ago. Failing that,

I'm perfectly comfortable writing fiction whenever necessary (see **Writer's license**, below).

When I had completed travel to nearly two hundred Texas counties, a sense of urgency came upon me. I needed some words! While each roll of film from the several trips had been processed, labeled, and neatly filed, acres and acres of my jaundiced "bulls," all the pages of my *Coffee Ring Journal,* were spread on the floor of my living room one night as I tried to will them into some logical pattern. I stared at my atlas and thought about an old friend, Roger Payne, Chief of Geographic Names Division, U.S. Geological Survey.

Note: Look up the word "organize" in a dictionary and you'll see a little inset picture of Roger Payne, the person who has the awesome responsibility of organizing the names of every city, hamlet, creek, river and rill, mountain, town, village, valley, forest, and mole hill in the United States—including Texas—for the people who make the maps like the one that served as my guide for 20,500 miles but which offered no direction for my journey into authorship.

With thoughts of all that, I resolved to get my sheets together and find the words to add to my notes to tell the story of where I had been and what I had seen in all those places with names that Roger Payne keeps organized for me, other passers-through, and everyone who calls those places home, even though they may never have thought to write a single word about the experience.

Hours later, without words and no longer able to focus on my blank computer screen (for whom the bull scrolls, Papa?), I went outside to sit in my pickup for inspiration (see **Writer's craft**, essay titled, "Pickup artists").

Writer's license:

I'm proud to say mine was issued by the University of Georgia in 1975; from the then Henry W. Grady School of Journalism—the "J School" as everyone called it. In truth, my goatskin reads that I received a degree in Public Relations, but trust me, after acing two News Writing and Reporting classes from Charles Kopp (God rest his soul), roaming

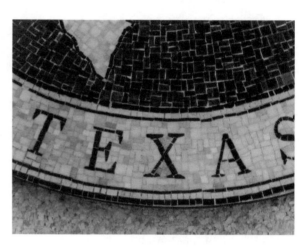

those hallowed halls for three years, rubbing elbows with the ghost of H. Woodfin on a daily basis, and learning "all that's print to fit"* by osmosis, I certainly was imbued with more than enough journalism to write as good as anybody.

Then again, who actually writes these days? Aside from hastily scribbled notes, we journalists have been typing for well over a century (the typewriter was invented in 1867 by American inventor Christopher Latham Sholes; Panati), and writers have been typing

their manuscripts ever since Mark Twain began the practice ("...on a Remington, soon after the machines went on sale..." c. 1874; Panati). Then typing evolved into word processing and data entry. Finally, writing is no longer even typing, it's keyboarding.

Regardless of the method one uses to actually get the words onto paper, no one

writes/types/keyboards the way they were taught in school. Journalists today might be able to recite Associated Press (AP) style and may have the current manual near their elbows or under their pillows, but short of a few sticklers at *The New York Times*,* anyone who adheres to it these days will churn out copy as dull and unreadable as, well, *The Associated Press Stylebook*. Personally, I never read the Libel Manual part... Ask a modern

*Apologies to *The New York Times*

journalist to name the five W's and one of them is likely to be William (Jefferson Clinton) or Wal-Mart. As for the "inverted pyramid," that was an early "X-Files" episode, wasn't it?

Change channels. Does anyone believe that television news personalities actually write? Hardly. Someone keyboards the stuff, sometimes data (but data has been known to contain facts and other confusing material), on the teleprompter for them to read, or else Peter, Dan, Bob, and Ted recite what someone is whispering in their ear. And style obviously varies (as a reference to the personality's clothing, hair, or delivery). To refer to these entertainers in broadcasting as "news" anything is often a stretch. They rarely give us pure, objective news—that doesn't equal ratings. They tell us stories. Stories with moving pictures and sound bites. And no less often than their "in-print" cousins, sometimes they tell us "whoppers." Not that I don't enjoy a little well-crafted fiction, but I'll never have a television in my vehicle. At least not until Charles Kuralt has another program. And for the record, I've never had the urge to read a newspaper while driving.

For the road, give me radio. Local radio. Sad as a small-town haircut radio. It's one of the reasons that I find driving such a pleasure. Give me the clumsy, unpolished but sincere

efforts of someone who actually lives near the news they are attempting to report and shops at the places in the ads they done wrote themselves to read so falteringly. Forget format and ratings. Close your eyes (pull over first) and imagine the styles (as a reference to the personality's clothing and hair). I, for one, can listen past the mispronunciations and miscues far easier than I can look past Ted Koppel's deadpan expression or that awful "do"!

If my radio driving companion isn't local, then give me National Public Radio (NPR). Sure, sometimes I wonder "whose nation?" and "what public?" but by and large, I know that Rick and Noah and Bob and Mara and all the rest are reading something they have written, or at least typed—on paper. Garrison makes no bones about it; he's telling us stories, not really news from anywhere. He and Michael Feldman are entertaining their listeners, giving them information that is new to them in the process. That's what I want to do when I grow up. But not on the radio. I'm only a journalist (2. a person who keeps a journal; *Webster's New World College Dictionary*). I try

to write something every day—first longhand, then type, okay, keyboard.

That's where the problem pulls up right in front of my house. At times, I drive a lot of every day. Put another way, while I'll never claim to be anyone's gift to journalism (holding up an applause sign), if ever a person was born with a silver ignition key in his mouth, it's me. My parents moved our family to another state every year of my childhood—my brother and I attended thirteen different schools growing up—but that's another story.

When I was still in college, I began designing a career around being able to work just about anywhere I wanted to be. I soon discovered that I wanted to be just about everywhere.

As I mentioned, my wanderlust developed at an early age and of such intensity only Charles Steinbeck could describe it adequately (see preface to Steinbeck's *Travels With Charley*). After logging nearly a million miles behind one wheel or another, when I began looking for Texas, I discovered I had a slight driving problem. On the other hand, perhaps it was a writing problem, since I only encountered it when I was driving, when all the things I saw demanded a note, a sentence or two, and sometimes a whole paragraph. On the other hand, it was definitely a driving problem, since I only experienced it while I was trying to write...while driving. On the other hand, that was precisely the problem; I didn't have an "other hand."

Fearful that I'd end my days as a Peterbilt hood ornament or worse, my wife bought me one of those little tape recorders. Granted, it

did allow me to describe what I saw, and it was great fun narrating my own travelogue, but it still took one hand to operate and hold the blamed thing. I told my wife this, and she pointed out that driving with one hand wasn't the challenge she was concerned about, it was the driving with one eye and writing with the other that she was fairly certain I hadn't mastered. I wasn't about to try and convince her that I had gotten pretty good at quick glances at what I was writing, so's I hardly ever swerved more than a couple of feet to the right or left. It was, however, pretty obvious that I was looking a fair amount at what I was writing because even other people could read it, though it was also obvious from the disjointed nature of my penmanship that I was in motion at the time the words hit the sheet. More than words would have hit the you-know-what if my wife ever found out that I took notes while I held the recorder out the truck window to tape wind-rushing and engine sounds for neat background if I ever got the chance to be on the radio.

No, the real problem with the little recorder was that I filled a whole drawer with little tapes I've never found the time to listen to. A well-meaning but geographically challenged (he don't get out much) buddy actually

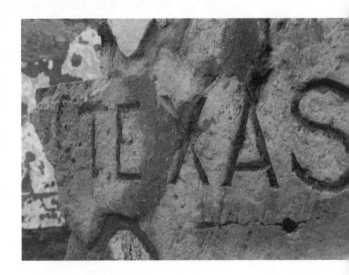

suggested I listen to them while I drove... On my very next road trip I wrote my friend a letter explaining how driving stimulated my writing muse, not the listening one, and how I didn't need more practice for senility by listening to myself talk, since I already did enough of that being the father of a teenage daughter.

All that is history, anyway. I still have life and limb and a valid Texas driver's license to go with my writer's one. One is on the wall over my desk. The other is around here somewhere. And there will be no more taping while driving, and definitely no more writing. No sirree, not since I got this little laptop computer and learned to drive equally well with either knee...

Yellow journalism

Wouldn't you know it? Right in the middle of looking for Texas (June 1997), I took a job as publisher of *The Commerce Journal*. It was an amazing experience, one result of which (a complete list may someday fill another volume) was my removing "publishing a small town newspaper" from my Top Ten List of Things To Do Before I Die...

The *Journal* sold in 1999, and I left that June to finish looking for Texas.

On the road again 1997 – 1999

All roads lead to roam

Coffee Ring Journal entry for October 27, 1997:

TX21E & TX87S—**Sabine County** 2:46 p.m.; **Hemphill** 3:09 p.m.; brick, no; clock, no; pecan, yes; Texas Street; shot wooden hearts, ornamentation under eave of building on the square; buzzard, yes, sgl. to the south; on to Toledo Bend Reservoir . . .

In 1990 I learned from the Sabine River Authority in Many, Louisiana, that the once-upon-a-time Columbus town in Sabine Parish had been underwater in Toledo Bend Reservoir since the early 1950s.

Three days after the first day of spring 1991, my sixteen-year-old daughter, Jennie, and I were in Sabine Parish, standing at the end of a blacktop road that continued into the lake. Into the center of what had been downtown Columbus, Louisiana. As a sleek bass boat zipped past (over which former house, yard, or street intersection? I wondered), the thought of an entire town being underwater gave me all sorts of ideas. Personal remembrances flooded my mind (pun intended).

Fast-forward six and a half years. I followed CR83 east out of Hemphill, following signs to Toledo Bend. A dirt road took me to the water's edge and I looked across the

lake—across Columbus, as near as my map could show—from the Texas side. The image of an entire town being underwater still fascinated me. Without Jennie, I felt no urge to skip a rock "through town" as we did in '91 and have my shoulder remind me the next day. On the way back to town, dust from the road settling on my white pickup reminded me of other roads.

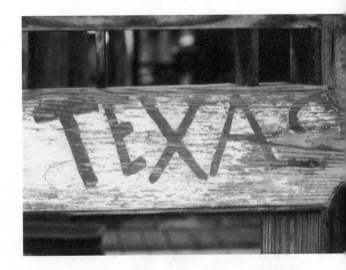

When I was growing up, several distant relations—kissin' cousins and removed aunts and uncles on my father's side—lived in a very rural area outside Dyersburg, Tennessee, along a road that I remember being dirt, then gravel, then "that damn blacktop," as Aunt Eva

called it. In spite of the fact the thing was less than seventy-five steps from her front door and had been there for two summers now, she hadn't quite learned to live with the new road.

At first the harsh blackness simply didn't fit; too much contrast where once a person couldn't tell where the yard ended and the dusty lane began. At first she didn't miss the dust.

The hardness of it she could handle, and the tar smell was not as noticeable as it had been at first, but the fastness; the fastness was going to take quite a bit more getting used to. Now she could hardly recognize folks whizzing by, so a wave was mostly wasted and a chat, well, a chat was out of the question these days; just a honk, if that, thanks to the fastness.

The fastness of it made it easy for more strangers to come and go, easy to swell the little town nearby, and easy to build their "country" homes, crowding this once peaceful, quiet little out-of-the-way section of the county.

The signs were put up and ignored. Speed Limit 45. Please Do Not Litter. Slow Curve. Sometimes something interesting was ejected from the shiny blurs, but mostly just fast food Styrofoam and paper that had to be picked up daily or risk having the road maintenance mowers turn it into yard confetti. She tried to live with the fastness and took heart as prices increased for hamburgers and gasoline.

The highway engineer fellow had told her the road would increase her property value. As if four generations of family had not made her few acres priceless. In the end it was the developers up and down the road who took advantage of property values, and everyone else got higher taxes—to pay for the road.

When the road was rededicated, after being resurfaced, she recalled a state official saying it was like a monument, a symbol to everyone in the county that a trip around the world began just a few yards from their front doors (73.5 yards from hers, to be exact).

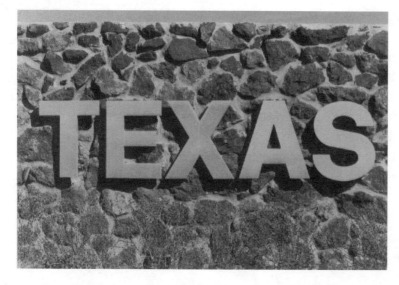

But the state official and the highway engineer weren't around to see how it was before; before the fastness, with all its noise and junk, now a constant reminder that progress has to smell bad and disturb your sleep. A newspaper writer who praised the growth didn't mention the several big old trees that were cut down to make room for all the big houses, or the once-clear streams that were always muddy now with runoff from the constant construction all along the road.

Before long she wished for the dust again. And when the fastness claimed another dog, then the umpteenth wild critter, she cursed the hardness, wishing the blackness would swallow up the shiny cars full of strangers, all the newspaper folks, the highway fellow, and the state official with his philosophy on world travel.

Finally, she learned to live with the thing, simply because she knew it had to end somewhere—a thought that gave her comfort.

Like my relatives, folks all over Texas never seem to be happy with whatever the condition of their roads. And the state's over

250,000 miles of roadway serve as examples of every condition imaginable, as well as some that aren't. That being said, Texans aren't a people to let much either slow 'em down or keep 'em home if they've got someplace else they want to be. To me any road is a good road as long as it's open and clear, just long enough to get me where I'm headed (I rarely take the same route home). And with the notable, exasperating exception of North Central Expressway in Dallas, there are no bad roads in Texas for my gas money...

I covered a total of 44 counties in 1997.

45

To the heart of it all

Never one to turn down an opportunity to hit the road (and I have a great home life), but some pretty important highway business involving Commerce was being discussed in Austin late in February 1998, so I assigned myself to cover it. I was invited to stay at the Driskill Hotel, with friends who would already be in town when I arrived for the meetings, so I left one day early to spend some time looking for Texas.

February 25, 1998; left Commerce at 7:30 a.m.; beginning mileage: 34,575.1.

I35S & TX6S—**Falls County** 10:43 a.m.; cloudy, misty rain; buzzard 10:47 a.m.; **Marlin** 10:55-11:18 a.m.; no brick or clock; pecan, yes; saw Conrad Hilton's 8th hotel—neat old structure; Chamber of Commerce sign read, "Home in the Heart of Texas"; Palace Theater; intersection of TX6 and TX7; neat metal sculpture

at fire department—Paul Wilson, artist & Leon Denena, metal sculptor; bought fuel; also passed through town of **Reagan** and shot (Reagan) sign on brick wall.

TX6S & FM46S—**Robertson County** 11:39 a.m.; buzzard-11:54; 3 over FM46S; **Franklin** 12:13-12:45 p.m.; no brick or clock; pecan, yes; lovely Carnegie Library; shot sign on fire engine; Love Abstract Company (interesting combination of words, Love and Abstract...) est. 1912; Lone Star Burger Bar; sign read, "A Team City"; saw wildflowers: fringed puccoon, spiderwort, corydalis, woolly-white, and baby blue-eyes.

US79W & FM485W & US77S—**Milam County** 1:02 p.m.; crossed the muddy Brazos River on Old River Road (FM485W); shot scenic windmill w/oaks and barns; buzzard 1:03 p.m.; 3 to SW—**Cameron**; shot Texas 1846 on

great welcome sign; 2:00-2:09 p.m.; no brick or clock; pecan, yes; lunch at Texas Burger; 1st Girl's Tomato Club in Texas is here—more research required...

TX36S—**Burleson County** 2:30 p.m.; buzzard 2:34 p.m.; pair circling to SW; **Caldwell** "Kolache Capital of Texas" and "Home of the Hornets"; 2:40-2:52 p.m.; no brick or clock; pecan, yes; shot Texas on defunct P.O.; "It's Here" bar.

TX21W & US77S—**Lee County** 3:10 p.m.; buzzard 3:18 p.m.; sgl. high to SW; passed by Old Dime Box and sign to Dime Box; huge patch of corydalis; **Giddings** 3:28-3:42 p.m.; no brick; pecan, yes; 4 broke clocks—3 stopped at 12:10 and one stopped at 3:50; 73F and overcast; Lee County Peanut Company; shot rodeo poster for **Plum**, Texas (Fayette Co.); oops, not paying attention and I

was halfway to Brenham on US290E—would take quite a while to get to Bastrop and Austin this way...

US290W & TX21—**Bastrop County** 4:15 p.m.; buzzard 4:22 p.m.; 4 circling N; shot Texas Registered Longhorns sign; **Bastrop** 4:40-4:51 p.m.; no brick; pecan, yes; 4 working clocks; shot lovely gingerbread cottage with dappled sunlight; gorgeous town—historic district; must come back and stay awhile... Also in Bastrop County—**Elgin**, "Sausage Capital of Texas," and "Brick Capital of Texas." From what I have determined from research thus far, the "Texas" brick was manufactured in **Ferris** (Ellis County).

NOTE: I ended the day, 2/25/98, in **Austin** for Texas SH24 meeting coverage on 2/26.

US290W & US87N—**McCulloch County** 7:11 p.m. 2/26/98—spent the night in **Brady** 2/27/98; 7:07-8:02 a.m.; no brick or clock; pecan, yes; "Heart of Texas" marker on square and name of many businesses; geographical center of state nearby; ate breakfast at Club Café—it had the most pickups out front; Damuth Taxidermy Shop was open on the square—early? Texas St. was only 3 blocks long; lovely museum in former jail—many towns now utilize their former jails

(oftentimes a beautiful, stout, stone edifice) in this manner.

US190W—**Menard County** 8:27 a.m.; saw 2 wild turkeys; 46F partly cloudy w/slight breeze; wondering if buzzards ever sleep in? Or are they all at breakfast somewhere? Buzzard 8:36 a.m.; saw sgl. to E, then 3 having a large yellow dog for breakfast—answered that question . . . ; crossed Scalp Creek; **Menard** 8:40-8:58 a.m.; "Touched by the Past, Looking to the Future," the sign read; no brick or clock; pecan, yes; Hoot's Pharmacy; The Busy Bee wasn't (boarded up); shot street names in tile—Gay, Tipton & Houston; Menardville Museum; pecan and meat processing.

US83N—**Concho County** 9:11 a.m.; Some visitors might find the gently rolling landscape of rocks and scrubby fauna to be boring, but thanks to my grandparents, I look for game and wildflowers; as yet, I've not traveled over any natural terrain that was boring—not true for many routes through more populous environs—the price of "civilization?" hard, sharp, twisted, sparse, rocky, dry, scrubby brush, Spanish needle and cacti; Hog Creek; sunny and clear; **Paint Rock** 9:49-9:58 a.m.; no brick or clock; pecan, yes; shot beautiful 1886 stone courthouse with gravel drive around it; purchased 3 lovely rugs at Ingrid's Handwoven Rugs, Inc.; must come back to see Indian pictographs; **Eden**—lovely theater and pretty town; Venison World; goat (wool center); buzzard 10:06 a.m. (may have been in Runnels County); sgl. E.

US83N—**Runnels County** 11:08 a.m.; crossed Fuzzy Creek and imagined it being named by a drunken cowboy; buzzard 11:09

a.m.; 3 over road SE; **Ballinger** 10:19-11:01 a.m.; no brick or clock; pecan, yes; shot nice arched window, Texas Theater (Adults .75, Students .60, and Child .45), Texas Grill, West Texas Utilities, Needful Things (shop), and Charles H. Noyes statue w/horse—this statue was a tribute to Noyes and all cowboys from his parents, "With love, Gus and Lula"; Noyes died at age 21 when his horse fell on him; huge holding area for more cotton bales than I've ever seen in one place.

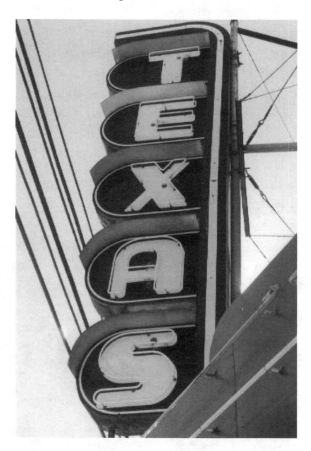

US67E & US84/283N—**Coleman County** 11:17 a.m.; Wynona Judd on the radio, singing "We Move On"—"What good's a dollar,

without a little sister...?" buzzard 11:22 a.m.; sgl. SE; everywhere there is evidence of battles with the prickly pear—and the landowners appear to be losing on all fronts; **Coleman** 11:37-12:09 a.m.; no clock; pecan and brick 2 sides of square; Tootsie's Antiques; plaque on square noted, "The day we got the courthouse bell, 1884 from Baltimore, Maryland"; shot "Brandin' Wall," The Texas Company (old Texaco sign); sign outside of town read, "You Are Leaving The Friendliest Town in Texas" —no argument.

US84E—**Brown County** 12:29 p.m.; **Bangs**—Texas Bank & Sandy's Cafe; buzzard 12:39 p.m.; sgl. soaring over road; **Brownwood** 1:01-1:39 p.m.; no brick (a path around a planting) or clock; pecan, yes; ate a sandwich on the square from Underwood's BBQ; Central Texas Commercial College—"A Career In A Year Or Less"; shot Texas Furniture Co., Texas Bank; **Blanket**—shot FFA sign for Brenda Teague, scenic & Mobil sign.

US67E & US377E—**Comanche County** 2:04 p.m.; buzzard 2:11 p.m.; sgl. soaring over

hwy.; **Comanche** 2:14-2:33 p.m.; no brick; one clock stopped at 6:50; pecan, yes; shot The Comanche National Bank, sculpted eagle detail on courthouse and front windows of the McCrary House.

TX16S—**Mills County** 2:52 p.m.; buzzard 2:52 p.m.; 4 circling over Mills/Comanche County line; **Priddy**—"Home of the Priddy Pirates" (can't quite picture that) and Priddy Body Shop (can picture that...); **Goldthwaite** 3:12-3:23 p.m.; no brick (walk only) or clock; pecan, yes; shot elaborate metal art sign with deer & wild turkey, Methodist church sign.

TX16S—**San Saba County** 3:32 p.m.; this is obviously pecan country; buzzard 3:37 p.m.; sgl. over road W; **San Saba** 3:45-3:58 p.m.; no brick; 4 working clocks; pecan, YES! Pecan Valley Hardware; shot courthouse; pretty little place.

NOTE: At this point, I am only 62 miles east of **Brady**—where I started the day...

US190E & FM581E & US281N & US84E—**Coryell County** 4:41 p.m.; cut

through a corner, then back into Hamilton County; buzzard 4:42 (Hamilton County?); 4:43 p.m. back in Coryell County; buzzard 4:43 p.m. (first road kill BUZZARD; I wondered—not long—what eats them?) this one is definitely in Coryell County—to stay; then 8 circling to N @ 4:47 p.m.—care to guess who they're having for dinner? **Gatesville** 5:04-5:22 p.m.; no brick; 4 working clocks and pecan; outstanding courthouse.

FM182E & TX6N—**Bosque County** 5:47 p.m.; buzzard 5:51 p.m.; sgl. to E; **Clifton** "Norwegian Capital of Texas"; **Meridian** 6:12-6:21 p.m.; no brick; pecan and one clock working—faces east on 1886 courthouse; "Top

of the Hill Country." Must come back for longer visit; losing light and I must make it to

Hillsboro to set up night shot of Texas Theater there.

TX22E—**Hill County** (first visited and shot 8/13/97) **Hillsboro**—great night shot of Texas Theater; courthouse still being renovated after fire.

I arrived home too late for supper on Friday, the 27th of February, but just in time to go to bed—10:ish. My ending mileage was 35,521.7 miles. The trip totaled 946.6 miles, with eighteen counties covered, not including minimal shooting in Austin (like Dallas and other larger cities, I made multiple visits to cover them completely), for an average of one county for every 44 miles traveled.

Oh, no, not a conference at the beach!

At least I think that's what I said, upon learning I had to attend a two-day meeting for newspaper advertising executives on South Padre Island. Well, someone had to go, and as I recall, I was very fair in making my choice of who would endure the ordeal. I believe I asked everyone at the *Journal* to guess the serial number of my Nikon...

The meeting was scheduled for May 1-2, 1998. I plotted two separate routes—one out and a different one for the return trip—each passing through the maximum number of counties, and departed Commerce on Wednesday, April 29 at 5:56 a.m.

Beginning mileage: 38,378.1.

TX183S—**Caldwell County** 11:05 a.m.; buzzard 11:05 a.m.; sgl. west of 183 @ TX21; **Lockhart** ("BBQ Capital of Texas") 11:19-11:58 a.m.; no brick; pecan, yes, and live oak; 3 clocks stopped at 5:30 and 1 stopped at

5:24 (NOTE: I always wonder a.m. or p.m.? and under what circumstances—recalls *Back to the Future*); ate lunch at Black's BBQ, est. 1932—one of Top 50 in May '97 survey by *Texas Monthly*—Oldest in Texas, owned and operated by the same family; interior had great character, BBQ good; shot oldest library in Texas.

TX183S—**Gonzales County** 12:20 p.m.; buzzard 12:38; sgl. east over 183; **Gonzales** 1:00-1:27 p.m.; brick, pecan, and 4 clocks stopped at four different times (see "Time keepers"); shot U.S. & Texas flags, bay window, nice vowels; saw "Tuck Me Inn" (B&B).

Alt. US90E—**Lavaca County** 1:42 p.m.; **Shiner** ("Cleanest Little Town in Texas"); **Hallettsville** 2:07-2:22 p.m.; pecan and 4 working clocks, no brick; buzzard 2:31 p.m.; sgl. to west; Texas Radio sign in **Yoakum**.

Alt. US77S—**DeWitt County** ("Wild-flower County of Texas") 2:49 p.m.; buzzard 2:57 p.m.; pair west of 183 & 77; **Cuero** ("Wild Turkey Capital of Texas") 3:04-3:15 p.m.;

pecan & palm, 4 working clocks and no brick; nice photo exhibit at library—Wildflower Assoc.; Christmas Shoppe at 134 Main, Decor Shoppe Wildflower Mart Gift Shop @ Gonzales St.; First Prosperity Bank across from First Capital Bank.

US87S—**Victoria County** 3:33 p.m.; buzzard 3:33 p.m.; sgl. over 87 to north; **Victoria** 3:50-4:04 p.m.; pecan, 4 working clocks, no brick; The Texas Zoo, Texas Truck, &...

US59S—**Goliad County** 4:23 p.m.; buzzard 4:26 p.m.; 4 circling W&N over hwy.; **Goliad** 4:38-5:05 p.m.; pecan, no brick or clock; met Faye Irby, "The Pepper Lady"— nice lady with very neat shop, "Faye's Texas Naturals," on the square; give her a call for something special and hot @ 1(800)231-Faye or e-mail her at chilpetin@aol.com.

TX239W & US181N—**Karnes County** 5:26 p.m.; buzzard 5:45 p.m.; 3 circling to far north; **Kenedy**—saw &/or shot Virgil's Bar, Texas Bar (closed), and Kenedy Bar (hopping); **Karnes City** 6:05-6:09 p.m.; pecan, no brick or clock. Thought for a grant request: Should a

dull-witted person bother to sharpen his/her rhetoric?

US181S—**Bee County** 6:27 p.m.; buzzard 6:32 p.m.; sgl. over US181 to north; **Beeville** 6:49-6:56 p.m.; pecan and 4 working clocks, no brick; jet from USS *Lexington* (I photographed the "Lex" for the Navy training base in Pensacola, Florida once); Rialto Theater. End of the day, 4/29; spent the night in Beeville. Ending mileage: 38,905.2.

Began 4/30/98 @ 7:00 a.m. in Bee County with coffee and breakfast.

NOTE: Where there is no mention of a buzzard sighting I have taken time out from doing so, as I cannot safely look for wildflowers and buzzards at the same time...

US59S—**Live Oak County** 8:07 a.m.; shot red oleander; **George West** 8:11-8:21 a.m.; pecan, no brick or clock; saw Desert Flower Realty.

US281S—**Jim Wells County** 8:55 a.m.; buzzard 9:11 a.m.; 4 circling to east; **Alice** 9:21-9:49 a.m.; no brick, clock, or pecan; How about a series of signs, "Look, Alice, Texas!"; Chamber sign at entry says, "Alice is Texas"; shot Texas State Bank with star; coming up the Chisholm Trail plaque; unidentified red flowers w/window and red yucca; Rialto Theater.

TX44W—**Duval County** 10:05 a.m.; **San Diego** 10:30-10:43 a.m.; no brick, pecan, or clock; REMARK: "This was a much nicer place once upon a time, as evidenced by numerous grand structures now in ruin all over the community; the town is a stand-out in this regard; I turned down a one-way street and a police office was most charitable; buzzard 11:11 a.m.; sgl. WtoE over TX359; getting cloudy; shot strawberry cactus, a bright flash of magenta red noticed at 70 mph, recalled the artificial flowers Judy and I once alerted on in San Antonio.

TX359S—**Jim Hogg County** (tell Russ Pigg, our family friend in Missouri) 11:25 a.m.; buzzard 11:25 a.m.; 3 circling to west;

REMARK: Are there no working windmills in this part of the state? What, a statewide windmill holiday? The wind is working, as always, why not the windmills? **Hebbronville** 11:34-11:41 a.m.; no brick, pecan, or clock; welcome sign was badly weathered—begs question, sincere? I shot a lovely St. Francis statue and church dome.

TX16S—**Zapata County** 12:09 p.m.; buzzard 12:15 p.m.; 2 circling high and far to west; one-hour Spanish lesson on radio while driving from Hebbronville to **Zapata** 12:43-12:49 p.m.; no brick, pecan, or clock; saw signs for candidate for Texas Agricultural Secretary and thought, "If they vote for him down here (great expanses appear so challenged, agriculturally), he's got it cinched!" shot orange prickly pear cactus and more at Frontier Ranch Museum.

US83E—**Starr County** 1:08 p.m.; buzzard 1:15 p.m.; sgl. S (in U.S. or Mexico, only 4 miles away?); **Rio Grande City** 1:42-1:48 p.m.; courthouse is high on hill overlooking town; no clock, no pecan, some brick in walkway pattern design.

US83E—**Hidalgo County** 2:07 p.m.; buzzard, NONE. I was too busy practicing my defensive driving! **Edinburg** 2:55-2:58 p.m.; no clock, brick, or pecan.

NOTE: US83E is the scariest road I've driven in quite a while—crazy drivers—the sobering experience recalled driving on Okinawa.

US281N & TX107E—**Cameron County** 3:26 p.m. (4/30/98) to **South Padre Island**; attended conference 5/1-5/2; shot Texas prickly pear with help from Terri McCreary (she held up barb wire fence for me to crawl under) after meeting and lunch on the way to airport, where I dropped off Terri; **Brownsville** 3:09-3:30 p.m.; no brick, pecan, or clock; Majestic Theater, Texas Southmost College (Texas on office of the president), southern end of U.S. Interstate System; there's something about a border town... 39,333.7 mileage at this point and heading home.

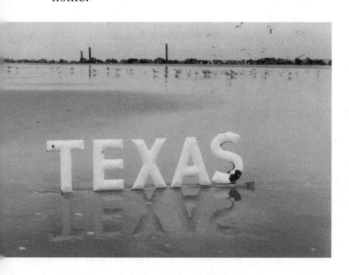

NOTE: Do a "Blame it on..." T-shirt series—Bosa Nova, Texas, El Nino, La Nina, San Andreas, New Madrid, etc.

US77N & US83N—**Willacy County** 4:17 p.m.; **Raymondville** 4:30-4:47 p.m.; no brick, pecan, or clocks, but palms! "Up the Chisholm Trail" plaque; gorgeous TEXAS Theater; buzzard 4:50 p.m.; sgl. to west of US77N; shot Texas navels (Juan's) and sign for Terri's; shot a _EXAS (chopped "T").

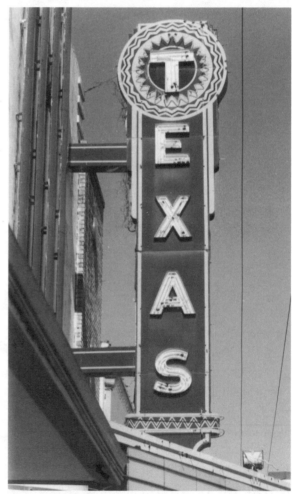

US77N—**Kenedy County** 4:59 p.m.; buzzard 5:00 p.m.; sgl. to west; **Sarita** 5:43-5:49 p.m.; no brick, pecan, or clock (what town? no stores, school, or church); Kenedy Pasture Co.; lovely, large hawk—white, with swept-back wings in flight.

TX285W—**Kleberg County** (passing through, see below) 5:52 p.m.; buzzard 5:57 p.m.; one on each side—N&S of TX285W; on to . . .

TX285W—**Brooks County** 6:06 p.m.; buzzard 6:13 p.m.; a pair to south over Paisano Creek on Rio Paisano Ranch; **Falfurrias** 6:17-6:22 p.m.; pecan, yes; no

clock or brick; Pioneer & Alameda Theaters; F.V.F.D (Falfurrias Volunteer Fire Department). Passed through Jim Wells County again—**Premont**, home of the Oasis Restaurant, "Finest Dining in Texas."
On to . . .

TX141E—**Kleberg County** (see above) 6:45 p.m.; WOW! Saw 1st and 2nd working windmills!!! Windmill holiday over?
Kingsville 7:17-7:25 p.m.; pecan, no brick or clock; King Ranch Leather Shop; gorgeous TEXAS Theater (now a bank); shot Texas A&I water tower.

US77N—**Nueces County** 7:27 p.m.; to spend the night near **Corpus Christi;** shoot later on 5/3. Ending mileage: 39,543.2.

Begin 5/3/98 @ 7:00 a.m.; breakfast then on to . . .

US37N to US77N—**San Patricio County** 7:19 a.m.; heard on radio that today is a festival day for the Roman goddess "Flora" (see **NOTE:** below); **Sinton** 7:25-7:29 a.m.; no

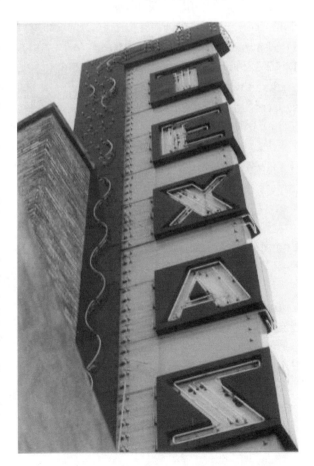

brick or pecan, one clock stopped at 4:39; Rialto Theater; buzzard (actually a crested caracara) 7:36 a.m.; sgl. flying NE; saw a buzzard buzzard in San Patricio County 9:38 a.m.; sgl. N over hwy.; passing through, en route to Rockport after Corpus Christi.

US77S to US37S—**Nueces County** 7:49 a.m.; **Corpus Christi** 8:27-9:23 a.m.; "Buccaneer Days shore left this place in a buckin' mess!"; no brick, pecan, or clock; buzzard (do beach buzzards count? sea gulls . . .); I see buzzards with such regularity, I'm beginning to suspect that a few might be following me; shot Business Interiors of Texas and the Chat 'n' Chew Café.

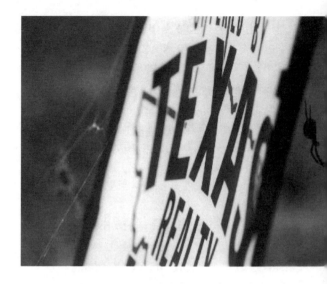

NOTE: The very lovely memorial to Selena, provided by the Durrill Foundation, looks out over the harbor in Corpus Christi. It is called the *Mirador de la Flor,* which translates as "Gazebo of the Flower," according to Mr. Abraham Quintanilla, Selena's father. " . . . *Flor*" is a reference to Selena, who was known as "The White Rose."

TX35N—I shot coral bean en route to **Aransas County** 9:55 a.m. (very cloudy); buzzard 10:03 a.m.; sgl. N; 10:49-11:12 a.m.; no brick, pecan, or clock, but palms! Saw a sign that read Antiques & Ducks; Estelle Stair Gallery on Austin St.; Bahama Bob's was for sale; "Tejas" (a shop on Austin St. and name on a boat in the marina where a couple on *Endless Summer,* in the slip beside *Tejas* gave me a "bacon brunch"); shot maritime museum anchor.

TX35N—"Refugio, Refugio, wherefore art thou, **Refugio County**?" 11:55 a.m.; buzzard 11:56 a.m.; 2 circling to east; **Refugio** 12:17-12:50 p.m.; no pecan, clock, some bricks in walkway design at corners of square; "Most Buzzards Award!" Nice native plant garden; While I was shooting, an old Mexican man, who was watching with interest (I shared my bottled water with him), motioned me to the bench on which he was seated; he pointed out some chrysales attached to the bottom of the seat; shot King/ Commerce intersection street sign and Texas Real Estate sign.

US77N & TX239S & TX35N—**Calhoun County** 1:29 p.m.; buzzard 1:32 p.m.; 3 circling to south; **Port Lavaca** 2:04-2:23 p.m.; pecan, yes; no brick or clock; shot Half Moon Reef Lighthouse; Port Lavaca Theater; open buildings in downtown for park (idea for Commerce?); 2 interesting windows shot and 2 cracks for Commerce earthquake story; mascot—sandcrabs.

TX35N & TX172 & TX111—**Jackson County** 2:31 p.m.; buzzard 2:33 p.m.; sgl. to south of TX35N; in **La Ward** I saw two signs, one for **Blessing** (with arrow), and one for **Lolita** (arrow in opposite direction); 'nuff said . . . **Edna** 2:57-3:08 p.m.; pecan, yes; one working clock; no brick; Edna Theater.

TX111E—**Matagorda County** 3:28 p.m.; buzzard 3:30 p.m.; sgl. N; Warning! (I have no earthly idea why I wrote that; my cold notes offer no explanation, so be careful . . .) **Bay City** 4:02-4:13 p.m.; pecan, yes; no brick or clock; South Texas Inn; shot Old City Hall

emblem; Bay City has the nicest landscaped SONIC I ever saw.

TX60N—**Wharton County** 4:23 p.m.; buzzard 4:24 p.m.; sgl. to west; **Wharton** 4:37-4:49 p.m.; pecan, yes; no brick and 4 broken clocks 4:07, 12:20, 12:05, & 10:22; the umpteenth Plaza Theater.

US59N & FM1301E—**Brazoria County** 5:25 p.m.; buzzard 5:27 p.m.; sgl. east over 1301E; **Angleton** 5:54-6:05 p.m.; pecan, yes; no brick; one clock stopped at 11:00; shot relief on courthouse.

NOTE: With a bag of fast food burgers on board, I headed north for home at 6:16 p.m.; FM 2234, just south of the Harris County line, 12 miles from Houston, is also called McHard Road, seriously; glad I can skip Houston for now; will get to it another time. I'm just too tired to face that McJungle . . .

I arrived home at 12:46 a.m. on Monday, May 4, 1998. My ending mileage was 40,231.9. The entire trip totaled 1,853.8 miles, with 31

counties covered, for an average of one county roughly every 60 miles. I shot seven new wildflowers, including Texas skeleton plant, water hyacinth, and palo verde. Along the way I softened and brought home souvenir South Padre Island T-shirts for everyone at the *Journal* who could spell Nikon...

The poetry of Texas

With just a little imagination, there are places in Texas that speak for themselves, places that inspire a certain specific action. Several books deal with the subject of the origin of Texas place names, but a few of the entries read to me like the author might have exercised a bit of literary license, so I figure I can exercise my own imagination in that area. Take Art, for instance, in Mason County. It's just got to be a special place where a person is going to be bombarded with a creative urge a minute. Or Crane, in Crane County. Why, I wasn't in town five minutes before I had folded an origami—say it with me—crane. I would have folded more, but I was on my way to an audience with Royalty in Ward County.

It's true. Just take a look at a list of Texas place names and see if several don't jump right out at you. Then travel to a place like Heckville in Lubbock County, and tell me you don't have the urge to yell, "Aw, to heck with it!" Of course, you might have a similar urge to say, "By gosh or Golly!" in DeWitt County or "Cool!" in Parker County.

And sure as there's poetry in Texas place names, there's also a place named Poetry, Texas—squarely a-straddle a little corner each of Hunt and Kaufman Counties. I went there once and did what any self-respecting, albeit lesser-known poet would do. I penned this haiku:

Summer ended then
the floating swallowtail was
dust on my windshield

Of course there was poetry written all over the community—verses on signs for businesses with names like Johnny's Paradise and Midnight Sonnet Ranch. Signs that read Turner's Point, Dry Creek Cemetery, Poetry Feed and Seed, Million Dollar Paints, Poetry General Store, Four Post Lane, Poetry Small Engines, and Rick Salisbury Taxidermy. Even the oft-repeated Blue Bell Ice Cream and Texas Lottery lines fit the easy meter of the place. Only the several "For Sale" signs stressed the rhythm a bit.

It being a glorious summer day, and there being no laureate in sight, this poetaster rose to the occasion. This triplet formed in my head as I turned down the well-worn lane towards a little white stand, beckoned by a sign that my imagination read as:

Figs, apricots, apples, and grapes so blue,
blackberries and peaches, all fresh as the dew
at Poetry's Akin Orchard 563-2012...

The Garlic Capital of Texas

"Eat no onions nor garlic, for we are to utter sweet breath."
Shakespeare: *A Midsummer Night's Dream*

Quite unlike Shakespeare's character, Chef Carl Sterling is determined to make garlic his "Bottom" line by growing, selling, and serving the pungent spice. He'll do this at his soon-to-be-in-full-operation Sterling's Garlic Farms, located just outside Cooper, Texas, in Delta County.

Sterling decided to move from Kaufman County in 1996. He needed at least fifty acres with the right kind of soil for his crop, plus a few additional acres for his greenhouses and other horticultural activities. The place he found was all that he required, and it also had a fifty-year-old house on it—a real fixer-upper, which he has just about finished fixing up.

"It's home for now," says Sterling, "and where I'll prepare and serve a five-course dinner for up to twenty-four guests after they tour the farms."

"Later on, part of the house will be a bed and breakfast," he added. Sterling says he will continue to serve the meal in the original house but plans to build his personal residence nearby.

By any other name, not all garlic is as tasty or as sweet or as completely nutritious as Sterling's "Silver Clove" strain of German, hard-stem, jumbo white garlic.

"It's sweeter than the California varieties and has more sulphur and selenium, making it especially healthy, raw as a spice or as a vegetable when it's roasted—great for that," says the self-taught chef of twenty-five years' experience. He notes that Silver Clove doesn't grow well in California. It needs a colder winter.

Sterling has worked with garlic in many forms—raw, dried, powdered—even garlic oil and juice. He has been involved with

experimental use of powdered garlic, which when mixed with diatomaceous earth is fed to cattle as a natural wormer and insect repellent. "Cows eat it like candy," he says, "there is also a garlic product being tested which acts as a systemic cotton pest repellent."

Hopeful that the fragrant mainstay of his new venture won't repel any prospective customers, Sterling stresses that the real draw to his out-of-the-way and out-of-the-ordinary

enterprise is the unique experience he plans to provide for his guests—one that will stay with them like, well, like garlic.

"No place in Texas has as many acres planted with garlic," Sterling claims. He has dubbed it "The Garlic Capital of Texas" and intends to get official recognition from the Texas Legislature.

"If Commerce can get named 'The Bois d'Arc Capital of Texas,' anything is possible," he said, grinning at yours truly (the author of Commerce's successful claim to that title in 1999). Who knows, one day we just might have a "Garlic Bash" out here in the middle of nowhere. Listening to Chef Carl Sterling talk about his dream, one can't help but believe it won't be long before this "middle of nowhere" is somewhere for a lot of folks.

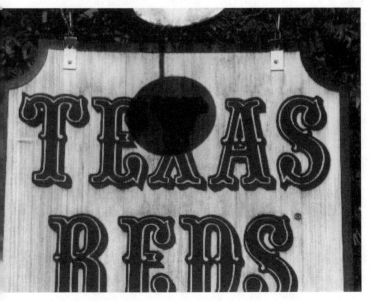

Getting to Sterling's Garlic Farms is not quite as simple as following one's nose. For information, directions, and reservations, call (903) 325-4444. 🌵

Home, home on the lanes

The conference call was invented to enable several people to hear "discouraging words" simultaneously. It is the method most widely used by mid-level management executives to deliver bad news, all at once, to a select group of underlings, who are, by virtue of the long-distance nature of the call, well beyond arm's length and even out of rifle shot range.

NOTE: Long distance is a safe way to "drop the other shoe," as it were. It is doubtful that anyone has ever tried a conference call to deliver the phrase, "The front office has decided to make a change . . . " to some guys sipping coffee in underground missile silos. They have a pretty effective long-distance delivery system of their own.

Several co-underlings and I (fellow newspaper publishers) shared a close encounter of the conference call kind one Saturday in early December 1998. The executives finally decided to come clean, verifying rumors that had been circulating for the past four months —yes, all of our Texas newspapers would indeed be sold, "But," they hastened to add, "there probably would be no changes in publishers, policies, or practices." We underlings all heard the size 13, triple E, steel-toed brogan hit the deck, and it raised the same concern for each of us—job security. Whereas all the other publishers were "lifers" and feared for their positions, I figured it was time to kick my pony in the ribs and get serious about looking for Texas before the whole shoe rack came down around me. I had vacation and comp time to use up before anyone showed me the door.

So it was that on Sunday, December 6, 1998, I pulled out my well-worn *Rand McNally U.S. Road Atlas* (I keep it handy for the big picture), inside of which was my much weller-worn Diamond Texas Road Map, and plotted a route to cover some of West Texas.

On Wednesday, December 17, 1998, at 5:00 a.m., I departed a mostly sleeping Commerce.

NOTE: A few days before, Judy had expertly whittled our nine-foot Christmas tree down to a more manageable five-foot height—actually to arrive at a trunk girth that our cheap Wal-Mart tree holder would accommodate. She had trimmed my pickup bed with the remains. I made a note to tell her that I hit the road with more Christmas tree than was left in our living room. Without decorations, of course . . .

I30W—**Parker County** 7:16 a.m.; sun not on horizon, clear, approx. 40F; **Weatherford**—on the square 7:35 a.m. FM51N; sun on the face of the grand courthouse; no brick, 4 working clocks, and pecan; short stack at Susie's Downtown Café: $4.00 w/coffee and tip; shook hands with Don Edwards (reminded him of his performance with Waddie Mitchell in Commerce for United Way banquet the previous October and jokingly told him he looked like Don Edwards; he said he gets that a lot); I had his and Waddie Mitchell's CDs to give a listen for the first time on this trip; shot Texas Butane and more around the square; passed through **Cool**, Texas; 30 miles to Palo Pinto; no buzzard, but it's early and cold. I guess the sun must get things cooking before they arise for breakfast...

US180W—**Palo Pinto County** 8:29 a.m.; drove through **Mineral Wells** and saw a man who stood like Bob Newsom (thought strongly of Bob, wondered how we was doing; no word

in a while regarding his battle with brain cancer; had a strong urge to call our church and ask Sharon Smith, but didn't; see below...); **Palo Pinto**—on the square 8:53 a.m.; clock just off square at Palo Pinto Café—lovely neon sign around clock read "Time to Eat"; no clock on courthouse, no brick on square, pecan, yes; cedar posts are big business in this area; Mountain Cedar art and furniture; shot Methodist church sign (stone); 2 buzzards sitting in tree 9:21 a.m. far to the south; corollary to my buzzard theory—"buzzard borrowing" is prevalent in West Texas; wasn't sure whether these buzzards were in Stephens or Palo Pinto County.

US180W—**Stephens County** 9:22 a.m.; **Breckenridge**—on the square 9:41-9:43 a.m. pecan, yes; no clock; brick on one side of square (Walker St. - 180W); Oasis Club; great mural w/TEXAS!; deer sighting, a fork buck; sign for **Necessity**, Texas; sign read 19 miles to **Ranger** on 717—the starting point of Jim Ainsworth's commemorative trail ride the previous year.

US180W—**Shackelford County** 10:06 a.m.; deer road kill (evidence that vehicle was damaged); **Albany**—on the square 10:30-10:37 a.m.; 4 working clocks, no brick, pecan, yes; High Lonesome; neat Main Street! "Old West"—a sign read, "It's a John Wayne meets Martha Stewart thing..."; a roadrunner at 10:50 a.m.—flew across road W to E; saw Ft. Griffin longhorn herd.

US183/283N—**Throckmorton County** 10:59 a.m.; ("Capital of the Cow Country") sign read, and Home of Bob Lilly; **Throckmorton**—on the square 11:13-11:34 a.m.; nice stroll; pecan, yes; no brick or clock; on lawn of courthouse were Christmas decorations fashioned from (mostly) soft drink cans—no beer cans used in cross for nativity; lovely roadrunner mural; met Cecil Mayes, publisher of the *Throckmorton Tribune*; bought fuel, $13.75 (50,156.5 miles); encountered my first tumbleweeds close-up; very dry here (coined? "Sure as a fence'll stop a tumbleweed...").

US380W—**Haskell County** 12:00 noon; sign said I had entered "Indian Country";

Haskell—on the square 12:14-12:25 p.m.; brick on 2 sides of square; pecan, yes; no clock; 55F.

US277S—**Jones County** 12:30 p.m.; **Anson**—on the square 12:49-1:05 p.m.; 4 clocks stopped at 4 different times: 5:45, 5:48, 5:54, and 5:50 (again, the nagging question: a.m. or p.m.? I must apply for a grant to study this phenomenon; do the movie or book first? *When Time Stood Still in Texas* or *The Day The Clocks Stopped in Texas*); pecan, yes; no brick; TIGERS; passed through **Hamlin** and the local high school team was, what else, the Pied Pipers... entered a tiny corner of Fisher County at 1:25 p.m.; a coyote ran across road W to E.

US83N—**Stonewall County** 1:26 p.m.; crossed Double Mountain Fork of Brazos River (nearly dry, only a puddle or two); **Aspermont**—on the square 1:38-1:51 p.m.; no brick or clocks; pecan, yes; shot neat word BANK sign; Salt Fork of Brazos River was dry! How many forks on the Brazos?

US380N—**Kent County** (named for Andrew Kent who died at the Alamo; the

marker was very prominent) 2:09 p.m.; **Jayton**—on the square 2:13-2:26 p.m.; pecan, yes; no brick or clocks; shot metal sign, yellow and black iron with glorious blue sky; shot 1929 Hotel with cottonwood, gate, and window; outside of town, some big ol' tumbleweeds!

TX70S—**Fisher County** 3:03 p.m.; **Roby**—on the square 3:24-3:25 p.m. pecan, yes; no brick or clocks.

TX70S—**Nolan County** 3:43 p.m.; **Sweetwater**—on the square 3:50—4:13 p.m. no brick or clocks; pecan, yes; Texas Bank & Trust Co.; TEXAS Theater (active); shot

Texas Tattoo on way out of town; plan to return for Rattlesnake Roundup.

I20W—**Mitchell County** 4:42 p.m.; very hazy; **Colorado City**—("The Heart of West Texas") on the square 4:54-5:03 p.m.; no pecan, clocks, or brick; "Branding Wall"; beheld truck-bed sized tumbleweeds and large v's of some waterfowl (not geese). I had to pull over during a phone conversation with Judy when she told me that Bob Newsom had died early that morning. She said she would let me know about his funeral arrangements.

TX208N—**Scurry County** 5:16 p.m.; clouding up; **Snyder**—on the square 5:36-5:45 p.m.; no brick; no clock; pecan, yes; great Christmas decorations; read marker about Mooar and white buffalo; Ritz Theater; great dinner at Spanish Inn, $11.75; shot "Bob Newsom's Sunset"—it looked like the "clabber" that we had joked about on our trip to Russia in 1997; bought fuel, $16.00 (50,410.7 miles); 525 miles end of 1st day. Spent the night at the Purple Sage Motel in Snyder—"American Owned."

Day 2—12/18/98

US180W—**Borden County** 7:20 a.m.;
light rain; **Gail**—on square 7:39 a.m. (actually
a crossroad); pecan, yes; no clock or brick;
someone had stuck a small wind chime in a
tree near courthouse; breakfast @ Coyote
Store Café: hot cakes and "real bacon," said
the waitress/clerk/cook, $4.00; left town 8:38
a.m.; watching for live deer—saw 5 dead so
far; crossed Five-Mile Creek (recalled creek
by same name from my childhood in Birming-
ham, Alabama); desolate area, with beautiful
mesas in distance; high desert a la Wyoming;
saw cattle and sheep eating yellowish fruit of
chain cactus—everywhere . . .

NOTE: Design a Commerce Tiger T-shirt
with all their opponents as items on a menu
(perhaps I sensed the Tigers would become
Division 3A Football State Champions in
1999). Parody on typos: "Exploring the
Mystery of Crap Circles," "Nothing Certain,
Save Death and Texas," etc. Product idea:
design a notebook-type computer in the
form of a yellow legal pad; the operator
would wear thin gloves with pencils as
fingers. I know what you are thinking; these
gems are always a surprise to me too . . .

RR669N—**Garza County** 8:33 a.m.; oil
activity everywhere! The weather cleared for
a dramatic period of lighting so I could shoot
chain cactus and sun on highway; still watchful
for deer; **Post** (named for C.W. Post, the
cereal magnate)—on the square 8:53-9:17
a.m.; brick and pecan, yes; no clocks; pump

jacks behind courthouse and on school
grounds; Tower Theater and Garza Theater;
Caprock Cultural Association; Mary Spencer
returned my call while I was on the square;
shot green and tan vowels.

US380W—**Lynn County** 9:32 a.m.;
"Welcome to **Tahoka**, One of the Friendliest
Towns in Lynn County"—on the square
9:59-10:05 a.m.; brick and pecan, yes; no
clock; shot old windows with ragged curtains
and a touch of peeling red paint; "someone's
home/dream once upon a time"; shot wooden

letters with a touch of peeling blue paint; theater building.

US380W—**Terry County** 10:19 a.m.; cloudy, cold, and windy! **Brownfield** ("Star of the South Plains")—on the square 10:40-10:50 a.m.; brick and pecan, yes; no clocks; could this be the crow capital of Texas? Rialto Theater (R in a square); seemed to have the largest percentage of places closed in any downtown—had it been Wal-Marted?

NOTE: I thought I'd bring home a tumbleweed, so I captured one—and learned a lesson about those things; they bite!

TX137S—**Dawson County** 11:06 a.m.; never seen so many pump jacks—recalled my oil field image from Burke County, North Dakota; and cotton; **Lamesa**—on the square 11:26-11:45 a.m.; brick and pecan, yes; no clocks; Punkin Center Gin and King Gin (not the drink...) clearing a bit; called Dennis Wilkinson in **Wichita Falls** about Bob Newsom's death.

NOTE: Fragments of stories often occur to me while I'm driving: Hootie still hates tumbleweeds. Probably because he was forced to take an unnecessary bath midweek once, because he thought he was getting company; he'd been seeing the dust for two and a half days (awful flat out in West Texas...). Turned out to be two of

the biggest tumbleweeds ever to roll across Dawson County. "They kept right on goin' too," he said and chuckled, "I only stopped 'em long enough to put a old set of Texas plates on 'em. I kept the Nevada ones they showed up with as a soovyneer."

US180W—**Gaines County** 12:06 a.m.; I freed a fence-bound tumbleweed and photographed a trophy 10-point mule deer buck road casualty 7 miles outside **Seminole**—on the square 12:45-12:51 p.m.; pecan, yes; no brick and 4 stopped clocks (on city building—3 @ 12:55 and 1 @ 12:25); Optimist Ham Shoot advertised—no optimism necessary, I thought; don't recall those things being given to quick bursts of speed or flight...

TX214N—**Yoakum County** 1:09 p.m.; **Plains**—on the square 1:50-1:56 p.m.; no pecan, brick, or clock; cowboys and cowgirls; story idea: why not do "The Boston Stranger Christmas Story" (think about it); 50,643.7

miles, Subway and fuel $20.00; **Denver City**—shot windmill and Texas flag images; when I passed an ornate iron sign for Newsom Vineyards (north of Plains), I called Judy and told her I was planning to cut my trip short and come home for Bob's funeral on Saturday. Words for his eulogy began to form in my mind...

TX214N—**Cochran County** 2:12 p.m.; **Morton**—on the square 2:36-2:43 p.m.; no pecan, brick, or clocks; cute paintings on some storefronts and walls—The New York Store; on "Texas Plains Trail" to Levelland.

NOTE: Silhouettes of so much that has been abandoned on the plains of West Texas—equipment, vehicles, homes, barns, and other buildings; all monuments to people's industry, their lives and dreams; or perhaps what was left from a battle fought here long ago; "Not so long ago," sighed the wind (see essay titled, "Monuments to dreams once"). Towns in West Texas have welcome signs placed predominately on the sides of very large buildings or on porous metal grates—one object, the ever-present wind can't move, and the other it can pass through easily. The wind moves just about everything else out here at will. It has snatched its share of cotton tatters from passing loads to litter every mile of roadside—seems like several bales' worth if it were all collected...

TX114E—**Hockley County** 2:53 p.m.; this is oil country, big time—pump jacks in every direction appear to have sucked the color out of the landscape—and every degree of elevation; **Levelland** (no kidding!)—on the square 3:08-3:27 p.m.; no pecan, brick, or clocks; shot Hotel Jennie, some neat windows and doors and sign, and 11 in a square; Eddie Smith and Bill Ward called me @ 3:37 p.m.

US385N—**Lamb County** 3:44 p.m.; **Littlefield** ("Home Town of Waylon Jennings")—nice, long main street, no square 3:57-4:02 p.m.; no brick, pecan, or clocks; RIO Theater, Needful Things, Coca Cola; on my way home @ 50,752.4 miles— 860 miles so far.

Bob Newsom's eulogy was pretty well completed on the ride home. I reached Commerce at 11:35 p.m., 12/18/98, having covered a total of 1,317 miles. On Saturday I drove to **Mount Vernon** for my friend's service and burial at **Purley**, Texas. I gave a copy of the eulogy to his wife, June, that day and read it at a memorial service in Commerce a few weeks later. I'll never forget having such a vivid "contact" with Bob as I passed through Mineral Wells on the morning he passed away. Perhaps the only drawback to spending so much time on the road might be the things we miss back home while we're gone. Of course, if I hadn't been on the road that December morning, I would have missed seeing that man who "stood like Bob Newsom." Here's what I wrote for him:

No one who ever heard Bob Newsom laugh could possibly doubt he was a child of God.

Likewise, no one who ever heard Bob pray or preach could imagine him as other than a man of God.

And when Bob lifted his powerful voice in song, it was obvious that he loved God.

Bob's laughter and singing often lifted the hearts and spirits of many of us. His words, whether in prayer or sermon, had a pure and simple directness. That was the way he spoke and the way he lived. He met everything and everyone head-on, with a firm handshake and a sincere, "look-a-person-straight-in-the-eye" greeting.

How about that handshake? It was as if you could feel the work of a lifetime done with those strong hands—a lifetime of touching other people's lives, helping friends and total strangers; lending his strength and sharing his love—in Commerce, Texas, or half a world away in Kazan, Russia.

We all know that God heard Bob's laughter, heard his prayers, and cherished his singing. Can anyone here have any doubt that God returned Bob's love for Him?

Consider these words by Rossiter Worthington Raymond:

*"Life is eternal; and love is immortal; and
death is only a horizon; and a horizon is nothing
save the limit of our sight."*

Bob Newsom always could see a lot further than many of us when he was on this earth. Just imagine what a glorious view he has now…

Wrapping up for Christmas

Judy looked at the map and my proposed routes, shook her head, and said, "See you next year, hon." I looked at the map and saw it as half full, or something like that. All I knew was, it was December 21, 1998, and I had a bunch of counties left to cover before New Year's, most of them way the heck down in South Texas or way the more heck out in West Texas. I looked at the weather map on TV that night, saw the freezing stuff predicted for everywhere south of Waco, and changed my trip around on the spot. West Texas it was—as far as I could go and still get back by Christmas. I had no team of reindeer, but I knew my pickup wouldn't let me down. And if it did, I'd leave the dang thing out on the High Plains with all those other abandoned, rusting objects.

At 6:37 a.m. on the day before the day before the day before Christmas, once again I saw Commerce, Texas, in my rearview mirror . . .

I20W & US377W—**Hood County** 9:16 a.m.; 20F, overcast and windy! shot a 7' square map of Texas (all Plexiglas); **Granbury**—on the square 9:39-9:55 a.m.; 5:40 on 4 broken clocks; no brick; pecan, yes; how about "Granbury Sauce" for the holidays—hot or BBQ; what a beautiful square! Gorgeous shops— Cactus Flower, Jellirose, and Rainbow; "The Gee Spot," Ratliff Gallery! Town is worth another visit and a shoot with Judy; do Texas poster suite! buzzard 10:04 a.m.; sgl. to south.

US377W—**Erath County** 10:20 a.m.; buzzard 10:24 a.m.; sgl. north; **Stephenville**—on the square 10:29-11:06 a.m.; 4 working clocks, no brick on square, but all streets off square are brick; pecan? Mailed Christmas to Jennie & Evan; called Mike McCarthy in Athens, Georgia—found out Bambi is due April 15; called Judy . . . shot beautiful eagle statue over globe on courthouse lawn; saw sign to Desdemona, Texas; Gorman—Texas Peanut Board, The Peanut Hut.

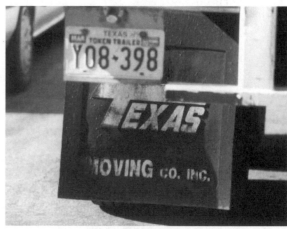

NOTE: These county seats are all beginning to look the same. How many blades on a windmill? Heard a neat seasonal story on radio about the King of Sweden in 1560 or 1516. He sent a cross to a pastor who had praised him (the King) during a service (did not know the King was present, incognito). Crows resemble pump jacks when they call. The dairy business makes moo-lah, no doubt.

NOTE: This time of year, people are suffering from/have succumbed to "gift wrapture"; everyone else is giving holiday shopping their "wrapt attention"; a "gift wraptor" is someone who swoops in front of you to seize the last whatever... Is no longer being lazy considered ex-lax? Saw bumper sticker, "I have a life, what I need is a (fill in the blank)." I'm sorry, but this must be said: "So many Santas waving from tractors in West Texas yards, so little imagination..." With the wind out here in West Texas there could be tumbletrees if there were more trees... Now there's a thought, do you suppose that once upon a time there actually *were* tumbletrees in West Texas? Story time...

FM8W/TX6N—**Eastland County** 11:27 a.m.; **Eastland**—on the square 11:57-12:08 a.m.; brick on two sides of square, no clock; pecan, yes; Majestic Theater; Hog 'n' Clover and Tumbleweed gift shops; buzzard 11:29 a.m.; sgl. to north

I20W—**Callahan County** 12:20 p.m.; **Baird** ("Official Antique Capital of Texas") version #1; ("Official Antique Capital of West Texas") version #2—seasonal? on the square 12:47-12:54 p.m.; no clock, pecan, or brick; shot color Texas & Pacific RR—mural by Peter Brock, 1996 - "Two, Ten & Four."

I20W—**Taylor County** 1:16 p.m.; **Abilene**—on the square 1:45-2:10 p.m.; pecan, yes; no brick or clocks; Paramount Theater, West Texas Wholesale Supply, and West Texas Builders Supply; nice weathered signs in warehouse section of town. Side trip (second visit) to **Ballinger** to get color of Texas

Theater and more; on to Bronte in Coke County to shoot TEXAS Theater (dull light).

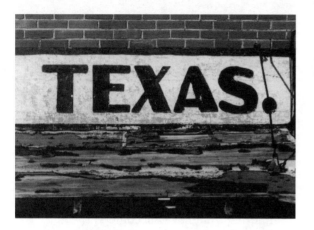

US277S/TX158W—**Coke County** 3:28 p.m.; went to **Bronte** first to shoot TEXAS Theater (see above); sign entering **Robert Lee** read, "Playground of West Texas"; shot Texas plastic sign—on square 3:54-3:58 p.m.; pecan, yes; no clock or brick; lots of old man's beard on fences in county (Texas virgin's bower, wild clematis); crossed Colorado River.

TX208S—**Tom Green County** 4:13 p.m.; **San Angelo**—on the square 4:35-4:49 p.m.;

pecan, yes; no clock or brick; Shot TEXAS Theater; Sonic for lunch $5.00.

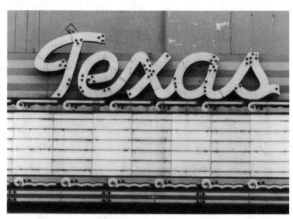

US87N—**Sterling County** 5:41 p.m.; **Sterling City**—on the square 5:52-6:01 p.m.; pecan, yes; no brick or clock; getting dark; saw neat framed Texas stamp enlargement in P.O.; shot through window of City Cafe on the square, "Home of the Famous Biggest Pancakes in Texas." Wonder what Hawkins, Texas ("Pancake Capital of Texas") has to say about that?

TX158W—**Glasscock County** 6:20 p.m.; **Garden City** 6:35-6:37 p.m.; pecan, yes; no clock or brick; dark, on to Big Spring to spend the night.

The day before Christmas Eve...

RR33N—**Howard County** 6:43 p.m. (on 12/22) **Big Spring** on the square 8:13-8:23 a.m.; no brick, pecan, or clock; nice pattern of faded paint on old buildings; Rose's Café; cloudy, 19 degrees 7 degrees chill factor with 8 mph wind.

NOTE: Someone on the radio was lamenting the approaching holidays and year-end, "The only exercise I get these days is pushing my luck, stretching the truth, pulling someone's leg, running up debt, and throwing caution to the wind." I thought to myself, "Maybe I could try harder to exercise good judgment; to lift mine or someone else's spirits (not the kind in a bottle or glass). But it is the season to be jolly..."

I20W—**Martin County** (spitting sleet) 8:47 a.m.; **Stanton**—surprise! Christmas Spirit told me to take a right on St. Mary St.,

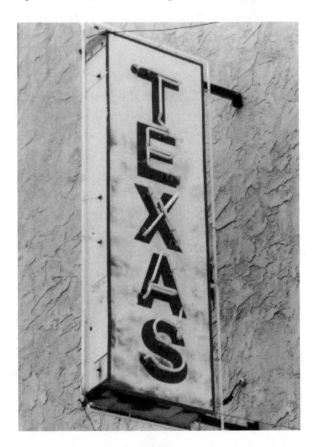

took a left onto St. Joseph St., and voila—an unexpected and totally unknown TEXAS Theater; Holt's Boot and Saddlery; on the square 8:54-9:02 a.m.; no brick, clock, or pecan.

I20W—**Midland County** 9:10 a.m.; **Midland** ("Tall City") on sqare 9:25-9:40 a.m.; pecan, yes; no clock or brick; Yucca Theater; shot Texas Street atop stop signs (intersections with Dallas and Fort Worth); shot Texas Refreshments Truck; fuel, $19.75 @ 51,916.5 mileage.

TX349N & TX176W—**Andrews County** 10:14 a.m.; weather clearing; **Andrews**—on the square 10:34-10:36 a.m.; pecan, yes; no clock or brick; flat! 32 miles east of NM; I called Clif Hopkins (close to his birthday, 12/31); odd thought to pop into my head: I finally understood Jimmy Buffett's play on words in "Banana Republic"—"...give me some words I can dance to, or a melody that rhymes..."

NOTE: Get in touch with Dr. Ty Cashion at Sam Houston State University (Huntsville) for the accurate quotes by Phil Sheridan and

Davy Crockett re: Texas/Hell; name a catering service van the "Thyme Machine," and call the servers "Thyme Travelers" or "Thyme Bandits." Or not.

US385S—**Ector County** 10:53 a.m.; **Odessa** ("City of Contrasts") on the square 11:17-11:30 a.m.; no pecan, clock, or brick; Ector Theater; shot Texas Building; Scott Theater; what do you know, a very cool buzzard 11:37 a.m.; single, very high (not just cool, but cold, no doubt in that thin, clear, brisk West Texas air!) to the east of US385.

US385S—**Crane County** 11:57 a.m.; **Crane** (cloudy again!) on the square 12:15-12:53 p.m.; pecan, yes; no clock or brick; Golden Cranes; I folded an origami crane; shot Texas "T" (with broken "E" in Texas, blue and yellow sign); Crane County windmill—flat (light?); I managed to carefully capture another tumbleweed to bring home; saw a hawk doing a buzzard impression at 12:54 p.m.

Insertion after the fact: Two years after this journal entry, I would have been stoned in

Crane County, sporting a Commerce Tiger hat, sticker, and Tiger tail. On Saturday, December 11, 1999 (at Shotwell Stadium in Abilene), the Commerce Tigers beat the Crane Golden Cranes 30-0, capping a perfect 16-0 season and advancing to the State Championship game where they defeated the Sealy Tigers for the Division 3A State Football Championship.

TX329W & TX18N—**Ward County** 1:02 p.m.; shot a rare touch of natural High Plains Christmas color, the bright red fruit on a small

(brand unknown) cactus; **Monahans** on the square 1:33-1:37 p.m.; no pecan, clock, or brick; skies are clearing again; Kent Kwik (convenience store); shot office door; visiting (Royalty, Texas).

NOTE: "Post Card from the Oil Patch": Honey, Remember those dreams of me coming out here and striking it rich in West Texas? Well, after two days, I've had enough. This petroleum smell is awful as a steady odor! Don't think I could ever get used to it, even if I did strike oil—that would only put more of the stuff in the air to stink. No thanks. And as for me hitchhiking back home, no way. I can't hold up my thumb, carry the duffel bag, and hold my nose all at the same time. Please send bus fare home to East Texas c/o General Delivery in Midland. Yuck! I guess that proves what your mother said all along; I wouldn't know the smell of money if someone rubbed my nose in it. God forbid! Tell my Uncle Cletus I'll be taking him up on the offer of a job at the pulp mill. See you soon. Love, Otis.

TX18N—**Winkler County** 1:45 p.m.; **Kermit**—Where's Miss Piggy? If not that famous frog's namesake (or vice versa), this little dead-of-winter High Plains West Texas place could

certainly provide inspiration enough for his theme song, "It's not easy being green"; on the square 2:00-2:13 p.m.; pecan, yes; no clock or brick; shot sign, Texas Moo_ Lounge; saw major thorns with snow (recalled a favorite Athens, Georgia image).

TX302W—(Oliver) **Loving County** 2:38 p.m.; partly cloudy; **Mentone**—coyote ran through town only three blocks from courthouse; church/school—oldest building in county; on the square 2:53-3:03 p.m.; no pecan, clock, or brick; Boot Track Café.

US285S—**Reeves County** 3:05 p.m.; **Pecos**—crossed Pecos River; great shots; on the square 3:31-3:45 p.m.; World's First Rodeo; State Theater; saw Teletubby piñatas, for crying out loud; no pecan, clock, or brick.

US285S—**Pecos County** 4:14 p.m.; partly/mostly cloudy; **Ft. Stockton** on the square 4:50-5:10 p.m.; no pecan, brick and clock; saw/shot "Paisano Pete," but did not see one live roadrunner in whole county; shot

"Fort Stockton fixer-upper"; Grey Mule Saloon is now a private residence, the lantern with ristra image; counted 24 deer; 13/18/21/25/38/45—my losing lottery numbers...

NOTE: Coyotes cross the road like tumbleweeds; tumbleweeds resemble balls of fur, same color (more thoughts on the "Tumbleweed Connection" theory).

US285S—**Terrell County** 6:06 p.m.; dark; **Sanderson** (uphill and very desolate road into the pitch black night) on the square 6:19-6:33 p.m.; no pecan, clock, or brick; planned to spend the night in Sanderson, but my truck was making an odd noise, so I headed back to Fort Stockton to spend the night in a very nice room with no frills ($19.95)—I'll be back; sleeting big time.

Merry Christmas Eve—ate a hearty breakfast, $6.60 (I always do that when I face the possibility of getting stranded on some desolate stretch of highway in the middle of nowhere in a blizzard or ice storm), 6:25 a.m. in Fort Stockton at Steak House Restaurant, folded a crane for luck and tipped the waitress well; 52,344.9 mileage; left for Upton County at 6:54 a.m.

US67E—**Upton County** (high clouds) 7:55 a.m.; **Rankin** on the square 8:18-8:21 a.m.; pecan, yes; no clock or brick; 21 degrees with 9 degree chill factor; Oil Patch P.S.: I hate the smell of petroleum in the morning, even more than during the rest of the day; neat mesas; "Jesus is Lord" on hillside (and everywhere else); crow and hawk having rabbit for

breakfast; iron ornamental cut-outs are West Texas icons and official State Art form?

US67E—**Reagan County** 8:31 a.m.; **Big Lake**—sun was peeking through a hole in the "clabber" (looked like buttermilk on the side of a glass) cloud cover—on the square 8:51-9:00 a.m.; pecan, yes; no brick or clock; Texas Street; shot West Texas Utilities Co.; I mean brrrrrr!

NOTE: Get a grant to study road greetings—various types of waves, nods, etc. (see essay titled "Howdy!"); Deer

road kill tally today: 11; I called Judy, then my mother in Missouri; hit a stretch of ice on the road during the conversation and hung up abruptly to get the truck under control... Whew!

TX137S—**Crockett County** 9:09 a.m.; **Ozona**—("Biggest Little Town in the West")—on the square 9:44-9:54 a.m.; pecan, yes; no clock or brick; shot West Texas

Utilities; Davey's statue: "Be sure you're right then go ahead." Shot jostled TEXAS on South Texas Lumber Co. sign.

I10E—**Sutton County** 10:15 a.m.; **Sonora**—very pretty little town! sign for Bitterweed Wash; on the square 10:38-10:48 a.m.; pecan, yes; no brick or clock; plaque honoring B.M. Halbert as the "Father of Angora Goats in Texas"; think about it... shot sculpted ram and ewe emblems on City Hall. Pretty slippery here and there; hopeful I don't encounter any worse between here and home.

US277N—**Schleicher County** 11:10 a.m.; ("Top of the Divide"): elevation 2,439 ft.; more feet than folks...); **Eldorado**—on the square 11:21-11:32 a.m.; pecan, yes; no clock or brick; Texas Woolen Mills plaque; "The Wrong Shall Fail and PEACE (The Right) Prevail" more "Christmas" cactus with red fruit; I heard the bells...

RR915N—**Irion County** 11:52 a.m.; **Mertzon**—courthouse is on a promontory, not a square (others have been this way: make a note that "on square" means on the

courthouse site in each county seat—it's not always a square) 12:07-12:18 p.m.; pecan, yes; no clock or brick; West Texas Wool and Mohair Association (black and white painted on brick with gorgeous blue sky).

NOTE: Out of the slick stuff and heading home; roadrunner on the roadside at 12:44 p.m. in Tom Green County; heard on radio that Don Edwards' birthday is March 20, same as my oldest daughter, Shay's; re-shot TEXAS Theater in **Bronte**—got great color. Saw huge TEXAS on an old building from the highway and turned around to shoot the 1925 former post office in **View** (Taylor County); play on Mack Davis' song, "...Texas in my rearview mirror." America—where people who can afford not to, drive antique cars; and those who can barely afford a new car, buy instead, pre-faded, already ragged jeans... Call Dave Dwinell in Athens, Georgia, about a show of his ballet images in our gallery. New "Road Guy" (see essay titled "Road Guise"), I10E exit 367; Mingus Thurber, James' outlaw relation who authored "Mingus Con" while he was incarcerated for intent to pillage.

Ho Ho Home at 7:05 p.m. on Christmas Eve, 1998; 52,939.6 ending mileage—a total of 1,604.9 miles on trip. 191 counties down, and only 63 to go. What's left of the tree is beautifully trimmed, the stockings are hung by the chimney with thumbtacks, and all I want for Christmas just kissed and hugged me welcome home. Merry Christmas to all and to all a good night...

Crane, Texas

On December 23, 1998, I parked on the square in Crane, Texas (Crane County) and folded a single origami crane. As I folded it, I thought about the following:

As a photographer, I can freeze time—capture an instant and hold it forever. As a writer, I can play with time—move it forward, backward, even fold, spindle, or mutilate it if I wish. I count myself fortunate that nearly anything I can imagine, I can render into an image (though many are not worth saving) on a piece of film, or fashion into words (admittedly, some better chosen than others) and place them on a piece of paper.

The traditional origami crane requires 31 folds of a perfectly square, serenely white piece of paper. According to legend, folding

1,000 cranes makes one immortal. If so, I achieved that status on May 22, 1994.

NOTE: Can one become immortal twice? On the outside chance, I decided to mark the millennium by folding 2,000 cranes before 1999 came to a close.

As of this writing, I have placed well over 100,000 images onto pieces of film, and written at least that number of words—my life's work, so far. But what pleases me the most is to close my eyes and picture everywhere I've traveled in the course of folding all those plain, white paper squares to give away—all of them, without a single word... 🤟

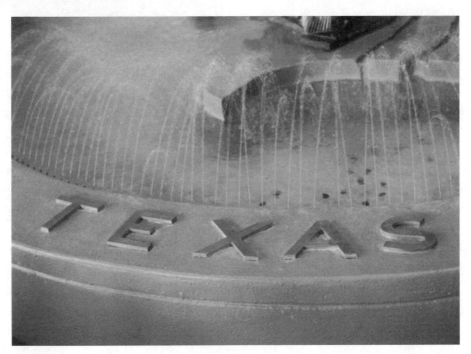

How to be a success

Do yourself a favor and have someone read this next piece to you while driving at night (on any remote Texas two-lane or oil top) with the window down—wind rush and tires on road surface sound will enhance the mood. Are you there? Okay, reader, begin...

There I was, on a winding, roller-coaster two-lane, smack in the middle of a pitch black West Texas night. It's beginning to sleet and my truck is making weird, from-under-the-hood noises, at least thirty miles in either direction from the nearest garage that has been closed for hours and probably won't be open for the next several. Did I mention it was two days before Christmas? It's at times like these that I have the oddest thoughts—even beyond those of survival. And it was precisely at that instant, wedged between awe at the utter desolation on either side of US 285 (aided by zero-visibility) and wondering if my charred or mangled, road kill body would make it back to Commerce for Christmas at least, that the following occurred to me:

Within the bounds of common sense and good taste, get a worthwhile someone's complete and undivided attention. When you have it, show them something they would consider unique and/or valuable—words or objects, it doesn't matter. Tell them what it can do for them; be direct and above all, keep it simple. Ask a fair price. Get paid. Do this a lot and voila! Success.

I made it into Fort Stockton that night. The sound that my pickup was making wasn't

fatal—not even very expensive. And I made it home for Christmas without further incident. Now, being the eternal optimist, I took that as a sign that I was on the winding, roller coaster two-lane, smack in the middle of the road to success. What else could it mean?

I had another thought on success more recently. Lying awake a couple of nights ago, I needed some company, so I changed the time on Judy's clock and made my alarm go off so she would wake up and talk to me. I do that every now and then, and so far she hasn't suspected a thing. We talk for an hour or two and I point out how it's only been a few minutes and that she'd better get her shower, while I start the coffee.

Anyway, the discussion turned to how we could get some folks to write some of those neat reviews for this book, and to make a long story short, the best way seemed to write them myself. Here's what I've got so far:

"ENTRANCING, ECCENTRIC, HILARIOUS, pierced by brilliance the way a storm is pierced by lightning."
—*Rick's Folks*

"A DAZZLING MODERN PIECE OF WORK BY AN ARTIST OF SEEMINGLY EFFORTLESS AND ARTLESS GRACE."
—*E. Hemingway*

"MIRACULOUS…EXCELLENT… WONDER OF WONDERS."
—*Vanity Fear*

"LARGE, EXTRAVAGANTLY EXECUTED…HIS WORK IS SEDUCTIVE."
—*Philadelphia Inquisitioner*

"VANDERPOOL'S WORK IS BREATHTAKING…HE IS SPLENDID, A MAJOR TALENT."
—*Lost Angeles Times Book Review*

"A WILD, ABUNDANT, GENEROUS WORK, part dream, part mad invention, and all of it worth a read."
—*C. Eastwood*

"A CASCADE OF BRILLIANT, ALLURING IMAGES, ARRESTING IDEAS, AND METAPHYSICAL SPECULATIONS— the sheer exuberance of one of our most talented writers…He creates tableaux of such beauty and clarity that the inner eye is stunned."
—*Publishing Weakly*

"ABSORBING, TOUCHING, BAFFLING, LARGER THAN LIFE, THIS COLLECTION STRETCHES THE BOUNDARIES OF CONTEMPORARY LITERATURE. It is less than a gifted writer's love affair with the medium."
—*Art Whirled*

"VANDERPOOL HAS SIMPLY GALVANIZED THE UNIVERSE! He is determined to loot the whole treasure house of human experience and to put it all on paper."
—*Art Complexion Daily*

"INVITES THE VIEWER TO SHARE IN A REVELATION. Vanderpool is more than a major literary talent; he has all the makings of great one!"
—*USA Anyday*

"I HAVE FALLEN IN LOVE WITH WORDS AGAIN. This sort of thing happens every now and then, usually about once in a decade, and always, it seems, by surprise…"
—*N.Y. Daily Snooze*

"APOCALYPTIC, PROPHETIC AND ALWAYS HAUNTINGLY BEAUTIFUL."
—*Miami Harrold*

"JUST ABSOLUTELY MEATY STUFF."
—*Stake and Ail*

I actually thought about asking the editor to consider sprinkling these comments on the inside front and back flaps of this very book. Yeah, Judy said the same thing…

XX-large, three X-large, and one medium

Convincing everyone at the *Journal* I was having a heart attack that Tuesday morning was no problem. Assuring them I could make it to the hospital emergency room alone was a bit of a stretch. Letting it slip that I probably wouldn't be back by deadline that evening nearly caused a mutiny. I called from a safe distance out of town to share this news and only managed to quell the uprising with promises of Cowboy Gathering (Alpine) T-shirts and lots of time-off with pay when I returned. I only half lied...

Beginning mileage: 54,077.3; February 23, 1999.

I10W & TX46E—**Kendall County** 6:02 p.m.; saw huge herds of deer on both sides of the road and my first axis deer (has spots and hard antlers year round); **Boerne** 6:17-6:49 p.m.; quaint and very picturesque downtown; pecan, yes; no clock or brick; grabbed a sandwich from Subway and ate along lovely Cibolo Creek; shared with (it's difficult not to) the "well-fed ducks of Boerne"; I had noticed the duck crossing signs on TX46; I look forward to a return trip—Judy and I could shoot and eat for an entire day here! gorgeous architecture; St. Peter the Apostle Catholic Church renovation; buzzards a-bed...

I10E & US90S—**Medina County** 7:39 p.m.; end of the day, stayed at Bruce and Jo Foster's Whitetail Lodge; **Hondo** 7:13-7:30 a.m.; very foggy; pecan, yes; no brick or clock; saw Raye Theater, Punky's Place, Geronimo's

Cadillac; Texas on fading Rock Shop sign; shot what has to be one of the most popular welcome signs in the state: "This is God's Country, Please Don't Drive Like Hell Through It."

TX173N—**Bandera County** 7:49 a.m.; to the tune of Hal Ketchum's "Small Town Saturday Night," I pulled into downtown **Bandera** ("Cowboy Capital of the World") 8:00-8:50 a.m.; pecan, yes; no brick or clocks (4 had been removed from clock tower); ate breakfast at Old Spanish Trail (OST) Restaurant (see essay titled, "Problem Solving 101"); it was

fitting that I should pass through the Cowboy Capital, as I was (at the time) en route to the Cowboy Poetry Gathering in Alpine; "Cow Chip Enterprises"; shot a neat window, an old door, and the Cowboy monument on square; shot Medina River scene outside Bandera; **Medina**, Texas—("Apple Capital of Texas"); home of Texas International Apple Festival (shot a neat old sign, hand-lettered); P.O. sign with icicle lights; Love, Clark, Duncan, and Evans—creek names en route to **Vanderpool**, Texas; shot cemetery in Vanderpool, Texas 9:54 a.m.; I had been here before when Jessica was an infant (1986); at the P.O., I got some postage cancels on blank envelopes and met Postmaster Eddie Pannell; also at P.O., met Ardell Nelson, emu oil baron; Bug Scuffle Ranch (Vanderpool was once named Bug Scuffle and **Ladonia**, in Fannin County, includes Bug Tussle community); buzzard 9:54 a.m.

RR337W—**Real County** 10:32 a.m.; buzzard 10:48 a.m.; sgl. over hwy. (overcast with mist) **Leakey** 10:50-10:56 a.m.; pecan, yes; no bricks or clocks; very nice stone buildings in Kendall, Medina, Bandera, and Real Counties!

Judy's Caboodle, shop on square; Canyon Theater (inactive); shot building on US83S en route to Uvalde Co.

NOTE: Do an essay on "Signs in the middle of nowhere," and one on "Texans' tendency to brag" (w/signs); these thoughts were inspired by an outdoor café/compound at the junction of US83S and TX127. Brisket was spelled "Brisquet" on one of the signs; should I call and demand they correct it? Another sign read, "You just passed the best hamburger between Mexico and Canada." That one turned me around—to shoot it, not to test the claim; also shot some very fragrant, fuzzy blooms w/major thorns: honey mesquite? & golden-eye phlox. Saw a bumper sticker, "Do Not Disturb—I'm Disturbed Enough Already."

US83S—**Uvalde County** 11:02 a.m.; **Uvalde** ("Clearly Texas") 12:15-12:29 p.m.; pecan, yes; no brick; 4 working clocks; shot Coca Cola sign; no buzzard.

US83S—**Zavalla County** 12:42 p.m.; buzzard 12:53 p.m.; sgl. E-W over hwy.; **Crystal City** 1:11-1:35 p.m.; no bricks, pecans, or clocks; Popeye statue 1937—formerly a huge spinach producing center; shot telephone bldg.'s decorative inserts; fruit at HEB for lunch $5.82; shot Spinach Festival sign; saw several of Otha's 20th-century tumbleweeds: the blue Wal-Mart plastic bag...

US83S—**Dimmit County** 1:55 p.m.; **Carrizo Springs** 2:06-2:11 p.m.; pecan, yes; no brick or clocks; blast all those who abbreviate Texas...

US277W—**Maverick County** 2:33 p.m.; **Eagle Pass** ("Where Yeeha Meets Olé") 2:58-3:20 p.m.; no pecans or bricks; 3 clocks (one removed) not working, 2 stopped @ 6:59 and 1 @ 6:50; former Iris & Aztec theaters; shot Fort (James) Duncan, named for Mexican War hero;

Border Burger sign, sounds dangerous...

TX131N—**Kinney County** 3:51 p.m.; buzzard 4:01 p.m.; 3 over TX131; **Brackettville** 4:12-4:20 p.m.; no brick or pecan; 4 working clocks; tried to call Terry "Tex" Toler in Sanderson, Texas; I was so tickled finally to see some color along the road that I alerted on three different colored balls of baling twine; it's too late and I'm too tired to go out of my way to see an Alamo *replica*; shot windows and doors in old stone buildings.

US90W—**Val Verde County** 4:36 p.m.; no buzzard yet; (wonder, do the T-38's, practicing touch and go maneuvers at Laughlin AFB, intimidate them?); **Del Rio** ("Land of Amistad") 4:54-5:04 p.m.; pecan, yes; no brick or clocks; shot boarded church windows across street from courthouse renovation; buzzard thoughts: saw "sunbow" at 6:18 p.m.; shot feather dalia and some stuff at **Langtry**.

NOTE: Buzzard thoughts: finally spotted Val Verde buzzards' aerial act, such impressive gliders, catching the major thermals along Amistad Reservoir (the highest bridge in Texas; over the Pecos River) after leaving Del Rio about sunset, 5:33 p.m. Who to sponsor a statewide Buzzard Spot (to confirm my theory)? Between the hours of 8:30 a.m. and 5:30 p.m. take a count and e-mail reports to whom? How about a waste management sponsor? Aren't buzzards the ultimate recyclers? They recycle death in a manner of speaking.

US90W—**Terrell County** (2nd visit) end of day 2/24; stayed at Desert Air Motel in **Sanderson** ("Cactus Capital of Texas") 7:42 p.m. end of day mileage 54,928.4—total miles so far on trip 851.1.

NOTE: Up at 6:00 a.m. 2/25 ablaze with ideas for products. Awoke thinking about Cow Hill Candle Company or Bois d'Arc Capital Candle Company; plan to make horse apple candles and cactus candles (Cactus Capital Candle Company); create an actual Coffee Ring Journal for writers, with 31 different rings printed on pages with days of week near or in coffee rings "Set your cup here..." and perhaps an inspirational quote. I ate a great breakfast at Jeanie's Kountry Kitchen ("The Best in the West"); interesting conversations overheard—see essay titled "Problem Solving 101."

Sanderson 7:27-8:18 a.m.; pecan, yes; no bricks or clocks; Chamber & Tourism office—GREAT POSTER AND T-SHIRT! Amtrak stops on occasion, good water (deep wells); a potter in town offers a Cactus Green glaze; silversmith; adobe repair guy and sculptor wife: Linda and William Chandler; Lloyd Goldwire is county commissioner with small foundry; Chamber offers "Desert Starter Kits—Do Not Pet, They Bite"; "Buzzard Rally" (motorcycle rally)— "Ricky Road Kill" is mascot—character doll made locally (I plan to sue...); I called Terry "Tex" Toler and told him I was on my way to El Paso and would see him the next morning; decided to blow off Alpine Cowboy Gathering in order to make it all the way to El Paso and back; left town after shooting some nice old adobe ruins (had a thought, later applied to Valentine, "It would appear or it could be argued that even the cactus has given up on spots in this little town..."); saw two roadrunners 8:28 a.m. & 8:33 a.m., leaving Sanderson and the sky cleared as I was talking

to Judy; shot antelope and desert scene—
great mesas!!!

US90W—**Brewster County** 8:42 a.m.;
Alpine 9:55-10:48 a.m.; pecan, yes; no brick
or clock; Ocotillo Enterprises Books and
Rocks; Granada Theater; shot neat signs!

great town! purchased cactus books at Front
Street Books ("Your Big Bend Source . . . ")
and visited Kiowa Gallery—very nice! Must
get back to Alpine soon . . .

TX118N—**Jeff Davis County** 10:58 a.m.;
shot outstanding scenics on the backside of
Mitre Peak; **Fort Davis** ("Coolest Town in

Texas"), read Chamber sign of welcome
11:19-12:14 a.m.; pecan, yes; no brick and 4
clocks stopped at 4:42; ("Best Soda Fountain
in Texas") in Old Texas Inn at The Davis
Store. I had one of their outstanding hamburg-
ers for lunch ("The Best in the West") $9.25;
"No Sniveling" the sign read on the wall
behind the old soda fountain . . .

TX17S—**Presidio County** 12:30 p.m.;
buzzard 12:36 p.m.; 2 to west of TX17S; shot
Thunderbird Motel sign w/Texas; **Marfa**
12:45-1:09 p.m.; pecan, yes; no brick or clocks;
Texas/Hill Street sign; Texas Theater; Palace
Theater; shot courthouse; do shot of Miller
Lite cans or bottles with nice moisture beads
and title, "The Lites of Marfa . . ."

NOTE: I was looking forward to visiting
Valentine, Texas, and meeting Maria
Carrasco, the postmaster. Judy and I make
handmade Valentine cards each year for our
special clients and select friends, send them
to Maria, and she cancels them with a
special cancel, designed each season by a
local student. That day she put another

stamp on and re-cancelled my four envelopes from Vanderpool. The town has perhaps the most "Old West," movie set character of any I've been in as yet: dirt streets and outstanding adobe ruins! No one appeared to be home anywhere, and this is the first town I've ever seen that was entirely on the other side of the tracks—literally. "Even the cactus has given up on places in Valentine, Texas."

US90W—**Culberson County** 2:54 p.m.; **Van Horn** 3:27-3:37 p.m.; Sage Theater (defunct) no pecan, clock, or brick.

I10W—**Hudspeth County** 3:36/2:36 p.m. (entered Mountain Time Zone); **Sierra Blanca** 4:09/3:09-4:15/3:15 p.m.; no pecan, brick, or clocks; Best Cafe, State Theater (for sale).

I10W—**El Paso County** 5:15/4:15 p.m.; Texas Red's 99¢ Burgers @ Fabens, Texas exit; shot water tower ("Birthplace of [jockey] Eddie Shoemaker"); **El Paso** 6:15/5:15-6:48/5:48 p.m.; no pecan; tiles, not brick;

4-sided working clock, freestanding at street level (with Texas on them!); Texas Street signs with some neat intersections; great seal on courthouse (shot from inside and out)... left town (got turned around and nearly had to enter Mexico). West, as far as one can go in Texas. Turned around and headed back to Terrell County.

I10E—**Pecos County** (2nd visit); end of day 2/25; drove only as far as **Ft. Stockton** to spend the night so I didn't have to travel on US90E after dark and become a deer road killer or a statistic. Same "no frills" motel for

$19.95 as my last visit here (see "Wrapping up for Christmas" essay).

US285S—**Terrell County** (3rd visit) 2/26 drove to **Sanderson** from Ft. Stockton for breakfast at Jeanie's with Terry "Tex" Toler (he'd completely lost his voice and had a terribly sore throat; he could only whisper); good to finally meet him in person; introduced me to several folks (named in above notes from previous visit this trip); shot some adobe ruins and left town 11:52 a.m.

US90E & TX349N & I10E & US277S & TX55S—**Edwards County** (passed through Dryden, the closest airstrip to Sanderson); TX349N would make an outstanding bike rally road—hills and curves and great scenery! road kill red-tailed hawk; 2:51 p.m.; buzzard 3:10 p.m.; on the 33-mile stretch of TX 55S to Rocksprings, I counted 22 road kill deer (I had been seeing an unusual number on this entire trip); **Rocksprings** 3:23-3:31 p.m.; pecan, yes; no clock or brick; shot Texas on wall of The Texas Mohair Weekly; J&M Cafe & Bar.

US377E—**Kimble County** 3:54 p.m.; buzzard 4:03 p.m.; sgl. to west of US377; on this 48-mile stretch of road, I counted 31 road kill deer; **Junction** 4:15-4:27 p.m.; pecan, yes; 4 clocks (3 correct, 1 was 10 minutes slow); no brick; shot TEXAN Theater—"Close, but no cigar..."

I10E—**Kerr County** 5:01 p.m.; buzzard 4:57 p.m. (actually could be over Gillespie Co.); **Kerrville** 5:13-5:47 p.m.; pecan, yes; no brick or clock; shot Texas Trash; Arcadia Theater. I hope I got everyone's size right on those T-shirts...

I10E—**Kendall County** (2nd visit); **Comfort**, Texas 6:10-6:27 p.m.—absolutely charming little town; great antiques! shot neat sign! I don't recall hearing so many people laughing loudly (the sound carried so perfectly) on any Main Street anywhere...Two ladies were talking and laughing after closing their antique shop across the street from the B&B; a group of six folks were playing checkers under an awning of a store down the street; and up the street two men were laughing, standing beside a car. The setting sun cast perfect light on everything, and the scene was idyllic, cool and soothing—a scene out of a movie. Reminded me of when our family used to stay at my mom's parents' in the summer. They never had air conditioning, and at night with the windows open we could often hear more than the neighbors might have preferred...

Cattle Co. in Lytle—begs the question, "…as in not heavy, or low in calories, or???" On I10E, near Exit 593: Woman Hollering Creek—there's a story there…

TX181S—**Wilson County** end of day 2/26, 7:25 p.m.; arrived at Best Western motel after a brief spin around the square at 7:49 p.m.; ending mileage 56,008.4; shot **Floresville** on 2/27 8:11-8:21 a.m.; pecan, yes; no clock or brick; peanut sculpture ("Peanut Capital of Texas"); Arcadia Theater (working); Big Dan's Place; The Brownstone Cafe (lovely, but closed & for rent, like so many lovely, used-to-be hubs of activity on so many small town squares—where do the problems get discussed and solved? See essay titled, "Problem Solving 101").

TX97W—**Atascosa County** 8:38 a.m.; saw first caracara of trip (Handel was playing on classical San Antonio station); passed through **Pleasanton**; saw Wisdom Manufacturing (recalled Rainbow Manufacturing in Columbus, Georgia—wisdom and rainbows actually are made somewhere…) and Plestex Theater; buzzard 9:39 a.m.; 2 over TX16S; **Jourdanton** 9:00-9:17 a.m.; no brick, pecan, or clocks; shot gray granite Texas on county jail building; passing back through Atascosa County on I35S from Pearsall, I saw the Light

TX16S—**McMullen County** 9:42 a.m.; **Tilden** (aka, "Dog Town") 9:57-10:10 a.m.; no pecan, brick, or clocks; shot Cowboy Café, "Information & Service Center…" Jeff & Kay O. Quinn on TX16S—Cross, Texas BBQ; sign read, "Closed, Gone Fishing" NOTE: McMullen & Webb Co.'s and surrounding area is called "Brush Country"; buzzard 10:41 a.m.; sgl. E-W over hwy.

TX16S—**Duval County** (2nd visit) 10:51 a.m.; **Freer**, Texas ("Texas' Official Rattlesnake Round-up & Muy Grande Deer Contest"). Sweetwater and Freer ought to get together on the rattlesnake deal...

US59S—**Webb County** 11:07 a.m.; buzzard 11:13 a.m.; pair to east; **Laredo** 12:03-12:26 p.m.; pecan, yes; no brick or clocks; Plaza Theater; bustling place! shot Texas Hardware; shot Texas Mexican Railway car from I35N; saw several caracaras.

I35N—**LaSalle County** 1:07 p.m.; shot rose prickly poppies! **Cotulla** 1:33-1:39 p.m.; no brick, pecans, or clocks; saw one truck at the Cotulla Social Club...; buzzard 1:58 p.m.; pair flying into Frio County.

I35N—**Frio County** 1:58 p.m.; buzzard 2:01 p.m.; same pair to west, flying into Frio from LaSalle Co.; **Pearsall** 2:20-2:30 p.m.; pecan, yes; no brick or clocks; Oaks Theater; City Hall (black and white Texas, did color shot . . .); South Texas Rural Health Center.

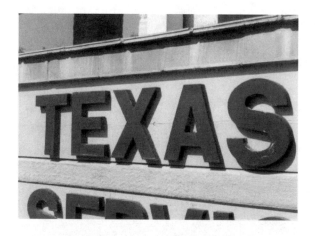

I10E & US77N—**Fayette County** 4:34 p.m.; major weather to the east; buzzard 4:36 p.m.; sgl. to south of I10; **LaGrange** 5:07-5:16 p.m.; pecan, yes; 4 clocks (5:05, 6:05, 5:05, and 8:05); no brick; lovely town and gorgeous courthouse! Beer office & Bottling Co. (Texas historical sign); Hart of Texas sign.

TX71S—**Colorado County** (umpteenth visit and I never get tired of coming here) 5:30 p.m.; **Columbus** 5:45 p.m.; 4 clocks not working (3 @10:20, 1 @ 9:50), no pecan or brick; end of day 2/27 mileage 56,480.7—total for trip thus far, 2,403.5; checked into Columbus Inn; just missed storm with hail and saw the most bizarre colors as I crossed the Colorado River! Left town the next morning 2/28 at 7:37 a.m.; shot brown Texas w/green stripe on sign in Altair; Eagle Lake ("Goose Hunting Capital of the World").

TX71S & Alt. US90E—**Fort Bend County** 2/28 Gorgeous, rain-cleared morning! 8:28 a.m.; buzzard 9:48 a.m.; sgl. over TX36; still in Fort Bend Co.? **Rosenberg**—Texas Grill! Cole Theater (main sign removed; check history of Cole Theaters in Texas!); **Richmond** 9:07-9:24 a.m.; no brick, 4 working

clocks and pecan; shot Downtown Grill and other bldg. "Wrong side of the tracks..." barber shop.

TX36N—**Austin County** 9:43 a.m.; **Sealy!** (do essay on revisiting Sealy after ten years and after two losing state championship high school football games against their teams); shot The Texas Theater and entrance sign; **Bellville** 10:42-10:51 a.m.; no pecan or bricks; 2 clocks: one 10:30 and one 10:50; Kim's Computers on the square.

TX159E—**Waller County** 11:01 a.m.; buzzard 11:01 a.m.; 2 on county line; crossed Brazos River and noted on recorder to Jim

Ainsworth and Co.; shot **Winkleman**, Texas. I asked a guy who was working on a building, what was Winkleman, Texas, and he replied, "It's a town..." **Hempstead** 11:07-11:12 a.m.; pecan, yes; no brick or clocks.

US290W—**Washington County** 11:19 a.m.; crossed Brazos River again, noted same on recorder for Ainsworth & Co.; **Chappell Hill**—neat town!! shot bank, Texana Cigar Co. and real estate sign; called Jerry and Kathy Chappelle and told them all they had to do was drop that "e" and they might lay partial claim to a town in Texas... they weren't interested; buzzard, sgl. over US290W (technically, it was

on the Waller County side by the time I got to Washington County, but it might have started out on the Washington County side...); then a pair in Washington County at 11:22 circling over road; **Brenham** 12:05-12:44 p.m.; home of Bluebell Ice Cream "We Eat All We Can And Sell The Rest"; no pecan or brick, 4 clocks: none works (6:30, 11:54, 11:51, and one without hands...); Simon Theater is now a Chinese buffet; Studio 212 Alamo—Potter, Amy Glascow; blacksmith sign; The Texas Store—rhinestone Texas pins etc.; Ant Street Inn—with reflection "Must Be Heaven" and beer sign... must get back here and spend some time! Shot Earlywine Store and Tex's BBQ—say it with me "Tex's"; and because the BBQ was so fine, I plan to consider this a bona fide "Texas..."

NOTE: I discovered the seeds (pun intended) of another blooming (two puns in one sentence) controversy over officialness (see essay titled, "Capital idea"), in sleepy little Chappell Hill. It claims to have the state's "Official Bluebonnet Festival," while

Burnet, in Burnet County, is the "Bluebonnet Capital of Texas"; DeWitt County is the state's official "Wildflower County"; and **Temple**, in Bell County, is the "Wildflower Capital of Texas."

TX105N & TX90N—**Grimes County** 1:41 p.m.; crossed Brazos River for the third time today—each time at a high rate of speed—and remarked on recorder; buzzard 2:00 p.m.; over TX90N; Miller's Theater in **Navasota**; **Anderson** 2:06-2:17 p.m.; no brick, pecan, or clocks; shot windows with bars and saw Fanthorp Inn—very nice.

TX6S & TX105E—**Montgomery County** 2:32 p.m.; **Montgomery** ("Birthplace of the Texas Flag"); Touch of Texas Restaurant (not open); buzzard 3:17 p.m.; 2 circling over TX105 & Lake Conroe; **Conroe** 3:30-3:37 p.m.; one side of square has brick (actually new pavers), no pecan or clocks; Texas Resale; Tejas Boots; Crighton Theater (fancy, 1934); **Liberty** (just passing through for about 20 minutes) 4:11 p.m.

mockingbird on marker and Sesquicentennial marker with silver Texas on gray granite at courthouse; Camilla P.O. sign in history village.

I45N—**Walker County** 5:25 p.m.; **Huntsville** 5:43-6:05 p.m.; pecan, yes; no brick or clocks; shot Cafe Texan; Texas Prison Museum and Citizens Bank of Texas signs; Town Theater; A restaurant revue or chamber of commerce guide might warn patrons and visitors, "Avoid being shocked or poisoned in Huntsville..." lovely sunset shot from fast-moving Chevy pickup on I45N headed home!

TX105E & US59N & FM2025N—**San Jacinto County** 4:31 p.m.; **Coldspring** 4:48-4:56 p.m.; no clock, pecan, or brick; shot

End of trip mileage 56,999.2—total miles 2,921.9; home at 9:42 p.m.—longest trip to date. And it felt like it. 🪧

Ooouch!

Originally the title of this story was "#@&%*!" but Judy gets upset when I talk like that, so I figured it wise not to get into the habit of typing with that language. But in all honesty, that's precisely the word that came out of my mouth, a little after 7 a.m. on March 8, 1999, the date I had first planned to depart for the Texas Panhandle. It's painful to recall, but here is what I remember...

Truck fueled and ready—check. Film and cameras—check. Maps and journals—check. Jammies and toothbrush—check. Clean jeans, T-shirts, socks, and none of your business —check. *The Cat Who Saw Red*—check. Showered, teeth a-sparkle, kiss Judy and Jessica, and I am outta there. Then Judy asked, "Rick, before you leave, would you mind changing the water bottle on the dispenser?"

"No problemo," I said. Yeah, righto...

I'm not exactly certain what a five-gallon glass bottle of pure water weighs—probably just a milligram or two less than the un-pure stuff—but I do know for certain that the next time one of those rascals gets of a mind to slip out of my hands, I plan to let the sucker go. No way am I going to let the tip of my right index finger... (let's pause right there a moment):

As a photographer, my right index finger is pretty important. I believe it was at age twenty-three or twenty-four that I stopped

referring to it as "Pointer" and dubbed it "Mr. Shutter Finger," aka, "Mr. Bread and Butter Finger." While not exactly Lloyd's of London policy material, it has nevertheless always been insured.

As a writer, my right index finger is only slightly less important to that function than it is to the act of typing. Kindly keep all that in mind.

(continue above paragraph)...get sandwiched between a falling water bottle and the very sharp edge of a Formica countertop.

Somehow, the bottle got away from me, and in the act of catching it, the tip of my right index finger did, in fact, come between the bottle and the counter edge. At that point I was too focused on getting a firm grip on the slippery bottle, turning it upside down, and placing

it on the dispenser, even to swear, although I'm positive there was a sharp, deep inhalation of breath, expressly for that purpose. Task completed, grab throbbing, smashed finger, insert expletive, maybe two...

Judy witnessed the ordeal. She then watched me pace around our small apartment, moaning, uttering gibberish, and holding my finger up in the air, not knowing whether I was going to throw up or pass out. Of course, in my mind I had just mashed my finger—no worse than hitting it with a hammer or slamming a car door on it, both of which I had done, lots of times. In my mind I was still headed for the Panhandle. I even asked Judy to go downstairs

and get the tiniest drill bit and sterilize it. I knew I'd probably have to drill my fingernail later in the day to relieve the pressure. Then I noticed the ache in my arm and shoulder. I was just a little dizzy also, the first indication that the trauma to my finger was the worst abuse any of my digits had ever received, not counting the time a friend screwed my left thumb with an electric drill (the Phillips bit slipped off a drywall screw) or the time a darkroom student nearly took off the same thumb in a paper cutter.

After fashioning an ice compress, Judy called the doctor, and you can pretty much guess the rest of this story. The doctor showed me the x-ray and told me I needed to postpone my trip, predicting that I would be in quite a bit of pain for the next day or two. Silly me, I said there's no way I could be in any more pain. Never say something like that to a doctor. It's like a personal challenge or something.

Naturally more pain was not only possible, but indeed, forthcoming. Rather than confuse the reader with all the technical details, basically, what the doctor did next was heat the tip of an unfolded paper clip until it glowed an angry red and drove it through the back of my dark blue fingernail to relieve the mounting pressure. If you will recall, I had planned to employ this very method of pain management, but very slowly and *accurately* with a tiny drill bit. Anyway, the doctor only slipped off the nail part a wee bit and hit the finger part before he made it into the nail bed. We both jumped at that point, but he managed to hang on to my finger, and at the same instant pulled the paper

clip out—all fourteen and a half inches of it, I ain't lyin' about that. The blood got us both (the savvy nurse saw this coming and shielded herself behind the doc).

After the procedure, the doctor wrote a prescription for some pain medication and said he didn't want me doing much with that hand for the next few days. Silly me, I said it'll just take a little adjustment, but I'll manage to get back into my normal activities and routine. Never say something like that to a doctor.

By the time the nurse had splinted and wrapped my finger, I needed an assistant to lift it and a wheelbarrow to carry it. Of course, the bulkiness of the bandages pretty well rendered the rest of the hand useless, unless I had been interested in taking up hockey—could have blocked the entire goal with one hand.

I went home and THROBBED very intensely for a few days. Then I merely THROBbed for a few more. Then the throbbing turned into a dull ache for about a month. Then just some soreness and stiffness for another month or two. Then only the stiffness, a bit of numbness, and the new, wider shape

to the end of my finger. Through all that, I made a list of the things a right-handed person can't do well in that condition. I made another list of the things a right-handed person can't do at all. And I came up with an interesting statistic: In the course of one twenty-four-hour period, the average person strikes the end of his/her right index finger on a hard surface over 16,000 times. Honest.

As of this writing, my finger still is a bit numb on the very end and will remain a little wider than its opposite, which means better coverage on my shutter release, though with some loss of sensitivity. Oddly enough, I have not been able to retrain myself to type normally (I don't use the index finger). Of course, I cross myself whenever I see a water dispenser. We got rid of ours shortly after the incident, and to this day, whenever I'm preparing to leave for a trip, Judy doesn't try to think of any little last minute chores for me to handle.

Anyone care to see my x-ray?

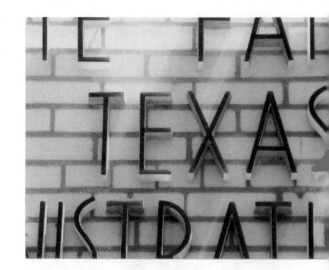

From the pan to the handle

Why not? If Texas has a "Panhandle," then the rest of the state must be the "pan."

On Monday, May 10, 1999, at 4:45 a.m., I departed from my part of the pan and headed for the handle part, rather—to pay this hunk of real estate the proper respect it so richly deserves for its prominent place in Texas lore, legend, history, and geography—I was bound for the Texas Panhandle. This is about as pure an account of any of my trips; pure for me at any rate. Hop in…

Beginning mileage: 58,726.9.

NOTE: My first "new" county to visit would be Childress. On the way, I passed through several favorite places, such as **Nocona** "Leather Goods Center of the Southwest"; Henrietta—got a better, color shot of the "Texas Best Beef Jerky" sign; called my favorite "road buddy," Lola Hope Borchers, in Lee's Summit, Missouri, for her birthday; heard a joke on the radio: What does a New York waiter say to a table of Jewish mothers? Is anything alright?

US287W—**Childress County** 9:17 a.m.; **Childress** ("Gateway to the Panhandle") 9:28-9:36 a.m.; mural "Valentine of Steel" (bomber); defunct Palace Theater; beautiful downtown, but worn/tired in spots; brick…none on square, but some streets; no clock on courthouse; pecan trees; clear and sunny; shot peeling yellow and red Texas on billboard; wildflowers! buzzard 9:52 a.m.; sgl. over road StoN.

TX256W—**Hall County** 9:54 a.m.; **Memphis** 10:09-10:39 a.m.; brick, yes; clock, no; pecan, yes; shot West Texas Utilities sign (silver), Texas Theater, Circa Texas Gallery, Fax Paux (color wall paintings), Bill Ballew Plumbing & Heating; noted Tumbleweed's and Noel Street; lunch at IGA in Memphis;

buzzard, 11:44 a.m. pair W over TX256; side trip to **Turkey** to see Bob Wills' hometown and Hotel Turkey (had met Jane and Scott Johnson three years earlier, former owners of the hotel, and originators of "Jane's Sweet Potato Pancake Mix"); Gem Theater; attractive, cut-out metal signs on all streets; John's Boot Shop; fishing lures as decoration in window; finally stopped and counted the number of blades on an Aeromotor (Chicago) windmill—been bugging me for miles; outside of town I shot spectaclepod (very sweet smelling).

NOTE: Gary and Suzie Johnson now own and operate Hotel Turkey as a B&B. Visit their web site www.llano.net/turkey/hotel or www.turkeytexas.com for pictures and more.

TX86W—**Briscoe County** 12:29 p.m.; shot service station ruin in **Quitaque** (Kitty-quay); **Silverton** 12:59-1:11 p.m. (w/fuel); example of diversification in business on square in Silverton: Roderick Irrigation, Inc. (also Ralston-Purina dealer) had a hand-painted sign in window "Jewelry for Mother's Day"; brick, no; clock, no; pecan, unsure, saplings? buzzard-0.

TX86W to RR378S to US70W—**Hale County** 1:53 p.m.; **Plainview** 2:03-2:35 p.m.; brick, yes; clock, no; pecan, yes; Fair Theater (not used as such); Granada Theater; Boot Shop; Old Mackenzie Trail; Stovall Radiator; buzzard-0.

I27N—**Swisher County** 2:45 p.m.; **Tulia** 3:07-3:20 p.m.; brick, yes; clock, no; pecan,

no; "Halleluja, I'm from Tulia" (bumper sticker) and "The Richest Land and the Finest People" (sign); shot Farm Bureau sign (blue, hand-painted w/touch of red); Royal Theater; Texas Burger, and white unidentified wildflower.

TX86W—**Castro County** 3:32 p.m.- 3:37 p.m.; Nazareth has 299 souls; Richard's Town Pump; Chubby Buns and German sausage; **Dimmitt** 3:52-4:03 p.m.; brick, no; clock, no; pecan, yes; "We have what you're hunting" (pheasant); First State Bank mural by Bob McClellan, 1990 Morton, Texas; Carlile

Theater; Texas Corn Growers (shot 2 signs)—
"Carl" asked me, "Why you takin' a picture of
my sign?" Said he had to "chew out the sign
painter," no ear of corn on sign as he had
requested; buzzard-0.

US385N—**Deaf Smith County** 4:17 p.m.;
Hereford 4:27-4:47 p.m.; brick-2 sides of
block only; clock, no; pecan, ? Texas
Credit/nicely painted 1936 bronze marker;
"Top of Texas Towns" & "Welcome to
Hereford, TEXAS USA" w/stop sign in photo
(painted on long wall)—could be the most sin-
cere welcome sign I've seen; buzzard-0.

US60E—**Randall County** 4:59 p.m.;
Canyon 5:14-5:31 p.m.; brick, 3 sides of block;
clock, no; pecan, no; Texas Souvenirs sign;
Texas (the play) signs at Center in town; into
Palo Duro Canyon; shot signs and wildflowers:
locoweed; buzzard-sgl. at 5:46 p.m., over Palo
Duro Canyon.

RR1541N—**Potter County** 6:45 p.m.;
Amarillo 6:55-7:06 p.m.; brick, no; clock, no;
pecan, no; Note for "Wave Theory" piece:
Women in general rarely wave, but West

Texas cowgirls do . . . ; Which is worse on the
sense of smell—feed lots, oil fields, or paper
mills? Stanley Marsh's Cadillacs begs the
question, "Why did he stop at 10?" Plenty of
field and lots of old Caddies . . . ; buzzard-0.

I40W—**Oldham County** 7:49 p.m.; **Vega** 8:11-8:19 p.m.; brick, no; pecan, no; clock, no; shot grain elevator; Vega was midway point on old US Route 66; then . . .

I40W—Along old US Route 66; shot Texas 66 on No Name Café, shot **Glenrio** (Deaf Smith County again) at dark-thirty on 5/10/99; ruins of First/Last Café/Motel in Texas; back to spend the night in Adrian. End of first day.

Begin 5/11/99 @ 7:13 a.m. in Oldham County with trip to Texas/NM state line to shoot Texas Welcome sign, wildflowers in median, and FFA Welcome sign—all in Deaf Smith County. Back in Oldham County; shot "Don't Waste Texas" sign; buzzard 8:58 a.m. 5/11/99; two on the ground being held off a road kill carcass by two crows half their size (gives rise to the "Legend of the Bad-ass Crows of Oldham County")—wouldn't I love to be a party to that breakfast table conversation? Down wind, of course . . .

NOTE: Called Eddie Smith in Commerce at 9:00 a.m. and Janet Duncan 9:07 a.m. to discuss a notion with these two native Texans: Things in Texas are bigger, reality or illusion? Both, actually: real—wind effect (taller plants?) weeds are smarter than flowers, they hunker down and spread out . . . ; illusion—sun effect/mirage: things appear wriggly, but bigger. Crossed the Canadian River on US385; shot Texas LIT gate marker; Prayer Town, just south of the Hartley Co. line; be careful laying down to shoot flowers out here—burrs! Heard song titled, "Shut up and Drive."

I40E to US385N—**Hartley County** 9:31 a.m.; **Channing** 9:36-9:48 a.m.; brick, no; clock, no; pecan, no; courthouse in a dense grove of trees; shot XIT General Office; only 8 doors on Main Street (Railroad Avenue); Cowgirls Café; cloudy bright, 44F out, and very windy; shot Channing Methodist Church; only 9 days until the Eagles graduate . . . ; buzzard 9:54 a.m.; sgl. N of 354.

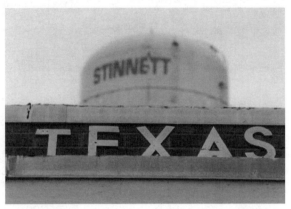

TX152E—**Hutchinson County** 10:57 a.m.; **Stinnett** 11:09-11:20 a.m.; brick, no; clock, no; pecan, no; oil! shot fallen sign outside town; Texas on "laid back" sign at P.O. with Stinnett on water tower in background; buzzard 11:35 a.m.; sgl. to N.

NOTE: Backtracked to Dumas on 152W, then north to **Etter** & **Cactus** on US287N; from 12:13-12:31 p.m. in Cactus; Bull Wash Out Sign; water tower; the only cactus I saw (that wasn't illustrated) was growing in front of the P.O. It was chain cactus; the word cactus certainly was written on every available object in the community; on to Dalhart.

TX354E to US87/287N—**Moore County** 10:08 a.m.; **Dumas** 10:28-10:37 a.m.; brick, no; clock, no; pecan, no; Root's BBQ; Evelyn Theater; shot Spider Crazy graffiti on wall; buzzard-0; antelope (3) @ 10:17 a.m.

NOTE: Rather than wait on a long train in Dumas, I decided, on the spur of the moment (why does that phrase seem more appropriate way out here?), to slightly change the order of the trip at this point and headed for Stinnett (Hutchinson Co.) on TX152E.

RR281W—**Dallam County** 12:49 p.m.; buzzard-0, but saw a prairie dog @ 1:00 p.m.; **Dalhart** 1:15-1:45 p.m.; brick, no; clock, no; pecan-saplings? Texas Blvd. intersections with Peach, Scott, and Keeler (Texanized Keillor?); XIT Museum and brands; State of Texas Seal on 1986 monument; Mission Twins Theater and La Rita Theater (gorgeous renovation); Texas Tavern.

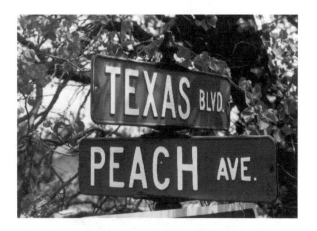

NOTE: Weather is clearing a bit... Reminded of a trip once to Luna County, New Mexico, where I postulated that the most unlikely disaster to befall anyone in that county would be getting hit by a train, since a train approaching in any direction could be seen for a week. I posed a trivia question for Stan Hodges at TDED: Where in Texas can a person stand on top of their vehicle and see 10-20 county seats, including one or two in Oklahoma? I'm on US54 to Stratford and it is 54 degrees at 1:49 p.m.

US54NE—**Sherman County** 2:16 p.m.; **Stratford** 2:22-2:31 p.m.; brick, none on square, but main drag is brick; clock, no; pecan, no; "Pheasant Capital of Texas"; Elks are the town's mascot, why not the Phighting Pheasants? Go figure... Dear Stratford, Texas: Eat chicken, photograph pheasants. Just a thought; 2:41 p.m. saw 2 burrowing owls (small, light brown), one with prey; at 2:52 p.m. I spied my first wild, ring-necked pheasant cock—huge!

TX15E—**Hansford County** 2:54 p.m.; **Spearman** 3:25-3:31 p.m.; brick-main drag has it, ends @ courthouse; clock, one on sidewalk to courthouse; pecan, no; old Lyric Theater closed, front only with boards; new Lyric Theater is modern; buzzard 3:14 p.m.; 2 N.

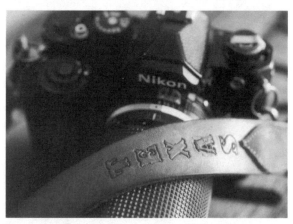

TX15E—**Ochiltree County** 3:37 p.m.; **Perryton** 3:54-4:14 p.m.; brick, no; clock, no; pecan, saplings? Shot The Texas Company faded sign on oil tank; window and door with Vander(burg); no-name Theater; Hot_l Perryton; shot ruined drive-in; buzzard-0; must be off hassling *Hank the Cow Dog*, a great series of children's books, written for adults, by John R. Erickson of Perryton.

RR377E to TX23S to RR3260E to TX305N —**Lipscomb County** 4:30 p.m.; **Lipscomb** 5:00-5:25 p.m.; brick, no; clock, no; pecan, no; Only 48 people live here, but every evening just before sunset, over 100 wild turkeys cross the square; prolific, they come off the creek, said Debby Opdyke. Some have been netted and used to stock three states in northwestern

U.S.; the town is an absolute oasis on the High Plains, watered by Wolf Creek. I couldn't stay for that evening's "Turkey Parade," but I heard bobwhite quail @ 5:20; Debby and her partner, Jan Luna, were completing work on an outdoor dance floor, adjacent to their very nice art gallery, "Naturally Yours," on the square. Call them for information and schedules (806) 862-2900— they advise visitors to "Bring your lawn chair, your bug spray, and your good humor"; shot neat old saddles on fence; Prairie Rose Bakery; buzzard 4:41 p.m.; 2 to W.

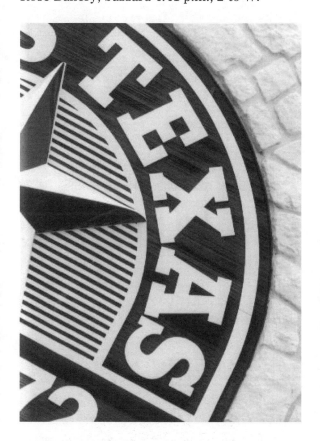

Palace Theater; City Drug; Modern Lumber; Davis Paint; shot loads of flowers between Hemphill and Wheeler Counties!; learned where stinging cevalia got its name; buzzard 5:46 p.m.; sgl. to S.

US60/83S—**Wheeler County** 6:44 p.m.; **Wheeler** 6:56-7:09 p.m.; no brick, clock or pecan; shot sign at Texas St. & Mobeetie intersection; Mel's Diner; West Texas Gas; Honey Inn Motel; Wheeler Times; buzzard-0.

TX305S to US60SW—**Hemphill County** 5:42 p.m.; **Canadian** 5:56-6:06 p.m.; brick, 2 sides of square; clock, removed? pecan, no;

NOTE: The sun came out at 7:40 p.m; clear and clean, just to hit me in my road-weary eyes. If you plan to visit **Mobeetie**, follow

signs carefully or get specific directions; shot Texas St. sign and blue Texas over curved tile roof; then TX152W, zigzag like crazy down a series of gullies and ravines—resembles landscape outside Moscow, Idaho—to the bottom of a deep depression, where there is another Panhandle oasis . . .

US60SW—**Roberts County** 7:57 p.m.; **Miami** 8:03-8:12 p.m.; no brick or clock; pecan, yes; Miami is the other oasis. I asked a group of cattle, "Can you even imagine being anyplace more lovely?" No answer. Obviously a mooooot point; Ferg's Café sign with Texas shape—neat; shot hand-painted Texas on gooseneck trailer; buzzard-0. Shot **Laketon**

Wheat Growers elevators with beautiful, brooding sky on US60S @ 8:19 p.m. en route to Pampa; spent the night in Pampa; day two ending mileage—59,964.8.

50 degrees, clear and sunny on morning of 5/12/99.

US60SW—**Gray County** 7:39 p.m. (5/11/99); **Pampa** 7:09-7:32 a.m. (5/12/99); brick on 2 sides of square; no clock or pecan; "Grandfather's Vision" (sculpture by G.L. Sanders); Texas Furniture; Roberta's Flowers; courthouse with longhorn.

US60SW to TX207S—**Carson County** 7:40 a.m.; **Panhandle** 8:17-8:34 a.m.; brick on 3 sides of square; clock, no; pecan, yes; Square House Museum; shot Bois d'Arc on the Plains (took samples . . .); shot Main Street sign on a well-worn building; Texan Hotel; shot Texas Trucks sign in **White Deer**; 8:59 a.m.—saw a ring-necked pheasant cock on roadside, went back and he had disappeared along the edge of a field—he'd gotten "low in a row." I flushed him!

TX207S—**Armstrong County** 9:15 a.m.; **Claude** 9:25-9:42 a.m.; no brick, clock, or pecan; shot a tore up windmill outside town; The Caprock Hotel and Café is now Yucca Pod I & II Antiques; shot elevator ruins; one cat (Siamese, if you please) was on top of the out-house and one (coal-black) was inside . . . ; Gem Theater; buzzard-0.

US287E—**Donley County** 10:03 a.m.; **Clarendon** 10:15-10:43 a.m.; brick, yes; no clock or pecan; West Texas Utilities with broken neon on one side only; Mary's Country Kitchen; A Texas Natural; Mulkey Theater (not in bad shape, but defunct); shot courthouse window details; Sandell Drive-In; It'll Do Motel (A Little Bit of Texas); buzzard 10:10 a.m.; sgl. to N, then 3 sitting on ruin of house to S.

US287E to TX203E—**Collingsworth County** 11:19 a.m.; **Wellington** 11:41 a.m.-12:28 p.m.; brick, yes; clock, no; pecan, yes; shot worn side of Coke case; Ritz Theater defunct; Mona's Cocina on the square for a positively outstanding lunch! Shot sofa in the yard and corner of ruined house; buzzard 11:24 a.m.; sgl. to S.

NOTE: US62/83S to US287E and heading home @ 12:29 p.m.; mileage at this point of trip 60,104.2; stopped in **Burkburnett** looking for an alleged Texas Theater—it's no mo'; at 2:17 p.m. I passed up **Wisdom** (Texas)—hey, we all make choices...

I would have arrived home at 6:49 p.m. on Wednesday, 5/12/99, but I stopped outside **Wolfe City** to help a friend, Mark Copeland, change a flat. My ending mileage was 60,422.7. The entire trip, just under 1,700 miles; 26 counties shot—one county every 65 miles, with 6 side trips—took a total of 62 hours, door-to-door. The wildflowers were glorious, and I collected shots of about a dozen brand-new ones.

One usually hears the Panhandle described as dry, flat, and colorless. I'll always remember the spring of '99, when the Texas Panhandle was in "full bloom gear." Another pleasant surprise, looking for Texas...

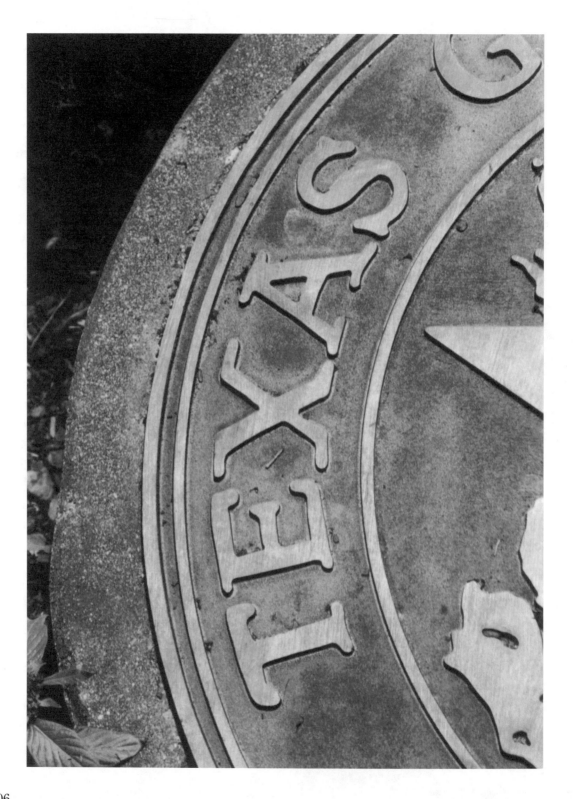

Still musing after all these miles

I'll grant you that

One of the things that occupies a great deal of my time when I travel is adding prospects to what I call my "Grant Opportunity List."

It all started a few years ago when the story broke about the government paying $600 or so for a hammer; then the outpouring of other examples of imprudent government spending. At first, as a taxpayer (one who often questions whether he's getting full value for his expenditure), I was outraged at the outpouring and began pouring my heart out to anyone who would listen. Generally that consisted of the newscaster who was delivering the message that set me off. How can the government be so wasteful? I asked myself.

I had just about calmed down when I learned that Congress was to handle the problem in the usual manner—by spending several weeks and several hundred thousand dollars to determine

why they spent $600 on a hammer. How could Congress be so wasteful? I asked myself.

When I began hearing and reading about the government's largesse towards exotic studies and outlandish research programs, I asked the same question as before; only this time I had an answer: Get a grant!

I had no idea just how intent the government was on giving away money until I started learning about all the grant-writing seminars it sponsored. And when I attended one, it became obvious that the government doesn't want to be bothered with amateurs taking

107

money from it for no good reason. No, our government wants highly (government-trained is an oxymoron of the highest order) trained individuals to take money from it for no good reason. So, I began to hone my grant-writing skills. And I began my list.

My "Grant Opportunity List" is not broadband; it is broad-based, and as such, it is not broad-banned (non-gender biased). It supports a free press and light starch always; pausing between "one nation," and "under God," when reciting the Pledge of Allegiance; 12 items or less in the express lane—no exceptions, ever; a legal finding that *rap is not music and is missing the letter "c"; grapes and strawberries are the only two acceptable items—rendered as jelly, jam, or preserves—to be combined with peanut butter and white bread; eyes closed when praying or kissing; blow out your

own candles; and never, ever, abbreviate the word "Texas."

I've identified my top three priority items as follows, the rest I'll get around to, in no particular order. With this kind of work, it's best to take nothing for granted and to leave one's options open.

The first item on my list, appropriately enough, calls for an examination of the prospect that perhaps a complete and total accident in some "cosmic laboratory" did in fact precipitate the beginning of the entire universe. List item: "The big 'dang' theory..."

The second item is a mandate to determine the most outrageous lawsuit ever filed in Texas. A friend suggested it would have to be an individual (Plaintiff) suing a school system (Defendant) for teaching (Plaintiff) to read; (Plaintiff) then reads something (which did not

contain any Warning Notice) in a newspaper (co-Defendant) that caused the (Plaintiff) or another party (Victim) harm. List item: Sue "U."

The third item is a study of odd words. This will require my exercising great care so as not to plagiarize the absolute master of the subject, Mr. George Carlin. It's doubtful however, that my grant request would ever fall under

his gaze. Besides, would even he seriously threaten a reprisal if there were no prisal? Then there'd be my buttal and his rebuttal. Personally, I think we both have better things to do with our time...List item: Spell Czech.

My plan is to submit at least one grant request a month for the next several years; and as someone is likely to note, there's no shortage of grist for the grant mill.

Get a grant to examine/study:

...whether two or fewer wild geese will still tend to fly in the characteristic "V."

...snowflakes: Are no two really alike?

...the proper wine to serve with Pittsburg (Texas; Camp County) hot links.

...a "no-brainer": Why should amoebas have all the fun?

...what is the longest period of time a cat has ever purred.

...blue towel distribution: Does everyone really own one?

...the impressions people leave on soft seating and what it says about personality.

...albino Polar bears.

...who on earth actually rents *Ishtar* on video.

...fingerprints: Are no two really alike?

...how cats know when they've licked themselves enough.

...why cowboys wear chaps and their horses don't.

...giving hurricanes male names: If God had wanted it that way, would we not have *himicanes*?

...a broad abroad.

...who makes those things and what are they called? Examples: toothpick wrappers; fake pearls; twist-ties; agitators for spray paint cans (DO NOT TRY TO OPEN A CAN TO SEE WHAT THEY LOOK LIKE!); plastic inserts for Tabasco bottle (the little things that mean the difference between a little heat/flavor in your Bloody Mary and a trip to the emergency room).

...beef jerky vs. deer jerky.

...generations A-W and Y-Z.

...wills: Living vs. ?

...anything labeled "Traditional" or "Old-Fashioned," that's made in Taiwan.

...topless dancers: Are no two really alike?

...crimes: Hate crimes vs. Apathy crimes.

...room temperature: My beer gets warm and my coffee gets cold—same room.

...the origin of the term "politically correct" and other oxymorons.

...morons, types other than oxy-.

...lying: How not telling the truth to Congress isn't.

...how to determine to which end of a box of Cracker Jacks the peanuts have settled, so as to open that end first, if desired.

...tumbleweeds: Part One: Are tumbleweeds more attracted to trucks or cars?

...tumbleweeds: Part Two: Are tumbleweeds more attracted to certain colored vehicles?

...tumbleweeds: Part Three: Are animals that eat tumbleweeds more likely to represent a higher percentage of road kill victims?

...what becomes of all the little scraps of bars of motel soap.

...conspiracy theories involving conspiracy theories.

...for a stress test (just kidding).

...why genies and fairy godmothers never offer to grant more than three wishes.

...smelliest dumpster—out back of an oyster bar or stadium lot after "Bowl" game?

...why female TV super-heroes are scantily clad and male ones wear masks.

...the pay phone: Does it return your quarter; how does it know?

...cell phone: How did your wife know you were on the golf course at 2 p.m. on Friday?

...why Texas doesn't have an official State Dog.

(to be continued)

The fourth priority item on my list is barbecue. Aside from clearing up, once and for all, the controversy surrounding the proper spelling (BBQ/barbeque/BarBQue/barbacue/BarBQ) of this properly Texan delicacy (no matter what anyone may claim in Kansas City, Memphis, or elsewhere), I simply intend to study it. Extensively. And for anyone outside the Lone Star State who convinces me they can prepare beef shoulder any leaner and tastier than Kreuz Market in **Lockhart** (Caldwell County), brisket any juicier than Louie Mueller's in **Taylor** (Williamson County), or a pork chop with half the flavor of the ones served at Cooper's in **Llano** (Llano County), well, I have a grant (as in $50) for you...

Author's note: From firsthand experience, I applaud the *Texas Monthly* barbecue judges who voted the three establishments noted above as the top three barbecue joints in the state. So far as I've been able to sample each, their choices for the balance of the top 50 are right on as well. Also, my well-worn copy of *TM's* Texas barbecue joint survey issue (May 1997) makes an excellent tray for a sandwich and side of beans or slaw...

Unwavering interest

Texans are the most expressive drivers in the world, and on the whole, they possess a natural propensity for a variety of friendly roadway greetings. Thanks to a generous grant from www.bucks2burn.com (b2b for short), I have studied these gestures in great detail and will share them with you now.

To simply describe as "waves" the various hand signs that Texas motorists share will be sufficient for my purposes here, dealing no doubt as I am with many readers unschooled in the subtleties of manual interpersonal communication.

There are over 7,700 variations of the basic wave (I think that got the grantor's attention—showed them I had done my home-work), but for the sake of brevity, we will deal with only a couple dozen.

Soon after obtaining a driver's license, every motor vehicle operator who's even half-way cool begins to drive with only one hand.

NOTE: See the results of another extensive study with funding from b2b, titled, "All the Stuff in the Universe That's Cool and Not." You can find it and over 7,700 others on the b2b web site, www/nowyouknowdiddley.org.

First, some basics. People tend to wave with their dominant hand, i.e., a right-handed person will wave with the right hand, and a left-handed person waves with the wrong hand. Some studies have seriously questioned the sincerity of an off-hand wave. Be that as it may, it happens. Begs the question, of course, who cares? During the brief instant in which the greetings are exchanged, as two vehicles pass one another at a high rate of speed, a greeting is a greeting is a greeting. And the greeting is what we are examining here, not the motivation of either greeter, no matter what some other study says about that. We are

studying my study, so na, na na na na, and phooey on their dumb old study.

Where were we? Oh, hand-positions...

There are over 7,700 different places where a driver can place whichever hand is not actually involved in driving, but for the sake of brevity, we will deal with only a handful: 1) If the left hand is holding the steering wheel, the right hand is going to be on the back of the passenger seat (with or without a passenger—other studies examine the likelihood of a male driver putting his arm on the back of a seat occupied by another male vs. a seat occupied by his dog, child, or wife—given they are riding in the cab of the vehicle).

NOTE: I neglected to mention that my study deals with truck-to-truck waving only. Automobile drivers rarely wave, and if they do, who cares? I also forgot to mention that this study deals with male and cowgirl drivers only. Other women drivers rarely wave, and if they do, they do it poorly. In fact, over 7,700 studies have proven that the only things women do consistently well behind the wheel of a car is talk on a cell phone, binge eat, and check themselves out in the mirrors (see b2b study titled, "Women Drivers Wanted: Back in the Kitchen").

2) If the left hand is holding the steering wheel, the right hand is either holding a beverage cup, from which he is drinking, or a beverage cup into which he is spitting. 3) If the left hand is holding the steering wheel, the right hand is writing. 4) If the left hand is holding the steering wheel, the right hand is slapping right thigh, keeping time to favorite road tunes. 5) If the left hand is holding the steering wheel, the right hand is draped around the shoulders of a passenger. Var. 5a: Passenger is holding steering wheel and neither of the driver's is...

6) If the left arm is out the window, the right hand is generally holding the wheel, although either the right or left knee (or as we have seen, a second party—though not to suggest partying while driving) may be employed in that capacity, in which case, the right hand may be on the back of the passenger seat, holding a beverage cup, writing, slapping time, or whatever.

Having covered the more common positions of the hands while driving, we are now prepared to examine the actual waves themselves. Again for the sake of simplicity, I will merely list a few examples as they are found in most texts on the subject. These texts are available only in the shopping section of the

b2b web site. The shorthand descriptor code for each quality of a wave is as follows:

M—Male
CG—Cowgirl
RH—Right Hand (may or may not be
 dominant)
LH—Left Hand (may or may not be dominant)
HW—Heel (of hand on top of steering) Wheel
FW—Fingers (on or near top of steering)
 Wheel
FTW—Fingers (and) Thumb (on or near top of
 steering) Wheel
WDW—Wrist Draped (over top of steering)
 Wheel
T—Thumb
P—Pointer
TM—Tall Man
RM—Ring Man
Py—Pinky
FH—Full Hand
Li—Lift
Wr—Wriggle
Wa—Wag
Pt—Point
MS—Mock Shoot
FHW—Full Hand Wave
EFHWWAE—Enthusiastic Full Hand Wave
 With Arm Extension
Sa—Salute
N—Nod
CU—Chin Up
Sm—Smile
H—Howdy! (either party mouths greeting,
 simultaneously with any gesture)
HUHSAS—Holds Up Hastily Scribbled Abu-
 sive Sign

Wave variables are indicated (when known) by an ID number that follows the complete descriptor code for each wave. There are over 7,700 separate variables, but these are the most common ones and their ID number, whether or not wave initiator or respondent was in the other's lane at the time of the greeting: (1), age of driver (49), driver fully clothed (54), direction and angle of sun (99), driver wearing hat (70) or cap (71), wave initiator or respondent (75), male-to-male wave (83), male-to-cowgirl wave (84),

cowgirl-to-male wave (85), cowgirl-to-cowgirl wave (86), driver mood (92), region of the state (549), specific type of truck (1,429), age of truck (1,430), color of truck (1,433), driver holding cigar or cigarette clenched in teeth (1,986), and the square root of the age of the driver, divided by the age of the truck, times the sum of all the numbers in the license plate on the vehicle (7,327).

Now we are ready to show a few wave samples. See if you can tell what kind of wave each descriptor code describes.

CG/LH/WDW/FH/Li/Wa/Sm/H(71)
M/RH/HW/N(1,433)
CG/RH/EFHWWAE/Sm(54)
M/LH/FW/TM(1)

Complete profiles of the sample waves will be posted tomorrow on the b2b web site.

How you greet your fellow travelers on all of life's roads says a lot about what kind of person you are. Wave if you feel like it, but always drive friendly . . .

Looking for a place to happen

Say it with me, please, *"Keep at least one knee on the steering wheel while approaching a pulpwood truck in a sharp curve, on a narrow East Texas oil top with no shoulder and a steep drop-off."*

While doing some casual research, preparing a grant application for a more in-depth study on the different types of waves from drivers (see essay titled, "Unwavering interest"), I decided to experiment with what type of wave would elicit the most unique response from an oncoming driver. Well, the theory was sound, but my timing was bad. Nearly a "permanent wave," to be precise, but like the old saying goes, "what doesn't kill us will oftentimes sink into even the thickest of skulls as a great big no-no."

It's a little known fact that long-distance driving is the loneliest activity in which any human being can be involved, even with a carload of screaming kids or a snoring wife, aka "co-pilot." **Aside:** It's a lesser-known fact that in this application, "co-" is an abbreviation for "comfortable." If a driver actually is alone, then the activity often becomes one of interminable boredom, hence the plethora of driving aids, games, and other distractions, not to mention the innumerable roadside attractions (signs and sights) to take a driver's mind off the job at hand. Or at elbow, knee, or whatever.

Unless I'm engaged in those brief, almost Zen-like, other dimensional moments of cat-nappiness (experienced roadrunners really

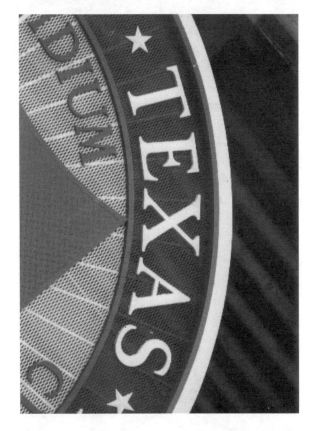

can sleep with one eye open), I am taking in the scenery—no matter how dull, taking in the stimulating billboards and signs on businesses—no matter how tacky, taking in the road kill—no matter how gross, taking in the architecture and ambience of each community—no matter the size or blight, and as always I am taking notes—longhand, and no matter the risk to myself, passengers, or fellow drivers. And with very good reason. It's another little-known fact that a priceless thought which occurs to someone driving at 70+ miles per hour will, in less than 14 car lengths, be indistinguishable in terms of recall, from a hand-painted, misspelled notice in front of a double-wide touting specials on "Wedding gown altercations and VW repairs."

Granted, I'd be the last person on earth to claim that it's a safe, sane, and healthy practice

to compose while driving. I myself have had those endorphin rush-producing moments where I looked away from the road long enough to drift into a situation where I saw my life flash before my eyes—the lane of an oncoming Peterbilt, for instance, the front grille of which was encrusted with exactly 2,749 insect body parts and goo—mostly of the order Lepidoptera—and a single primary flight feather of an immature, male, eastern meadowlark. Rest assured, at those moments, I found the earliest opportunity to pull over and gather my wits, collect my thoughts, catch my breath, and air out the vehicle.

Good news! No need for note-taking for a while. Another grant came through for my wave study, and I'll actually be photographing the different ways that drivers wave on the highways and byways of this great state of ours. I'll not further trouble the reader with details here, but I will ask that you wave or gesture as you normally would anytime you are on the road and feel the urge. If you don't wave as a rule, then don't. I'm not, in any way, suggesting that people initiate a wave or even return one. That's not the reason for my study. Oh, perhaps my findings might point to a friendlier driving population in this or that county. Who knows? The important thing is that I gather valid information. And to do that, I'll simply take the photographs—totally at random, with and without a wave on my part—then write up my findings when I've stopped for the night. Since I am able to drive for long periods of time equally well with either knee, I have plenty of time (and both hands) to focus sharply, wave, or whatever.

So, no more of that unsafe note-taking practice for this driver. Nosirree. Now, if you will (as part of my recovery therapy), please repeat with me one more time: *"Keep at least one knee..."*

People make stuff

My visit to Chappell Hill (Washington County), Texas, was a side trip en route to Brenham (Washington County) from Hempstead (Waller County), on Sunday, February 28, 1999; one of those lucky finds of a place—a lovely little town. I called some very good friends in Georgia, Jerry and Kathy Chappelle, and told them all they had to do was drop the "e" and they might lay claim to a neat little Texas community. No sale. But then again, they live in Happy Valley...

> *"Life is just drinkin' beer and makin' stuff."*
> Jerry Leon Chappelle, c. 1982

Everyone should have a friend like Jerry Chappelle. In spirit at least (and usually in the form of one of his coffee mugs), he made every trip with me looking for Texas. As often as possible, I borrowed his perspective and tried to look at all the stuff along the way, the way he would.

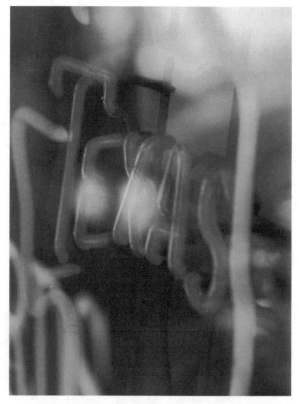

First, time began and then people began, quite a time thereafter. Then time kept going and people took time off from making communities, making war on other communities (human and every other life form), and making offspring. People then had time to make stuff—whether straight from need or imagination—first from stuff they found, then from stuff they had already made, and in the case of some artists, from stuff they made from stuff they found, then lost or discarded and found again.

If necessity (must we have a better mousetrap, or simply the creative urge?) is the mother of invention, is it not logical that the father is some hunk of raw materials? Therefore, it must follow that the offspring of this pairing would be stuff of one type or another, right? No problem so far.

A problem arose when people started making comments about other people's stuff. Then came the quality issue, and some people stopped making stuff so they had enough time to judge other people's stuff. Those who made a career of this activity became purchasing agents, critics, and editors. Those who merely did it part-time became wives, kids, and neighbors.

Finally, the making of stuff evolved as well.

Some people began to make stuff professionally and others continued to make stuff unprofessionally. The former made antiques, while the latter became U.S. automakers. Some stuff was made for sale, "products," which quickly broke or wore out, to be thrown away or used to make new stuff; and some stuff was made for the sheer pleasure of making stuff. This stuff sold for a great deal of money (much more than most "products," and even more than that after the maker of the stuff had met his/her Maker). This high-priced stuff, made for fun by people who often take themselves far too seriously, came to be known as "art."

Put simply, as Jerry Chappelle sees it, stuff is what we make from our lives. Think about it, our lives are both the raw materials and the need or urge to create stuff. We are our own parents—Mom Yin and Pop Yang, if you will.

And when we're not making stuff, to use Jerry's metaphor, we're drinking beer—all in all, a pretty pedestrian activity when done in moderation; an altogether positive, recharging activity if practiced in moderation. Jerry would want me to add for the record, however, that beer drinking taken to extreme can strand a person's pedestrian butt in the middle of a freeway at rush hour.

Jerry Chappelle is a potter. Leaving it at that would be like the media reporting that Hiroshima was hit by a water balloon. Jerry is also a philosopher, painter, sculptor, husband, grandfather, teacher, and friend. To listen to him, walk with him through his home, studio, and gallery, surrounded by all the stuff he's made, one just might get the impression he was making it long before most people discovered they could take time off...

Everyone should have a favorite author like Henry David Thoreau. In spirit at least (and often as a copy of *Walden*), he made every trip with me looking for Texas. As often as possible, I borrowed his perspective and tried to look at all the stuff along the way, the way he would, even though he probably would pooh-pooh my wanderlust.

Perhaps Thoreau would have been at odds with Jerry Chappelle too. Though his philosophy on life ("Simplify, simplify...") might have been be similar to Jerry's, and both men share the same opinion on new clothes, with all due respect (he'll forever be a favorite), the stuff that Thoreau made reveals a serious lack of beer drinking...

April fooling and fixing

You never know who's passing through; what they'll see and what they'll do.
What they'll like or not, can't be known, but that first impression will stand alone.
Might they someday call this place their home?

Virgil Race

Each time I returned from a trip looking for Texas, I would look through my notes for comments I had made on the various towns I'd passed through, specifically where I compared a town to Commerce. Sometimes I noted and photographed an improvement that might work here—a neat way to hang flower baskets or banners around the square; interesting lighting; murals—that sort of thing. Sadly, though, I began to notice that too often my notes asked the same questions, trip after trip; questions like, "Where are all the children?" "Why so many shops closed in the heart of this little place?" "Is anybody home?" "Would it help if I told them what's neat about their home?"

There is something neat about every little town on earth. People settle in a place for a reason—and begin its history. The reason may have dried up and blown away, but not the history. It may have a fascinating name—more history. And the history of a town exists for no better reason than to instill pride in its inhabitants. And if a place has got inhabitants, it's got potential to attract more, even if it's a ghost town.

Common Thread

Marked by the layers of paint and dust,
the things unmended or covered with rust,
the common thread is the passing of time—
improving with age or leaving behind.

People come to a place to settle and name,
the common thread is that they came;
and the words in their stories to deny or believe,
hold the reasons they stayed or their signal to leave.

The streets were here, the houses there,
and all the shops around the square,
thrived when folks called this place home;
now it's no place to be and the children are gone...

Folks do need someone to tell them how neat their town is and what there is to be proud of in it. But it's not my job, even though I'll do it every chance I get. It's the job of community leaders; leaders with vision and imagination, and if they don't have that personally, they need to have the sense to admit it, to try and cultivate it in themselves or others. Failing that, they flat don't, by God, need to be holding whatever position and calling themselves leaders.

And what if a small or medium-sized town has temporarily lost its "heart and soul," its faith and pride in itself? What if they have thrown party after party and no one has come?

NOTE: This is the "Fix It With A Festival" or "5K Our Troubles Away" syndrome. Small-to-medium towns must face the fact that there are only four weekends a month, twelve months a year. Every town in Texas can't have a festival of its own. Even if the event isn't sad as a back porch haircut, how many festivals can the average family afford to attend in a year, with all the other commitments and priorities demanding their time and money? Answer: Less, not more. Many counties are going to have to take a serious look at this problem and some resources are going to have to be pooled, or else many pools are going to be closed or will dry up.

Someone (several someones, actually) in every county in this state has good taste, good sense, and good judgment in

abundance. They only need support and encouragement—help in spreading themselves all over their county, to share their ideas and vision. They'll come up with good plans and worthwhile goals. And given that, there is no shortage of people with willingness to work sun to sun to fix up where they live.

Commerce, I'm proud to say, has all the ingredients to be a great little town. It has a fine university with outstanding leadership, and like most places that get everything right most of the time, it's always one election away from getting everything right once again. When I was at the *Commerce Journal*, I would occasionally write a preview of the upcoming month to give the readers an idea of what to look forward to and plan for; most of it they already knew, but some of it they could never imagine without a little help. This is from the piece for April 1999:

> "March was Texas History Month. I bet I asked at least fifty people and no one could tell me anything they had done, so far in their lives, to make Texas history. On top of that, no one knew anyone personally who had made Texas history. What's worse, no one I talked to had, as yet, made any plans to make Texas history. Sad? Not really, there's plenty of time for anyone to make history before he/she becomes it. Being the optimist that I am, I say that such a situation merely spells o-p-p-o-r-t-u-n-i-t-y. There's a whole year until next Texas History Month."

In April 1999 Commerce began an annual tradition called the "Big Event." It's a weekend of *everyone* doing something to fix up, clean up, and build up around town. At the end of the day the participants get together and celebrate. It was hugely successful that first year, and the 2000 version was even more so. Just an idea for other communities; think of it as a "Fix-it Festival."

Here's a fix-it idea for our state leaders. They really should spend a little less time admiring what all their work has done to improve the economies of Dallas, Fort Worth, Austin, and Houston. They need to spend a little more time looking for the rest of Texas. And while they're at it, I suggest they ask themselves, as they enter a small town with a welcome sign badly in need of repair or paint, "How sincere is that welcome?" And they should begin working on a response for when they come upon a town with no welcome sign ... 🦵

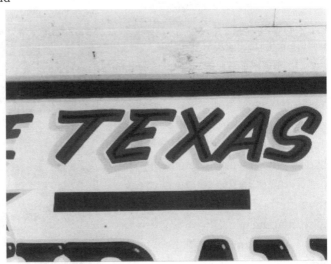

Square one

We lived on a small town square while I was looking for Texas. Our apartment looked east over the brick-paved heart of our community, over the tops of the neatly planted trees and flowerbeds.

4/4/96

It's just town, whether up or down,
with or without courthouse or city hall,
a plaza, a park, some plaques perhaps;
landscaped, with monuments great or small.
Trees, flowers, and a flag, maybe two;
Options: gazebo, bench, and cobblestone,
broad walkways invite us,
architecture to delight us,
in this heart of the place we call home.

Depart with me, if you will, from a strictly factual interpretation of our nation's history (doing that makes history far more believable), and imagine some of our cocky, independent, recently English forebears wishing to remove themselves so totally from their past, aching to veer so radically from their traditions, that the following might have occurred...

"We'll show King George," said a group of early architects and planners of American communities, "instead of those silly circles we had to put up with in England, we'll put a square in the center of every town in the New World." And that's why, instead of a "Piccadilly Circus," Americans have "The Square."

Of course there were those deep pockets of resistance to change—as stubborn and hard to uproot as, well, a dandelion from the crack in a sidewalk on the square. No sooner had the well-meaning architects laid out a perfect town

5. City founders, fathers, uncles, and step-whatevers who lacked vision; or

6. "Gypsies, Tramps, and Thieves," in other words, current community leaders whose families probably made money from the sale of land to the railroad or interstate or movie company, and who possess the same lack of vision as their predecessors.

While looking for Texas, I also looked at a lot of town squares, and not merely the county seats. I compared them, large and small, saw trends, and formed an opinion or two, but I never lost sight of the fact that I was merely a visitor. Just passing through. And always on my best behavior in someone else's home, but more than willing to share my insight.

square in this hamlet or that burg, than British loyalists invented the practice of "circling" it.

A history lesson, like a root canal, works best as a complete surprise. And like one fire ant up your pants leg, enough is enough, so lesson over.

If you've got a real, live town square, consider yourself lucky. If you don't or it looks like a ghost town set from an old black and white western film, you probably have one of the following to thank:

1. A railroad, for bypassing your town in the nineteenth century, forever ensuring its smallness;

2. An interstate, for bypassing your town in the twentieth century, forever ensuring its smallness;

3. An old black and white western film production company for not tearing down their set, and your parents for taking up residence there, thinking it was a real town;

4. Wal-Mart—go figure as you circle their parking lot . . . ;

Go back to the list above. Items 1-3 need not be fatal to any small town. In fact, they can often be blessings in many ways. Thank God for tourism! Item 4, well, too many towns let

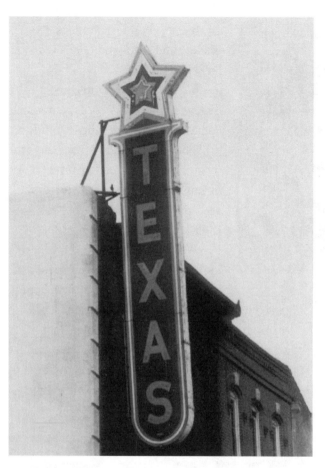

that Trojan horse in and must deal with the consequences, but allowing such a "citizen" to take up residence in your town still needn't be fatal. Fill your lovely old downtown buildings with nontraditional enterprises. Make all the things that Sam Walton's greedy progeny can't make. And get your town on the map for visitors. Thank God for tourism! Don't sweat item 5 either; except for those of us who are cloned, our parents aren't a choice. Even item 6 isn't always a stake through the heart of a community. All a town has to do is wipe out apathy and ignorance among its citizens, and poor leadership is as easy to correct as getting rid of all its fire ants and dandelions. But then, replacing today's leading brand of leaders with honest, hard-working souls who have the entire community's best interest at heart is a mighty tall order. That type person is probably circling someone else's square...

One more river to cross

Long before I began noticing the coffee-ringed aspect of my scribblings, I called the pages on which I put down my thoughts, sentiments, and put-downs *A Riparian Journal.* My several UFO sightings were logged separately, on odd-numbered pages of books I have probably loaned out, never to be returned. The notes were written in a code for which I have not the remotest cipher. All I can remember is that I headed each entry, "See X-File." Anybody out there have my books?

Born, as I was, seven or eight blocks from the Mississippi River in Cape Girardeau, Missouri; working as I did (before moving to Texas from Athens, Georgia), in a studio situated on a lovely, shoaled stretch of the Oconee River, in a damp, dank, structure of the oldest textile mill south of the Potomac River (Washington, D.C. area); and possessing, as I do, many fond memories of float trips and fishing with my grandfather on Big River, near his home in St. Francois County, Missouri, I am prepared to concede that rivers have been a major force in shaping me thus far. The "polishing" is far from complete, however, but still, a river, any river, never fails to make an impression on me...

Rivers—a progression: natural boundaries; sources of water and food; paths to follow; places to camp; obstacles to ford; reason for bridges; features to name; wriggly blue lines on maps; places to settle; commercial routes; natural treasures as recreation destinations; natural disasters as conduits of waste; Things

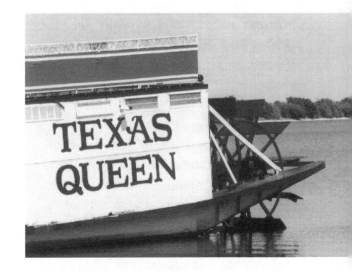

to harness and control; generators of power—one way or another.

Where do turtles go when the river is wild; have I overlooked them, high in the trees on the banks above the raging torrent? What do the fish hold on to in the flood; or do they simply go with the flow and swim back home when the waters calm?

Souvenirs and keepsakes from the rivers I've known never fail to remind me of each visit. Small, smooth stones, driftwood and mussel shells, fishing lures and colorful shards of broken glass—all chapters in stories about the element that once swept them along on its powerful shoulders or swirled them within its deceptive currents to drop them, uncaring, high and dry, like bits of treasure dropped by a careless thief.

Although I'm certain I crossed nearly every river in the state, the only crossings I

noted, while looking for Texas, were the first time I crossed the Pecos—(Loving/Reeves County line, 12/23/98; see "Wrapping up for Christmas"), and several crossings (the same day actually, 2/28/99) of the Brazos River, during which I made harassing phone calls to Commerce.

NOTE: In the summer of 1998, a good Commerce friend of mine, Jim Ainsworth, along with his cousin and a couple other companions, retraced—entirely on horseback and wagon—the route Ainsworth's paternal grandfather had taken eighty years earlier, moving his young family from near Ranger (Eastland County) to Delta County. A highlight of the trip occurred on Monday, June 8, 1998, when Ainsworth and Company crossed the Brazos River, just the way Jim and Marion's grandfather had done it. To this day, anytime Jim speaks of how inspiring the crossing was, I delight in reminding him that I and my "250 horses" crossed that old Brazos River three or four times in one day—no sweat, yet hardly all that inspiring—via wide bridges, at seventy miles an hour.

Jim knows I'd have given just about anything to make that ride. But unlike him, Marion, Charles, Jerald, and Jordy, I had a real job that summer at the *Commerce Journal*. Naturally, I assigned myself to drive out to photograph and interview them a couple of times on the trail, during which I did my usual "looking." Decatur, in Wise County, was

logged on June 11, 1998; as was the note that Ainsworth's trail cook, Charles Horchen, chicken fries the best steak in Texas.

To say that a river runs through it is rarely a completely accurate depiction of our oftentimes precipitationally challenged state, since many of the so-called rivers appear to be withering and dying, just as surely as the scraggly vegetation in some parts of the state. Although when Texas does experience periods of "normal" seasonal rainfall (twice since the last Ice Age, according to old pictograph albums and

studies done on petrified buzzard droppings), it is crisscrossed by countless rivers (you say muddy ditch, we say river here in Texas) with magical names like the South Sulphur River, the Middle Sulphur River, the North Sulphur River, the Between The North And The South Sulphur River, and the North Of The South And Middle But Not Quite To The North Sulphur River.

Texas is bounded by a couple of very famous rivers, the Rio Grande to the southwest and the Red (actually brown) to the north. Counting the Sabine, on Texas's eastern border with Louisiana, the Lone Star State has natural river boundaries against large-scale invasions by Sooners, Cajuns, and any killer bees that might be afoot from Mexico.

NOTE: Wouldn't you know it? On the only Texas border without a river (the Texas Panhandle is protection enough from Okies and New Mexicans in their right minds) and thanks to the indecisive founders of Texarkana, very low profile litigation has persisted for over a century. What's at issue is whether Texas's northeastern border extends to Memphis, or does Arkansas' southeastern border extend to El Paso...

Holy rolling

Ever wonder how many churches there are in Texas? I wish I had kept count of all I drove past looking for Texas. Nearly as many as I've attended, the way I figure. My "faith accompli" (I am a practicing Pedestrian) assures me that a person can get partial attendance credit for simply driving by a church service—of any denomination. I just didn't stop to go inside and sign the guest book or check the "visitor" box on the little colored slip for the collection plate. It's the thought...

Speaking of thoughts, I did manage a reverent one of those as often as possible during my travels. And I noted the fact when I passed through or nearby all the "holy" places in Texas—Nazareth, Bethlehem, Antioch (6),

Joshua, Jericho, Balmorhea, Hebron, Glory, Ben Hur, Paint Rock, Henderson Chapel, Bethel (4), Bishop, Gethsemane, Blessing, Israel, James (2), Box Church, Buda (close enough), Easter, Chapel Hill, King, La Gloria (2), Palestine, Zion Grove, Weeping Mary, Harris Chapel, Christoval, Church Hill, Mercedes (Benz?), Henry's Chapel, Corinth (3), Jonah, Trinity, Zion Hill (2), Corpus

Christi, Godley (close enough), Mission, Omega, Cross (2), Crown, Eden (2), Enchanted Rock, Siloam, South Padre Island, Galilee, Mecca, Navidad, Bethany, and Luckenbach.

Honorable mention for "near holy place" status goes to Joy, Sugar Land, Unity, Valentine, Purley (Bob Newsom rests there), Welfare (for my Pedestrian friends), Sunrise, Refuge, Wesley (for my Methodist friends), Mount Pleasant (2), Mount Rose/Calm/Olive/Bethel/Haven, Vanderpool (just for my family and me), Pilgrim, Sweet Home (3), Providence (2), Star, Welcome, Harmony (4), Paradise, Sweet Union, Sanctuary, Utopia, Loving, Comfort, Hope (for all my other friends), and Terlingua (for my chilihead friends).

Also, to honor the memory of my very Catholic great-grandmother, Bessie Dunkin, I was especially pious when in any community named for a Saint, a San, or Santa.

Once upon a time, while looking for Texas, I went so far in my piety as to pose the following:

What if . . .

If I had a congregation each week,
I'd pretend they were all without clothing, I think;
(I'm kidding, I know that's
not fair.)
But do I have the words, can I fashion them too
into garments that fit and they'd wear?

If each pew in the House held a very blank face,
each depending on me for Amazing Grace;
(would the blind trust a wretch
like me?)
Could I summon the sweetness to melt them as one,
or the power to part a small sea?

If I had a congregation to lead,
all those spirits to heighten and souls to feed;
(my goodness! my children?
my flock . . .)
How would I get them to listen to me,
not their stomachs and stop watching the clock?

If I had a roomful of hearts to fill,
and more than a boatload of fears to quell;
(what lessons to comfort?
my Lord!)
Should I steal a routine from "Saturday Night,"
or simply trust in the choir and The Word?

And if row upon row of lives needed mending,
would I have the strength and the faith for lending
to the unloved, the unknowing,
the lost?
(Could I really give more than all of me,
and surrender, no matter the cost?)

Thanks to The Dallas Morning News' *Texas Almanac*, a constant companion while I was looking for Texas, for the list of Places, Towns, and Cities.

Big finish

Coasting to the finish line

What a great feeling; 250 down, four to go, and I will have visited every county in the state, looking for Texas. That's the way it was as Jessica and I set out on July 9, 1999. Packed into the cab of my pickup like sardines, we were—Jessica would be spending a week with friends in Katy, so the only clothing item she left in Commerce was her ski parka—and only certain items could ride in the bed of the truck. As I would only be away for three days, I had my usual toothbrush and a change of underwear. Jessica and I took turns holding them out the window, there being no room for them inside or in back.

My plan was simple. Cover Liberty, Chambers, and Harris Counties, saving Galveston for last. Once it was done, celebrate with an admiring throng at Joe's Crab Shack in **Kemah**. Sherman marched to the sea and I felt no less victorious as we roared southward on I45. Once I even unfurled my Jockeys, banner-like, which mortified my very proper young passenger. A carload of beach-bound youngsters gave me a thumbs-up. I noticed they slowed down, and as we drove past them, danged if they didn't show their underwear. I gave them a thumbs-up. My proper young passenger was horrified, and I thought to myself, "nice act, Jess..."

I45S & FM1969E & US90E—**Liberty County** 2:57 p.m.; **Liberty** 3:27-3:35 p.m.; pecan, yes, no brick or clock; shot great Texas with longhorn on welcome sign coming into town; crossed Trinity River at 3:15 p.m.; Park Theater; Ott Hotel; no buzzards.

FM563S—**Chambers County** 4:00 p.m.; **Anahuac** 4:11-4:18 p.m.; pecan, yes, no brick or clock; shot silver Texas on green tile wall at P.O. and painted dark blue and white sign on glass door of building next door; saw nothing

about Anahuac's claim to be the "Alligator Capital of Texas"; Jessica noted that we didn't see any alligators either...; no buzzards.

Jessica and I arrived in **Katy** at Lance and Jennifer Gammill's home. When Jess checked in with her stuff (Lance and I made several trips) Jennifer only had to move a few pieces of furniture into the garage to accommodate the influx. Several margaritas for dinner, and I think we ate something... Lounged around the next day (7/10/99) until I could focus.

I10E—**Harris County** 4:49 p.m.; **Houston** 6:47-7:00 p.m.; clock, no pecan or brick; no buzzard, but lots of pigeons (Sandy, a friend in Chicago, calls them flying rats...); shot lots of images: Goode Co. Texas BBQ, Taste of Texas Restaurant, Dixie's; shot 500 block intersection of Smith and Texas Streets and The Mural by David L. & Susan Kelly-Frye c. 1993 @ Texas Art Supply—neat! Also shot battleship *Texas*; San Jacinto monument was undergoing a facelift.

NOTE: Books read across the state—make a list! Compare the total number of miles traveled to rolls of film (approx. 400, B&W and color) at 43" per roll for 24 exp. and 60" per roll for 36 exp.; how many places where I've knelt to change film—perhaps a modest marker at each site? Kodak to fund? Just a thought...

What a great feeling; 253 down and one county to go. Lance and I practiced the celebration activities so thoroughly that we didn't arise on 7/11/99 until the crack of noon. What a horrible feeling... Last minute change of plans. Better judgment prevailed. Jennifer told Lance and me she didn't believe we would survive another celebration, whereupon she suggested we have lunch at Joe's and then shoot Galveston. Lance and I humbly acquiesced. Sherman had burned cities on his way to the coast. Lance and I had simply burned out...

I45S—**Galveston County** 3:00 p.m.; **Kemah**—Joe's Crab Shack for seafood! Now that's the way to celebrate almost being done with something! buzzard, single to the west @ 3:40 p.m.; **Galveston**—on the square (Moody

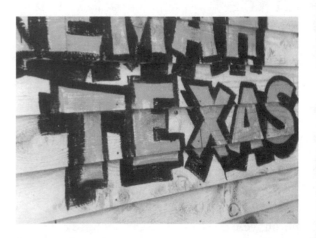

Avenue) 4:04-4:30 p.m.; no brick, pecan, or clock; shot Texas Bakery; saw *The Daily News*, Texas's Oldest Newspaper.

NOTE: What an odd feeling, 254 down and none to go; I had completed (first visits only, I assure you) looking for Texas in all 254 counties...

My companions and I headed back to Katy for a rather quiet evening. I planned to leave early the next morning to locate a famous bois d'arc tree.

Sunday, July 11, 1999—mileage 66,281.8; departed Katy 8:30 a.m. heading south; crossed Brazos River 9:03 a.m. I'll never cross the Brazos but what I don't think of Jim Ainsworth and Co. crossing it with mule and wagon and on horseback.

US90W Alt.—**Fort Bend County—Fort Bend** (second visit) shot some great old buildings, BBQ signs; Rosenberg (second visit) shot Texas St. (and Texas Ave.), South Texas

Barbecue @ 2516 1st Street "Authentic"— shot neat signs and talked with owner who feared I was with health department... Holmes Smokehouse—**Pleak Village**, Texas "A Real Texas Store"; "Taste of Texas." Shot marker and Freedman's bois d'arc (male) on Sweeney Plantation 10:31 a.m.; caught by fierce, fast-moving thunderstorm! Shot the former "A Taste of Texas," now Hardtack Café and bustling with Sunday lunch crowd; owner said he had legal squabble with someone who claimed rights to "A Taste of Texas"; he gave me a key chain with "A Taste of Texas" on it and offered to buy me lunch; I declined (don't know why); **West Columbia**—former capital of Texas—intersection of TX35 and TX36; headed north and home; noted a "road gal," Magnolia Hempstead, on I45N exit 81, FM1488.

Home again 4:23 p.m. 66,334.7 ending mileage; total miles to cover final four counties—1,037.8. What an odd feeling...

Ashes to Austin, dust to DeWitt

Judy and I decided, not long after we met and traveled to Sedona, Arizona, together, that we wished to be cremated upon our deaths and have our ashes sprinkled on all the lovely places we would visit in our lives together. By the time we had returned to

Athens, Georgia, from that trip, we had over fifty places marked on the map to receive our remains.

We were crazy in love for a while after that even, and every place on earth was beautiful and worthy of our gift, we felt. It never occurred to us until years later that whichever one of us survived the other would be pretty busy spreading ashes all over creation. What really hit us like a ton of ashes was the realization that we would each need to be about twice our present size in order to render enough of the stuff to go around. Love may be crazy, blind, and even ignorant in the math department, but we both came to our senses, geographically at least, and decided to be way more choosey when it came to selecting our favorite final and multiple resting places . . .

Turning fifty in July 1999 got me thinking about the whole scenario again. While not quite twice the size I was when I wore a younger man's clothes, I do remember his clothes

affording a bit more breathing room in the waistline. One day shortly after that trauma in July, I sat down and re-created our list of favorite places, on which many Texas favorites now appeared. Then I did the math. If each of the 254 counties got half an ounce of each of us, then adding a combined ounce for another favorite place in each of the other forty-nine states, Hong Kong, the Bahamas, Mexico, all seven Canadian provinces, Russia, UK, Tahiti, Peru, Australia, and New Zealand (plus a pinch for the Atlantic Ocean, Pacific Ocean, and Gulf of Mexico), we'd have to have a combined weight of over 500 pounds at the time of our cremation—assuming, of course, that we departed this world together (still having those romantic thoughts after all these years). What I could in no way assume was how Judy would look, tipping the scales as a whopping 325-pounder. Naturally, I had no trouble assuming I would maintain my sleek 175-pound physique—assuming I managed to drop about 25 . . . I shared all this with Judy, and you can imagine the reception I received for all my careful calculations.

Oh, I almost forgot an extra pinch for the oyster beds off Apalachicola, Florida. My

goodness, Judy's up to 326. This thought occurred to me as I was reading the dinner portion of the menu in a small café in Brady, Texas—the geographical center of the state, "The Heart of Texas"—and wondering where such a landlocked place got oysters to fry. As always, thinking about fried oysters got me to thinking about raw oysters, which got me thinking about S & D Oyster Company in Dallas. Actually, Aw Shucks in Dallas serves Judy's and my favorite oysters on the half shell, but the gumbo at S & D is my favorite on earth. And S & D's broiled snapper is, hands down, the best at any inland restaurant anywhere. I promptly made a note to myself to reroute my return trip to pass through Dallas around lunch or suppertime.

Judy added another dress size as I thought about our love for the wildflowers of our state and made a note to sprinkle us liberally over DeWitt County, which was named the "Wildflower Capital of Texas" by the state legislature in 1999.

Ooops, let out another seam, dear; we must not forget an extra ounce or two over our state's capital, although a couple more folks making ashes of themselves down that way might be like "carrying coals to Newcastle."

Now before some of you readers dash off scathing letters decrying my patent gravitational bias towards my lovely (and quite svelte, I might add) wife, you will be pleased to hear that I made that stop at S & D Oyster Company on my return from Brady and points south. Admitting that I could never resist frequent visits to S & D for the world's best gumbo, plus an occasional sampling of the incomparable onion rings and outstanding brisket at Sonny Bryan's, and lunch, as often as I can manage, at Johnny Orleans—all of which would no doubt affect yours truly's portion of the ashes' bottom line, I decided to adjust the numbers. Besides, 180 pounds looks good on me. Well, gotta go; off to Dallas to fatten up the roommate. Write or call for progress photos . . .

Pickup artists

There are three categories of pickup truck owners. Each category determines how the truck will be used, which in turn determines the types of things most likely to be found in the truck bed. Government statistics* claim that half the litter on Texas's highways flies out of pickup beds; therefore it follows (I picked up the trail, at any rate) that the variety of litter in Texas can be predicted. And as any pollster will attest, if something can be predicted, there's a group or individual somewhere who will consider it akin to what blows out of the bed of a pickup...

The first category of pickup truck owners is the folks for whom pickup trucks were invented in the first place; they're hard-working people, who, in pursuing their chosen profession, actually need to haul more stuff than will fit in the family vehicle—like several bales of hay, or merely different stuff than one would normally haul in the family vehicle—like a bull. Of course cattle and horses are usually transported in a trailer that is hitched to a truck. It should be noted that category one pickup truck owners keep the entire world's custom trailer manufacturing industry afloat. It should likewise be noted that oftentimes the pickup *is* the family vehicle. In those instances, through a series of complicated social negotiations, often weather dependent, a large dog (or several) may or may not have the entire truck bed or toolbox perch to himself, should the wife and/or kids choose not to ride in the cab. Has anybody ever seen any family's cat riding (uncaged) in the pickup bed?

The most common objects otherwise found in the beds of the first category of pickup owners are: paper sacks, drink cups,

sandwich wrappers, receipts, windshield flyers from parking lots, and cheap windbreakers (the most prevalent litter items up and away, out of the truck bed, and onto our roads in less than a block from the DQ, Wal-Mart, or Brookshire's); feed and fertilizer sacks (2nd most notorious litter agent); baling twine (another very

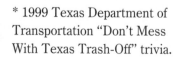

* 1999 Texas Department of Transportation "Don't Mess With Texas Trash-Off" trivia.

common litter item); empty aluminum drink cans, crushed or intact (uncrushed, these items can contribute to highway litter); gloves (for some unknown reason, only one will blow out); coolers (an empty Styrofoam cooler is a natural kite, but what good is an empty cooler anyway? The heavier plastic and metal versions will usually stay put, empty or full); drink bottles; plastic jugs (rule of thumb: full-sitter, empty-litter); shop towels (kiss 'em goodbye and watch 'em fly); deer stand and related paraphernalia, such as feeders, ladders, etc.; propane tanks; cookers and smokers, often of a scale to be pulled behind the vehicle; containers for gasoline and kerosene; antlers, skulls, and other "found" artifacts; various buckets and other odd, empty containers; cans of oil; toolboxes, attached and portable; various loose tools, hand and power varieties; sections of pipe and lumber; tree limbs; suitcases; spare tire(s); fishing rods, tackle boxes and minnow buckets; tarps; anchors; paddles; boat seat cushions and toy floatation devices (adios, they go in a heartbeat); lawn furniture; muddy boots—different from the rubber ones which are placed soles-up between the bed and truck cab, like some guy was caught there as a dragonfly might be captured in the front grille; coils of rope and wire; fence posts; odd bricks and concrete blocks; lengths of chain, cable,

and hose; and the ever-present generator, which the stiffest Panhandle Norther or West Texas mini-cyclone can dislodge, just before the Australian shepherd or catahoula becomes airborne.

Given the undeniable fact (and the unofficial survey results above) that category one pickup truck owners undoubtedly contribute over 97 percent of the litter on Texas's highways, it is likewise to the credit of members of this category that not only have they been observed collecting their own roadside litter wherever it occurs, but also that of others (see article on "Yard sales"). An unsupported theory suggests that obviously the government survey guys manage to drive through any target survey area on a Monday or Tuesday (they crunch the numbers and do the paperwork the rest of the week). Duh. Don't they know that yard sales occur on weekends, and that serious "gathering" takes place the latter half of the week? The unsupported theory goes on to postulate that 97 percent of Texas is litter free Wednesday through Saturday at sundown...

Aside: Speaking of serious gathering, an artist friend of mine started a sideline business once, where he went around small towns throughout the state, taking Polaroid pictures of the contents of pickup truck beds. He then attempted to sell them to the owners. He was

severely beaten early-on in this venture by unknown assailants outside a small South Texas watering hole and decided to go back into making sculptures from pieces of tire tread he collected from alongside the highway. He gathered them in his old pickup (see "found" artifacts, above) and called them his "roadside abstractions." When he discovered that New York dealers were buying them and reselling them overseas, he tripled his already considerable prices. Then the gallery owners from Dallas and Houston began buying all he could turn out. The New York dealers still come to his studio, dressed in designer jeans and boots, some even attempting a swagger and drawl. He can spot them a mile away. Their pickups are rentals...

Where were we? Oh, yes, the second category of pickup truck owners are people who think they might need to haul more stuff than will fit in the family vehicle, but rarely ever do. The family vehicle is overpriced, but trendy.

This category of owners is why pickup truck consumer marketing divisions were invented and why they once flourished. Alas, this is also becoming the rarest of the three categories, its population having shifted into ownership of the product they may have invented for themselves—the so-called Sports Utility Vehicle (SUV), or "pretend truck." These vehicles are generally enclosed and who knows what's in the back; just watch out for the Spoiled Operating Brat (SOB) up front...

Category two pickup owners often are retired from category one professions and truly enjoy driving a pickup truck. Thus the contents of the bed are generally of a more temporary and recreational nature—fishing tackle and the like, although they occasionally do have more semi-permanent items in the bed of their trucks, like campers and seasonal floats. I include myself in this category, and although I've never had a category one profession, my '95 Chevy Silverado suits my transportation and hauling needs perfectly. If I were into vanity plates, mine might read, "Wrtrs Crft."

This second category of pickup owners has been known to contribute little more than the occasional small cooler, boat seat cushion, or Land's End parka to the milieu of roadside litter. On the other hand, members of this category, like the first (although stirred to action by a completely different motivation), also stop and retrieve litter. Some, who have "adopted" a stretch of road in their community, are placing a whole new genre of stuff in

the backs of their trucks—big, black trash bags of what else but litter. Truth be known (heaven forbid any government findings of a positive nature), category two owners of pickups probably pick up an amount of litter far beyond what blows out of category one's pickups. Y'reckon?

Which brings us to the third category of spurious pickup truck owners. Sadly, members of this category most often cover the beds of their trucks with specially designed products in order to place speakers in the backs of their vehicles. They otherwise change the entire character of a pickup truck by elevating it to dizzying heights with huge tires and drastic alterations to the frames and axles. Or else they cause their pickups to ride so low that they wouldn't clear a respectable cow-pie.

It would seem that most members of this third category have chosen pickup truck ownership simply due to the fact that semis, busses, and vans are generally more expensive to over-accessorize and customize. Category three pickup owners require and demand a vehicle with more surface area to polish and on which to tastelessly paint and decorate. They rarely carry anything other than adoring fans and accomplices in this effrontery.

Instead of the regular types of litter, members of category three broadcast another type of pollution from their pickups—the audio and visual variety. Unfortunately, this kind of litter is under far less

stringent regulation. In fact, beyond minimal enforcement of local noise ordinances, good taste, and common courtesy, there is little control whatsoever over this type of stuff on our streets and roads.

I didn't intend for this little piece to turn out lecture-like, and I'd just like to end it on a positive note. Whatever it takes, let's all work to put a stop to senseless littering of our streets, roads, and highways. Put something heavy—the wife or one of the kids, if necessary—on top of that stuff in the back of your pickup, neighbor. Of course we can't do much about those category threes, but we can sure salute those hard-working members of category one. Patronize their yard sales and maybe even pick up that occasional feed sack or spit

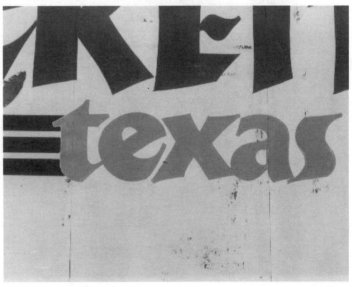

cup. And by all means, give anyone you see out picking up our roadsides a toot and a wave if you can't stop and help—even if you don't drive a pickup ... 🤘

Time keepers

Care to bet a cold drink and a brisket sandwich there's at least one clock on every square in Texas?

Every time I entered a town square on my travels, I made that bet with myself, actually multiple bets—clock or no, how many, working or not—and when the results were tallied, I owed myself over twenty-five brisket sandwiches, etc.

"Till like a clock worn out with eating time,
The wheels of weary life at last stood still."

John Dryden, *Oedipus*, [1697]

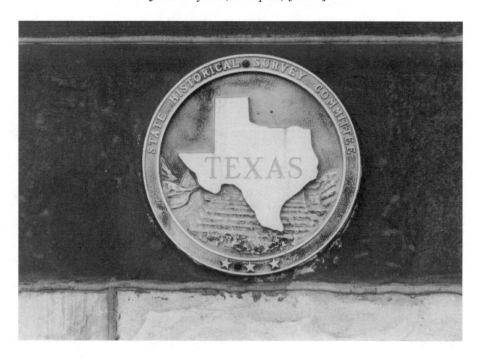

Between my trip notes and Drs. Kelsey and Dyal's *The Courthouses of Texas*, the definitive work on the subject of those structures in our state (Texas A&M University Press), only 59 of the 254 county courthouses have clocks. By the time I began keeping track of that particular statistic, I was about halfway through visits to all 254 county seats, but as far as my notes and later research go, just a handful over half of the 59 show the correct time. The rest "keep" time, but they keep it to themselves, because they no longer work, or else they keep their own time—ahead or behind the correct time. Such knowledge might indeed earn

you lunch on a bet, but that is hardly the most interesting aspect of my "timely" discoveries, as you will soon see.

Speaking of time, in 1968 Andy Warhol said, "In the future everyone will be world-famous for fifteen minutes." If Andy were around today (he's been, shall we say, "working on a larger canvas" since 1987), I would ask him just when in the future, in order to prepare. Actually, I can't shake this nagging suspicion of late that my fifteen minutes may have been pirated by some cosmic computer hacker and given to, say, Bart Simpson, Monica Lewinsky, or someone else who deserves only fifteen nanoseconds of world fame, if that long. According to a recent NPR piece, the source of the quote is in dispute, but the sentiments are sound, "prediction is difficult, especially when it's about the future."

Time out: On Friday, March 8, 1996, I parked on the square in Kaufman and waited with the rest of the traffic as a midday funeral procession snaked through downtown. Hell of a lunch hour, not to mention something to really sour a weekend, I shared with my journal. The clock on a former bank building on the square (none on the courthouse) also waited (it no longer worked). In every sense, time was frozen on the square, as somone's dearly departed departed from it.

"Time is dead as long as it is being clicked off by little wheels; only when the clock stops does time come to life."

William Faulkner, *The Sound and the Fury* [1929]

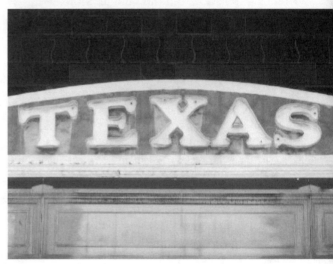

Remember the movie *Back to the Future* and how central to the plot was the stopped clock on the courthouse? Well, Texas has several lovely courthouse clock towers with stopped clocks in them. Like huge, unblinking eyes declaring smugly, "It's 4:20—forever!" The first time I encountered one of these "temporal anomalies," as I call them, was in Lockhart (Caldwell County), 4/29/98. After

that, I began making note of 1) whether or not a courthouse had a clock(s) and 2) did it/they work?

On Wednesday, April 29, 1998, I entered the square in Lockhart at 11:19 a.m. (hardly an accident to arrive so close to lunch, but rather the ideal time to visit the "BBQ Capital of Texas") and noted that three clocks were stopped at 5:30 and one was stopped at 5:24. Begged the question, "A.M. or P.M.?" The situation also presented a technical dilemma, perhaps even a cosmic one; if all four faces of the clock run off the same mechanism, how can they not all stop at the same instant? Call Agents Scully and Mulder...

NOTE: I'm very pleased to report that Lockhart's lovely National Register-listed courthouse has been completely renovated and the clocks brought up to speed as well. About time, everyone in town says...

Another "temporally challenged" courthouse presented itself in the very next town I visited that day in 1998, Gonzales, in Gonzales County. All four clocks were stopped at different times: 12:32, 5:49, 2:27, and 6:13. I made a note in my journal to get a copy of the text of a lovely poem, titled "The Old Town Clock," by Robert Lee Brothers. It was printed on a plaque on the square in Gonzales.

"Unconsciously we pause to hear
The old clock's throaty chime.
It knows our family secrets
But it only tells the time!"
Robert Lee Brothers, "The Old Town Clock"

When I was writing this piece (is it not a "time piece?"), I obtained the number from Marti Macias in the Gonzales County Clerk's office and made a call to the Gonzales Chamber of Commerce and Agriculture.

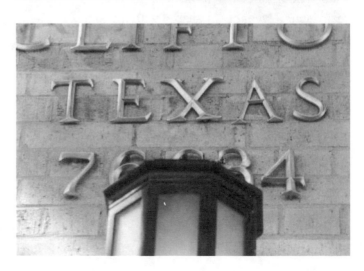

"You can fool some of the people all of the time,
and all of the people some of the time,
but you can not fool all of the people all of the time."
attributed to Abraham Lincoln

Now, I have often called other chambers in other towns and will not in these pages embarrass anyone. Suffice it to say that my queries, regarding this or that bit of information, have fooled some of the residents of some of the towns, some of the time. Not so with the very helpful and very congenial Bradley Avant in Gonzales. She had information to spare and proudly shared it, faxing me, the same day, a copy of Brothers' verse and some background on this poet, known as the "Prairie Laureate" of Gonzales County. She said that the 1896 vintage Seth Thomas clock (four faces) was working and chiming as good as new, thanks to the efforts of a team of experts (who worked on it from 1995-1999), and in spite of the "curse."

"Excuse me, Ms. Avant," I said, "did you say 'curse'?" She then told me that a man named Albert Howard was the last person hanged in Gonzales on March 18, 1921. The following is from a town history document sent by Ms. Avant:

"A legend persists that while Albert Howard was in jail, he paid strict attention to the clock on the courthouse to keep up with the number of hours he had to live. He swore that his innocence would be shown by the clock and that none of the four faces would ever keep the same time." (Ms. Avant assured me

that was indeed the case until the recent repairs.)

So, perhaps the questions that were raised each time I had seen clocks stopped on a town square are worth pursuing: When did the clocks stop, and how, in some instances, could the faces have been stopped at different times? Are there other curses in other towns? And if I were to undertake another series of journeys to photograph and document the existing town square clocks in the Texas county seats that have them, could I call myself a "time traveler?"

When I called a number for some Shelby County office, a cheerful (it was a Monday) Peggy Hutcherson answered and said she was up to the task of obtaining some information regarding her town's clock. She called me

back, only minutes later. She had walked across town (not a very long walk, Center is a pretty small place), having verified that her town's clock was "two-faced," as she put it—in more ways than one. I instantly dubbed her my most capable research assistant in Shelby County.

The clock in Center is not attached to the courthouse, but is on a stand-alone pedestal outside an entrance to the building. The new courthouse in El Paso has a separate clock also, but with four faces—the one in Center has two, each with a different time: 10:07 and 4:15. Peggy was very thorough. She said it hadn't worked in years, though everyone in town wished it did. She proudly noted that the courthouse had just undergone renovation, but not the clock. "We're so proud of our courthouse," she said.

Peggy knew nothing of any curse on the clock in Center (other than age), although she said there had been a hanging tree in town that had died and been cut down in the past fifteen years or so. She suggested I travel to all the county seats and photograph any hanging trees I found. What, another travel project? I told her honestly, I had no idea where I'd find the time...

Editor's note: Rick already is working on another "time piece" and might be "hanging" around Texas town squares again soon, for other reasons. ✦

Post partum and everything else

Carrion baggage

Buzzards. The word always reminds me of a story that a friend, who was living in Terrell County at the time, tells about his dogs. When one of the animals didn't come home with his kennel mate one night, my friend spent the next few weeks searching the desert around Sanderson—and the desert skies, looking for circling buzzards. He never saw the buzzards, but eventually he did find the body of his dog, which he buried on the side of Sanderson Canyon.

A week or so later, an eyewitness cleared up the mystery of the dog's demise: After sustaining severe injuries in a confrontation with javelinas, the two dogs managed to find relative sanctuary on some railroad tracks. Whether in shock or unable to move due to his wounds, the one dog did not respond as the engineer of a slow-moving ore train rounded a curve, saw the animals on the tracks, and began sounding the horn. The second dog was tossed from the track by the front of the engine as it crushed his companion. Bloody and badly hurt himself, he limped home. The second dog recovered from his ordeal, but within a few days of the desert interment of his buddy, a rare flash flood inundated Sanderson Canyon, removing every trace of the grave. But that's another story...

While looking for Texas, I also spent a fair amount of my time looking for buzzards. Even made buzzard-sighting notes in my journal. All to support this theory I have that at any given time, on any given day (foul, fowl-flying weather notwithstanding) at least one buzzard is wheeling aloft over every county in Texas, just trying to catch a particular fragrance on the ever-present breezes we have here in our state. Go ahead, snicker (or gag) if you must, but I have enough verified sightings and even some lofty statistical verbiage to convince any skeptic.

Ever run across the term "*Poisson distribution?" Well I did, and in doing so I probably saved the government big bucks, as I was just about to apply for a grant to prove my theory. Briefly, this guy Poisson (I think that's French for "fish," which makes sense, since his calculation could apply to locating them as well) came up with "a frequency distribution that may be regarded as an approximation of the binomial distribution when the number of events becomes large and the probability of success becomes small." Now, if that doesn't prove my theory, nothing does.

Then there's my "buzzard-sharing" corollary for West Texas. It deals with the fact that given those see-dust-from-a-tumbleweed-on-the-horizon-for-days, wide-open spaces out there, one is never quite sure precisely over which county one is espying a particular buzzard a-flying. Also, buzzards do appear to be somewhat scarcer out that way, so sharing certainly is in order. This little wrinkle in my theory hasn't been completely ironed out at present, and I might have to get a government grant after all. I'll be needing to capture a few members of the West Texas buzzard population, band them, and outfit each with one of those global positioning system gizmos, most likely in suppository form, from what I understand.

You know, now that I think about it, thanks to Mr. Poisson, I'm actually pretty well satisfied with my theory as it applies to East Texas. Why should I hog all the choice research? Yeah, let someone else have some fun. Time to pass the gauntlet, I say. Or the barf bag...

**Webster's New World Dictionary of American English*, 3rd College Edition, 1988. 🪧

Hook, line, and thinker

The Tennessee Valley Authority (TVA) was created by Congress in 1933*. Over the next sixty years, fifty dams were built along the Tennessee River and its tributaries, changing the entire region, radically and efficiently. Congress did that? Radical, yes, but, efficient? Our U.S. Congress? Is anybody going to believe that, simply because the *World Book Encyclopedia* says so? Not me.

I have an alternative theory which posits that the TVA actually began as some top-secret genetic experiment gone awry, creating a strain of mutant, humanoid beavers. Which dots are easier to connect: fifty dams and beavers, or Congress and a success story like TVA?

Beginning in 1935 with the creation of the Rural Electrification Act (REA), rural Texas and the rest of rural America began to change for the better. President Franklin Delano Roosevelt established the REA by executive order

* *World Book Encyclopedia*

to Congress, thanks in large part to Speaker of the House of Representatives Samuel Taliaferro Rayburn, who co-authored the bill and worked tirelessly for its passage.

Both TVA and REA dams created lakes; and those lakes created two things directly—power and fishing holes. That's important because this is a *fishing* story, in every sense of the word, with only the names changed to protect the story.

Lake Fork, located in the corners of Rains, Hopkins, and Wood Counties in East Texas, is the best lake in Texas for largemouth bass and one of the premier lakes for that fish in the country. Construction of the lake began on Lake Fork Creek, a tributary of the Sabine River, in the early 1970s, and it was stocked with Florida largemouth bass in 1978. Lake Fork has a total surface area of 27,690 acres and probably an impressive length of shoreline and number of gallons of water, but who cares? Certainly not the fishermen; to them, the most important statistic is the one touted in all the

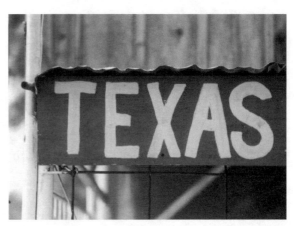

149

literature promoting the lake: "34 of the top 50 Texas State Record Largemouth Bass have been caught at Lake Fork Reservoir, including *the* state record, a whopping 18.18-pound lunker."

Getting on a (public) lake in Texas is easy. There are over 6,700 of them. For the serious fisherman, however, getting off a lake is the problem; particularly when the job or the wife can be put aside, when the beer is cold, or even when the fish are biting. I'm a serious fisherman, when I can afford the time, and I know about these things. I know that fishing is a disease to rival golf, stamp collecting, or yard work.

What I discovered, just outside Quitman (Wood County), "Big Bass Capital of Texas," and must share with you here, will damage my credibility as a fisherman if I don't tell you that I generally fish with artificial bait; lures, plugs, jigs, spinners, and the like. Beyond sacrificing a school or two of minnows on occasion, and drowning several cans of nightcrawlers as a boy, I have had scant experience with live bait. Also, my mind was nowhere near the subjects of fish or fishing during my visit, so I really was not in the right frame of mind to deal with the series of events I am about to relate.

It was on a Saturday afternoon in March 1996. I was paying for some gas and a cold

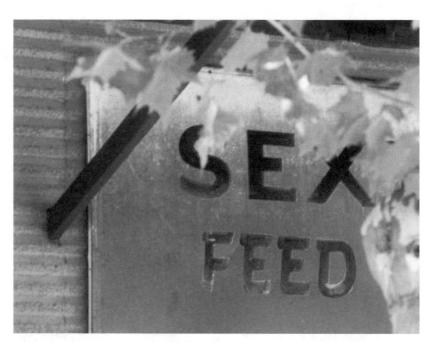

drink at this small service station/grocery store/curio stand/gossip corner/bait shop, when I overheard some guy ask the lady behind the counter for some "reds."

Needless to say, my ears perked up and I thought I was going to witness, firsthand, an honest-to-goodness, grass roots, middle-of-nowhere, East Texas, over-the-counter drug deal. The lady gave me my change (did she wink wickedly, or did I imagine it?) and walked calmly towards the back of the store, just as another customer called after her, requesting some "pinks" or "jumpers."

Good heavens, I thought, these folks are certainly bold, brazen, or blind not to recognize that a total stranger was in their midst while they were ordering their drugs as nonchalantly as anyone might order a burger and fries to go.

Well, to say the very least, I was uneasy by this time, but I was not about to leave and miss the complete transaction. My truck was just a short sprint away; I didn't feel particularly threatened, and figured I was pretty safe as long as I didn't make any sudden moves. No one "official" or undercover appeared to be hanging around, ready to bust these blatant dealers. What the heck, I thought, maybe this is legal around these parts.

Suddenly, oddly, I was comfortable with what was going on. Who was I to judge these folks? Too much television, I thought to myself. These were sensible adults, obviously into a little recreational use of one controlled substance or another, and it was none of my business what was going on.

I was just curious I told myself, and it was not like they were going to sell the junk to kids, right? Wrong. Just then, a boy of ten or eleven banged open the screen door, jingled the little dangley bell, and made me jump a foot off the floor.

"Katie, got any 'blues'?" he asked.

"Comin' right out," came the lady's voice from the back of the store.

With that, everything changed, and I had to leave that terrible place. I heard the bell behind me and the sharp slap of the screen door. My truck engine sprang to life, and though my wheels spun to match my thoughts,

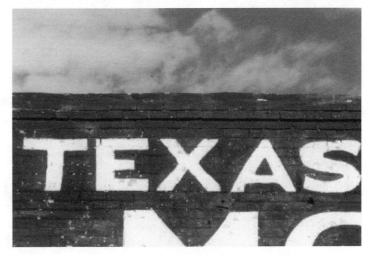

I managed to get safely out of the lot and into the street, headed for Gilmer in Upshur County.

I pulled into a quiet little restaurant-looking place near Rhonesboro, as I recall, for a cup of coffee to settle myself. There were few other customers, no evidence of other than food-related activities, and I was well down the road from that "drug den." I began to relax a bit.

As I sat there grappling with what had happened, sipping a second cup of coffee, one of the locals came in with some photos to show the cute waitress. I heard him bragging on the largemouth he had caught earlier in the week, over at Fork, with some "jumpers." I think I blushed as the realization hit me, but I recovered in a sip or two. "Ever catch any on 'pinks' or 'blues'?" I asked the proud angler.

"Sure," he said, "but give me a 'spring lizard' around here for the real 'hawgs.'"

I finished my coffee and watched the waitress for a minute, as a verse began to form in my head. The next morning, at home, over coffee with Judy, I related the story of my experience with the "annelid dealers" of Wood County. As she usually does, she made me feel better; well, sort of. She was thankful I hadn't tried to make a citizen's arrest...

Soap operation

Ever wonder what becomes of what's left of that "Barbie doll" sized bar of soap from your motel room shower or bath? Now maybe some folks use up the whole thing in one scrubbing, but I've taken a bunch of showers in all my years on the road, and there's always at least half a bar left (most often in two or three pieces) when I finish the job of removing the day's travel grime. Maybe some frugal folks even take the leftover scrap home. That's cool, they paid for it, but personally, I look forward to getting home to my very own, favorite fragrance, real human being-size bar.

So what does happen to all those little slippery slivers of strange smelling, off-brand barlettes of barely lathering pseudo soap? Might some frugal lodging proprietors collect them for personal use, or does housekeeping have that angle covered? Is there perhaps a wholly untapped opportunity to develop a soap recycling industry and save goodness knows how many hapless horses in the process? Just imagine a fleet of little trucks shaped like bathtubs going from B&B to this inn and that lodge and

even those high-dollar chain suites and homes-away-from-home, collecting the stuff. Hey, given that 1998 statistics from the Texas Department of Economic Development, Tourism Division* show the state had 58,085,000 lodging nights, that's a lot of soap scraps to simply toss.

And if the lodging industry already is realizing revenue or any other benefit from the material (which their guests have paid for), then perhaps a rebate of some sort is in order. It could be as simple as returning the unused portion at check-out and receiving a small deduction from that whopping bill. On the other hand, considering how the American business mind operates on a basic reluctance to give back money already received from a customer, under any circumstances, if a big deal was to be made of the situation, the lodging owners' lobby would most likely just arrange for all the soap manufacturers to make even smaller bars …

* Thanks to Sarah Tumlinson-Page, TDED-Tourism, for the stats. 🪆

Retired wildlife photographer

It's still a hobby. Probably never will get completely out of the habit of photographing critters. Of all types. Wherever I can find 'em. It was a specialty once upon a time, but now I rarely have the time.

To establish a little credibility for my background as retired wildlife photographer, I am proud to have photographed quite a broad range of species before moving to Texas, where, if I may say so myself, I got some really drop-dead specimens.

Here's a rundown of some of my favorites:

Not every retired wildlife photographer can boast both a trophy whitetail (Minnesota) and mule deer buck (Texas), each in exquisite surroundings—the whitetail posed beneath a very moody sky, and the mule deer with the Texas Panhandle Plains stretched out beyond it. A nice image of a red fox and one of a beaver also came from a Minnesota trip.

A hen pheasant made a dazzling flight out of sparse cover just before I captured her portrait one very overcast morning in northern North Dakota.

Next to dramatic clouds, there's absolutely nothing like mountains to enhance any photographer's composition. The Colorado Rockies provide a breathtaking backdrop for my shot of a yellow-bellied marmot, and the distant snow-capped Beartooth Range almost embrace my snowy porcupine close-up outside Absarokee, Montana.

Downwind is the only way to approach a skunk, as I did near Pagosa Springs, Colorado. A raccoon from outside of Peever, South Dakota; a cottontail rabbit near Ponder, Texas; and a gorgeous indigo bunting from St. Francois County, Missouri, round out my favorite images, pre-looking for Texas.

Just let me say, and proudly, that Texas is pretty much the end of the road, as far as this retired wildlife photographer is concerned; such an infinite variety of subject matter. And it's more than fitting that my all-time favorite armadillo and wild hog images are from Texas, although my best coyote photograph was taken in Mississippi, near Meridian. I haven't managed to capture a roadrunner as yet, one of my favorite creatures to watch in the wild. No rattlesnakes, either, but Walter and Ruth Franklin have promised to help me find some the next time I visit their spread near Llano.

The choice simply had to be made, and in the end, looking for Texas and wildflowers is much more important to me than retired wildlife. Although I certainly do get a passel of oohs and aahs (or similar sounds) whenever I show my retired wildlife photos to a prospective client. And then after that initial shock, they usually agree, "retired wildlife photographer sounds a whole lot better than saying I shoot road kill."

Now lest anyone get the wrong impression, I've never photographed anything that I myself have hit. I even revived a mongoose

Speaking of perilous places in which a creature might place itself, in all my miles (nearing one million), I have squatted, knelt, sprawled, and stood alongside or in the middle of interstates and dirt roads to record these "tragedies in transit." My wife swears I'll meet the same fate as my subjects, but I assure her that is an unlikely fate for an intelligent creature.

Personally, I feel sorry for those unknown, unsung critters and have become an activist of sorts for their "right of way,"

(how's that for exotic?) that I bumped with an old '63 VW while I was in the Air Force, stationed on Okinawa.

Of course, road kill per se is not a pretty story, but it is most definitely one that must be told. Everyone hates to see it, but everyone looks. And while most drivers truly hate to hit any animal, it is, after all, a concrete jungle out there on America's highways and byways, where the unspoken rule of the road is "dodge or be Dodged."

To begin with, my photographs are not what you might be imagining. I do not picture the bloated, the flattened, the smelly, the sun-dried and mummified, or the unidentifiable. Nothing gory and nothing gross. In fact, without exception, my subjects appear to be in a quiet, peaceful state of repose, as if each had decided to take a quick nap, albeit in an unlikely and unsafe place.

albeit posthumorously. As a Chronicler of Concrete Casualties, my road kill portraits—real "traffic stoppers"—have been touted as a collection of Roadside Abstractions, what one critic referred to as "a body of work [pun intended?] which serves to commemorate an unfortunate but unavoidable aspect of travel." He went on to add, "Vanderpool's photographs may even be considered a celebration of the fragile balance of life, the impact of which [pun intended?] might actually move some viewers to slow down and let other creatures enjoy their share of the road—without becoming part of it."

We all should do as the signs say and "give 'em a brake." If you can't, at least respect the right of way of the clean-up guys—the buzzards and crows—they gotta eat too. And they've never been told there's no such thing as a free lunch. In truth, most audiences do

find my images quite tasteful. You might find that word hard to swallow in reference to road kill, but a friend actually sent me a menu and T-shirt once that touted a place called "The Road Kill Café." Can you imagine that? What some people won't dream up…

Problem Solving 101

Breakfast is most definitely the most important meal of the day, but nutritionists have only half the story. Business is discussed over lunch—with or without martinis—and deals are consummated during dinner (families have supper), but all the really big problems of the world are solved at breakfast. Or else, suspended piñata-like, the major bafflements of the day are likely to be way too battered to offer much resistance for the lunch crowd...

Holding forth at breakfast in Bandera

The old guy at the corner table was wearing camouflage, but everyone in the cafe could still see him, and everyone within five blocks could hear him.

Five guys at a table for four were leaning in and talking low—a conspiracy, no doubt.

Nine gray heads in the far corner—that's where the real solutions were formulated.

Every customer, coming and going, spoke to the expressive and talkative little blonde girl in the pink nightshirt at the table near the cash register. Her only problem was convincing the lady seated with her (an aunt perhaps; a mother would likely not tolerate such antics so early of a morning), to pull her golden hair back into a ponytail, which the little girl took down after about thirty seconds.

A shabbily dressed woman came in alone. She may have been pretty once, before a cigarette became a permanent fixture on her frown, and at least a hundred pounds ago. She snapped an order at the waitress and looked around the place. If anyone knew her, or vice versa, it wasn't obvious.

Aside: Do real cowboys drink decaf?

Sounding off in Sanderson

Listening shows a certain amount of respect for a speaker. So does polite laughter or a simple nod of the head and affirmative grunt at the proper time.

Monte Goode had recently returned from a school board member workshop in Corpus Christi, where he had been asked why residents didn't water their yards in Sanderson. He said he replied, "It's kinda tough to water 15,000 acres with a goddamn water hose." Each of the six men sitting with him burst into loud laughter. He lowered his voice for a bit and I resumed my note making. There was intermittent laughter, with some of the other men adding to the conversation.

Upping his volume again, a few minutes later, I overheard Monte say that he was

surprised he or any of his friends lived past twenty-five years of age. "If it wasn't crazy or dangerous, we didn't do it," he said. His companions made comments, almost in unison, agreeing with his observation.

Aside: Is a "rasher" of bacon three slices or four?

Long distance in Weatherford

One old gentleman sat at a table for four. It was obvious he was a regular as he ordered coffee and greeted the waitress. He nodded to the only stranger in the place—me. A few minutes later another fellow, roughly the first man's age, came in and also sat alone at a table for four on the opposite, far end of the place. He too ordered coffee in a way suggesting he was well known by the waitress—and the man across the restaurant. They struck up a conversation that lasted longer than my stack of pancakes, and it never occurred to either of them to move to the other's table. Though

squarely in the middle of their conversation, I offered not a single word, nor was I asked to.

Aside: Is a reference to one's head being stopped up "tighter than a bull's ass in fly season," suitable material for a breakfast conversation broadcast?

Appetites for discussion in Brady; sounding board in Commerce

Should certain problems be tabled at breakfast, they are most likely to be next taken up on tailgates let down...

I couldn't help but overhear a rather heated discussion during breakfast at the Club Café in Brady. I finished my meal a few minutes after the table of locals had adjourned to the parking lot where, between two pickups, the conversation continued. When I drove by the lot, several minutes later, after I had driven to the square to shoot the courthouse, the meeting was still in progress. And if all the arm waving was any indication, the issues being discussed were still sensitive ones.

Issues are devoured later in the morning as easily from the back end of a pickup as were the eggs, bacon, and hash browns from the sturdy café china earlier. Picture one speaker with a leg up on the tailgate or bumper, another seated thereon, and one or more lookers or talkers, with arms draped over the sides of the truck bed—now an amphitheater for the whole performance.

Bob Grove (Hunt County) said he once invited a couple of inquisitive strangers to "step into his office," whereupon he curtailed his cattle feeding activities, walked around to the back of his old Ford, and dropped the tailgate.

Aside: Which has the best acoustics, the bed of a Dodge, Ford, or Chevy?

Point-Counterpoint outside Alice

Fences and gates sag from supporting generations of problem-solvers all over rural Texas. Likewise, front steps, back steps, porches, benches, and stools in towns of every size in the state show the wear from the burden. Agendas smother creative thought and offices restrict it, unlike a pitcher or two at a back table in a local watering hole, or a bottle passed around a campfire in full view of countless blinking witnesses.

Aside: Anyone know the derivation of the term, "get a leg up on a situation?"

Checkers in Center

Quite a little crowd was gathered to watch the game on the square, under the gazebo, in the shadow of the Irish castle replica, Shelby County courthouse. As always there were players and there were the lookers-on.

Aside: Only a couple of old fishing buddies will plug away at a problem that others won't even nibble on.

One-on-one near Blanket

The pickup was parked on the highway side of the cattle guard at the open gate. The man was half reading the letter he held with the rest of the mail in his left hand and reaching out with his right one to the small calf that was stretched so far forward in the man's direction that another inch and the creature would fall on its face. Only a foot or so separated the two. Whether or not the calf's mother, standing nearby, uttered a warning or encouragement, the calf shot a quick glance in her direction and bolted the next instant. I saw

all of this in the seconds it took me to pass the scene.

Aside: First rule of problem solving: grab the sucker by the horns...

City commissions and town councils meet monthly and accomplish nowhere near what two or three old boys can get done in an hour, "kickin' dirt," as Ken Bishop's (Fairlie, Hunt County) grandfather used to say. More projects are born or ended over well-worn checkerboards on rickety tables; more deals are made or broken in a ring of ladder back chairs, tilted on two legs around a potbellied feed store stove, than at the fanciest conference table in any boardroom; projects, deals, and solutions to problems that affect families, friends, and neighbors—real people, not bottom lines, paper profits, and nameless, faceless shareholders who might sell their interest with a few keystrokes or a phone call—over breakfast...

You know

Any road worrier worth his/her salty beef jerky and bottled water knows the signs.

You've been on the road too long when:

You don't feel sorry for "suicidal" possums and armadillos.

The skin on your left arm is forty years older than the rest of your body. Except for your "spare tire."

You actually enjoy eating at Flying J and Petro, even when you're not on the road.

A fading radio station feels like losing an old friend. In fact, you'll turn up the volume until the static etches the inside of your windshield.

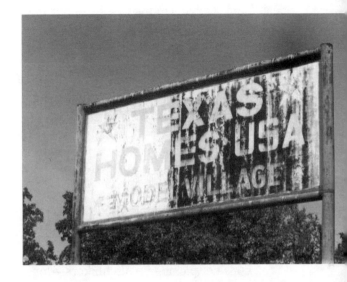

There are things you only do (well) in a truck stop restroom. One of them is shop...

You can drive equally well with either knee.

Reading bumper stickers on other vehicles causes you to miss turns and exits. Speaking of bumper stickers—you take them personally, believing them to be some higher form of communication, and deeply resent outdated ones for political candidates who lost in national elections.

Wendy winks at you.

You argue with road signs, and lose.

You have more stuff in your vehicle than you have at home. You have so much stuff on your dash that you have five fifty-pound bags of sand in your trunk just to keep the rear wheels on the ground. A passenger sustains a concussion when twenty pounds of receipts fall on her head from behind the visor.

You allow the graffiti on bathroom walls to upset you.

You ask your (non-smoking) significant other to waft cigarette smoke in your face so your eggs taste "normal" during breakfast at home.

You contribute to the graffiti on bathroom walls.

You imagine nipples on the peaks of the golden arches.

You consider a Dr Pepper and a Snickers "fast food," Burger King is "dining out," and Wendy's is a really big culinary experience.

The monthly payment on your vehicle is four times that of your residence.

You correct spelling and grammar of the graffiti on bathroom walls.

You install an air-dryer, a prophylactic dispenser, and a urinal in your bathroom at home.

You name your vehicle.

You have stickers printed which read, "Objects in mirror are smarter than they appear," and "Objects in mirror are sexier than they appear," to stick on friends' rearview mirrors.

You are designing a computer game called "Road Rage."

You attempt to understand mile/metric conversion.

You have meaningful conversations about religion and national politics with late night gas station attendants.

You expect to see people you know in cars several states away from where you live.

Your back has a "50-mission crush."

You consider picking up hitchhikers—for company. Or to take notes…

You have seen every combination of burned-out letters on Waffle House signs (2 to the 11th—2,048 variations).

You know which coffee rings on your notes are from truck stop brews (the ones that bleed through a dozen pages and change the chemical composition of the paper).

Monuments to dreams once

*"All parts of Texas touch the same sky; some parts make a more
lasting impression than others."*

Virgil Race

Put in any length of time driving in West Texas and you can't count all the left behind ruins of houses, barns, outbuildings, and stores on all your fingers and toes and those of everyone you send a Christmas card or Valentine. Ten times that number is the total you're likely to see of thrown away and rusting away windmills, pump jacks, vehicles, and farm implements of every make, model, and description. Every single item was a piece of someone's life once, if only a tiny piece of an even tinier life. Or perhaps those things were bigger chunks, like parts of dreams. Maybe some folks simply had to move on to bigger, better dreams, with no idea how to dispose of the smaller ones. And maybe some folks' lives now look like the stuff they left behind in this place, with the wind making sounds in all the holes caused by being alone.

Some of those things out on the landscape of West Texas make interesting photographs. Some resemble whimsical sculptures; some could pass for equipment casualties of a long past war; others are more like monuments, and as such, deserve to be preserved for other folks to see and think about what's been etched on them by the sun, the rain, and the relentless winds that have tormented this land since the ice retreated....

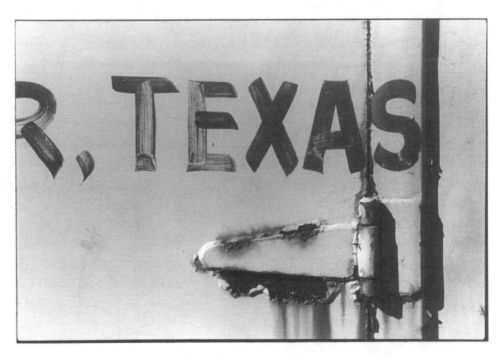

The Old Bishop Place

Another winter has taken its toll on the Old Bishop Place;
with the cold that cracks and the rain that rots.
Uncaring vandals and thieves have invited these wicked agents to come and go at will;
to sweep, carte blanche, past empty, rusting hinges and glassless panes
that stare like hollow, sightless eyes on the warped and naked floorboards,
barely able to support the frail beams, rafters, and pillars above.
The sagging roof allows these rude guests easy access,
as the crumbling shingles fall away like chain mail from a battle-weary knight—
the once stout chimney and hearth that stood as if to hold together the entire structure
and all who called it home once, with the strength of its warm glow alone.
Long past saving now, and no way back to warm and dry;
so very far beyond hearing happy footfalls, laughter, or even tears;
light-years out of reach of loving, caring hands without and within.
Now, just the memories remain to hover unseen about the old place,
or else they flutter in the gaping windows, tattered shreds of old curtains,
as if beckoning, certainly stirring the curiosity of passers-by.
While in concert with the sounds of ruin—here a crack, there a snap or soft moan—
the earthy perfume of Nature masks the scent of her henchman
as they grimly and efficiently repossess another dream, lost or forgotten.
The answers to "When?" "Why?" and "How?" are most likely matters of public record;
in musty, dusty files, somewhere deep in the red tape bowels of some courthouse,
itself recently restored by those who can choose to legislate decay...

The stuff that makes the landscape of West Texas a little more interesting—breaks it up in different ways than do the lovely mesas: the ubiquitous cacti; transient tumbleweeds and the other, more stay-at-home varieties of scrubby plains flora; the stuff that varies the horizon in any direction, more than the mundane white-faced cattle or the now-you-see-em-no-you-didn't jackrabbits can possibly do—also accents the landscape of the Texas Panhandle. In fact the stuff looks so similar after viewing a few thousand miles of it, one might wonder if maybe some eccentric Texan has not hired a crew to move the whole lot of it from place to place. It's not that farfetched in a part of the world where someone could hire a person or persons to half bury a bunch of Cadillacs in the ground, then dig them up, move them, and re-bury them...

Over the past fourteen some-odd millennia that human beings have been in this area, some of them with lesser mettle (and even some with lesser metal) have simply given up on the places we call West Texas and the Panhandle. They moved. Relocated. Migrated. Vacated. They changed at least one or more of

transferred. To put it simply, they're presently ensconced, embosomed, posited, and otherwise settled elsewhere. In short, they were gone; oftentimes, without so much as a by-your-leave or an address to forward mail— e- or otherwise.

At any rate, any note left on any door either blew away or was removed when some admirer removed the door. Same for a note left on any windshield. A note that very well might have read: Y'all

the following: region, time zone, street, city, state, county, address, zip code, area code, phone number, base, HQ, hemisphere, continent, political affiliation, denomination, country, or whereabouts. They immigrated. Flew. Fled. Transplanted themselves; replaced themselves; repositioned, re-established, re-situated, and re-parked themselves. They

come see us. Write or call. Anytime. We'll not be back in this lifetime...

We can but imagine what came before, what circumstances transpired, what precipitated the action, what prompted the decision. Was anything discussed? Were alternatives considered?

If we stay

If we stay here another spring, let's paint this old place;
make it brighter and warmer.

Let's ask the spiders to leave the dark corners;
patch the holes that let in the draft and the dust uninvited.

Let's dress it up just a bit, outside and in;
add some color, some windows, some life.

Let's rearrange, remove, and redistribute;
refurbish, rethink, and regroup.

Let's clear the shelves of sow's ears and wooden nickels;
clear the air of latent genius, ghosts, and laurels best forgotten.

Let's pitch or polish, streamline and improve;
refine, redirect, and refocus—not just for image or change's sake.

And if we have another spring here, let's forgive each other's habit
of saving worthless things to gather dust or fill dark corners.

But dreams are fickle things, as are dreamers. What we want one minute often changes the next. Dreams are rarely shared completely; something's lost in the translation, or changed, even as a dream passes from one heart to another. Dreams seldom are inherited intact, not always a clean handoff.

Interpretations vary. Records must be checked. Things measured and samples taken. Objectivity must clarify. Horseback guesses may be made by qualified experts only. Next of kin will be notified if a balance is due. Time is on our side. Did you get my good side? Dream on. Film at 11 . . .

History sleeps

History sleeps in darkened, obscure places with one eye open,
as a patient spider might repose;
its web of names, dates, events, and accidents
ensnaring countless pages—all innocent victims of context and opinion;
mutilated casualties of interpretation or translation;
the smothered prey of convenient memories, left to yellow and crumble.

History sleeps in freshly painted, bright environs,
ever mindful of the dear school it keeps;
a patient teacher with well-worn primer, its lessons are tools for some,
an entrancing litany for others, incomprehensible for most;
a priceless volume to be reviled, revered, or criminally revised, as Time permits.

History sleeps amidst its own cauldrons bubbling;
this penultimate alchemist, as archaic formulae dictate,
passively notes the transmutations and trials by fire;
suggesting spells which pass for reality,
knowing all is chance and whimsy alloyed with baser stuff;
history sleeps before the mirror of itself, with one eye open . . .

Wake up. It's time to go home. You must have been dreaming. Not all dreams come true, nor should they. And once we realize that, they are history. What's left is life. Or something that resembles the landscape of West Texas...

Written in the art of Texas

Judy has agreed to someday have one of my (shorter) essays produced in what must be the "State Art of Texas." Of course, I'm referring to cut-out silhouette metal work, and my appreciation for the medium has increased with every trip looking for Texas. In fact, I have several images of the word in metal.

Capital of Texas" and a perfect location for a colony of metal art designers and crafters. I made other notes on the subject after encountering countless fine examples, executed in the medium, around Turkey (Hall County); where the signs for all the major streets (there are only a handful), as well as two elaborate

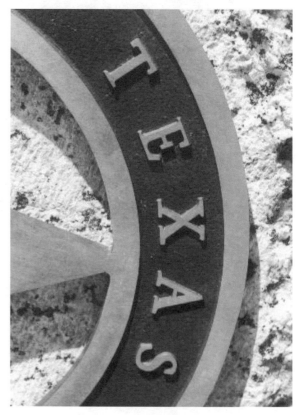

The thought of promoting any official recognition of the craft first occurred to me in Art (Mason County), a place with a great name, but totally lacking in any discernable creative industry—an ideal candidate for "State Art

works, situated at the two main entrances to Turkey, welcoming visitors to Bob Wills' hometown, are iron. By the time I had visited Goldthwaite in Mills County, where I saw more of the work, I was convinced that

Texas's legislators had another item to add to the state's list of "official stuff."

My staff of research assistants-at-large is currently scouring various depositories, repositories, and other -tories in other states to see if they too have the amount of "official stuff" that Texas boasts. Here are the ones (called State Symbols) you can find on various published lists and documents:

State Flag—Lone Star, 1933
State Song—"Texas, Our Texas," 1929
State Capital—Austin, 1840
State Grass—Sideoats grama, 1971
State Stone—Petrified palmwood, 1969
State Gem—Texas blue topaz, 1969
State Wildflower—Bluebonnet, 1901/1971
State Tree—Pecan, 1927
State Dish—Chili, 1977
State Bird—Mockingbird, 1927
State Reptile—Texas horned lizard, 1993
State Shrub—Crape myrtle, 1997
State Shell—Lightning whelk, 1987
State Fiber & Fabric—Cotton, 1997
State Battleship—USS *Texas*, 1995
State Nickname—Lone Star State
State Large Mammal—Longhorn, 1995
State Flying Mammal—Mexican free-tailed bat, 1995
State Citizenship Designation—Texans/ Texian, (early history)
State Motto—Friendship, 1930
State Small Mammal—Armadillo, 1995
State Pepper—Jalapeño, 1995
State Native Pepper—Chiltepin, 1997
State Musical Instrument—Guitar, 1997
State Fruit—Texas red grapefruit, 1993
State Sport—Rodeo, 1997

State Vegetable—Texas sweet onion, 1997
State Fish—Guadalupe bass, 1989
State Folk Dance—Square dance, 1991
State Air Force—Confederate Air Force, 1989
State Insect—Monarch butterfly, 1995
State Plant—Prickly pear cactus, 1995
State Dinosaur—Brachiosaur Sauropod, Pleurocoelus, 1997

Texas also has a State Seal, State Fair, State Railway, and Pledge to the Texas Flag.

Okay, you knew this was coming, didn't you? Here is a list (truly one that could be created only by someone who has traveled our state as *thoughtfully* as myself) of more candidates for Texas' "official stuff" collection:

State Fossil—Petrified palmwood is officially a fossil. What if, back in 1969, when it was declared the State Stone, the search committee had been told they really were looking for a State Fossil? Could have been a lot more fun. My nominee today would have to be Dr. Lawrence McNamee of Commerce. Send your choice to your legislator right away...

State Joke—(hint: "Did you hear the one about the three Aggies...")

State Secretary of State—God bless "Mr. Sam" Rayburn, the "Bald Eagle from Bonham."

State Female Vocalist—three-way tie (with votes still coming in): Nanci Griffith, Tish Hinojosa, and Selena.

State Vocal Group—Dixie Chicks

State Department Store—Neiman Marcus, period. No matter what statistics come from our neighbor state to the NE, and no

matter how many ugly, blue, plastic (Otha Spencer calls them twentieth-century tumbleweeds) bags litter Texas landscapes.

State Road Kill—It's actually a four-way tie among armadillo, skunk, possum, and rabbit/hare, depending on what part of the state you tally. An unnamed source submitted this commentary: According to a recently completed, fully government-funded TxDOT study, slam-dunked skunks outnumber RV'd armadillos nearly 2:1 in the NE part of the state, while pavement pate 'possums are pasted roughly three times more frequently than any other species in the SE. The State Small Mammal holds its own record for highway kamikaze stunts in Central Texas, while in the Panhandle and West Texas, jackrabbits get hi(ghway)-jacked in numbers surpassing all creatures except windshield splattered and largely unidentifiable members of the insect family.

State Cereal—Gra'ma's oatmeal with a side of honey.

State Condiment—Guacamole.

State Sandwich—Brisket, what else?

State Vice-Sandwich—Hamburger, what else?

State Bagel—Get serious, "them things is just donuts with a attitude..."

State Omelet—One with three real eggs, chorizo, onions, jack and sharp cheddar cheeses, and lots of jalapeño slices; salsa, toast, bacon, potato du jour, and coffee (hot, black, and fresh, not du yesterjour).

State Hobby—Women: Antique collecting; Men: Driving women around antique collecting.

State Game—Neither Lotto nor football, but deer; mule or whitetail.

State Shell—Winchester, of course, the other is a misprint; who would name a shell after a polka bandleader?

State Rattlesnake—If for no other reason than to rattle Sweetwater (Nolan County), Freer (Duval County) claims to hold the "Official State Rattlesnake Round-up." Which variety are they gathering?

State Social Activity—Pretending not to be drinking "adult" beverages anywhere such activity is frowned upon or banned.

State Passion—High school football.

State Steak—Grilled: T-bone.

State Steak—Battered: Chicken-fried (by Charles Horchen of Winnsboro).

State Hat (leisure/dress category)—Stetson; (working/recreation category)—ball cap, with bill *forward*; (ranch/rodeo category)—generic Western.

State Boot—Old and broke-in.

State Dog—Old and broke-in.

State Wife...

State Horse—One a cowboy can stay atop of for eight seconds or longer.

State Ride—Texas Star Ferris wheel.

State Vehicle—It's a pickup truck, for-crying-out-loud; the so-called "Cowboy Cadillac" is for the wives of them yuppies from up north, where they're manufactured.

State Bait—Crawfish. No one says bait can't be ate; some folks even take to chicken livers quick as a channel cat will; only difference being, folks generally prefer 'em fried (they livers and they catfish)...

State Side Dish—Made by any decent, local potter; in a size ample enough to embrace a nice helping of hearty soup/stew, coleslaw, beans, or potato salad.

State Wine—Llano Estacada Winery's (Lubbock County) "Cellar Select."

State Red Meat—Beef.

State White Meat—Pork.

State Fowl—What, did we run out of meat?

State Sausage—Anything from Elgin, "Sausage Capital of Texas."

State First Name—Boy's: Tex; Girl's: Billie.

State Bull—Any politically challenged Texan whose lips are moving.

State Dish—I still say it ought to be Anna Nicole; make chili the State Entrée.

State Beer—Shiner Bock, by God; it's born in Texas and mighty fine! All that the good folks down at Spoetzl Brewery have to do is put their brew in a longneck bottle. "Lone Star?" Never heard of it…

Of course, this list could go on and on, as well it should. The obligation to ensure that it does now rests with you, dear readers. Bear in mind, though, since it takes an act of Congress, literally, to get something dubbed "official," you had better get your suggestions for new categories and nominations to your local congresspersons soon. And by all means, be creative—imagine your senator or representative climbing a tree, or at least having a good laugh when they read what you've written. After all's said and done, they need to have a little fun, especially after all the rocks they usually have thrown at 'em…

Train of thought

How irritating when the station is fading on your vehicle's radio and you miss the end of a favorite song or program. It's like losing an old friend, especially at night—a night cold enough you have to keep the windows up and the radio was the only thing keeping you awake. It's not like even those alleged "oldies" stations ever play "Diamonds and Rust" nearly enough, and there I was, between Roby and Snyder—not Midway, but nearly—and Ms. Baez is taking me back... *"I'll be damned, here comes your ghost again, but that's not unusual, it's just that the m*

How's your memory? Mine comes and goes at the weirdest times. For instance, I can never remember what I was doing when the fish hit my bait—how I was holding my mouth and what action I was giving the little do-hickey on the end of my line—but I always remember to keep my rod tip up and crank like he

Who on earth invents jokes? Whoever does it is certainly working big time overtime now, cranking out all that interfodder. Are you surprised at how many of your friends

obviously have so little else to do than share it with you? Man, thanks to a couple of my buddies, I've had to replace my delete key twice on a keyboard less than a year old. Just wore that little sucker down to a n

First Lou Costello and Mr. Greenjeans, then Dr. Seuss and Charles Shultz; how can you feel such a sense of loss at the passing of someone you never met in pe

Did you save one? I did. Brand new; never made a mark with it. Don't ask me what Binney & Smith did with all they must have had left over. Probably mixed them with some other colors to make Grey. Then mixed those with some other colors to make Gray. Are they the same color or what? I miss MAIZE. Never dreamed there would ever come a day without mai

Why do I keep stopping mid-sentence? It's a protest, that's all. I made a note one trip to West Texas to write something about a situation that seems ridiculous. Why no cabooses on trains anymore? Whose bright idea was that? I asked a friend, and she agreed, "It's like a sentence without ending

punctuation." More like a house without a back wall, if you ask me.

Well I don't mind admitting I get upset every time I see one of those forlorn, incomplete sentences crawling across the landscape. What am I saying? The caboose was a heck of a lot more than a period (now a dot, but that's another story) or question mark. Even more than an exclamation point or two; it did nothing short of completing a train, for crying out loud! And trains these days are not only shorter without them, they just look silly. Cabooses were cute, even when they weren't red. Where are they all now? I miss them.

We all know the type of individual who could do such a thing, don't we? The only reason I wrote this piece is hopefully to irritate that person and others like him—the type of person who uncolored MAIZE, cancelled *Cheers*, and killed off Mr. Spock. What a son of a

What I'd still like to know...

I'm never satisfied. After all that I was privileged to see and otherwise experience while looking for Texas, I still have enough questions to fill another book; which is precisely my plan, only I won't be writing the next one. You will—the readers of this very book. And since I'm not authoring, I get to play editor (note the small "e"). But of course, the real Editor will look over my work...

I hope to get at least one respondent from each county. Small town, big one, it doesn't matter. But I expect honest, constructive answers. Grades will be posted, no, wait, that's another survey. Names will not be published without permission, but no submission will be taken seriously without a name, address, and phone number (or e-mail). Goes back to a "Letters to the Editor" policy thing.

Now here's the survey, the results of which will be published—perhaps on-line @ something or other. Let's make the first question, "What do we call this survey?" or better yet, "What will we call a book from this survey from *Looking for Texas*?"

NOTE: As you learned in school at a very early age, do not write in your books. Instead, copy these pages and write (PRINT, please) upon the copies. After you have answered all the questions, please send them to: editor, P.O. Box 1316, Commerce, Texas 75429. If you expect a reply, include the appropriate information and usual SASE; better yet, look for the book. In it, I will personally respond to all submissions—promise...

General information:

Date: _____

Name of town: _____

County: _____

Personal information:

Name: _____

Address: _____

Phone: _____

e-mail: _____

How long have you lived there? _____

Occupation: (optional) _____

Are you a good cook and is your house clean? (optional) _____

Very personal information:

What's your sign? (do not respond if it's "Wet Paint" or "No Fishing") _____

Read any good books lately? _____

Come here often? _____

What color are your bedtime slippers? (optional) _____

Very, very personal information:

Are you ticklish? _____

About my town:

1. What entity (chamber of commerce, city, other) is your town's best promoter? (Do not give a person's name unless you include a signed consent statement from that person.)

2. Describe your entire town in one word. _____

3. Describe your entire town in one sentence. _____

4. What's the best thing about your town? _____

5. What's the worst thing about your town? _____

6. Do you know much about your town's history? _____

7. Do you frequent the town library? How often? _____

8. Where's the best place to eat breakfast in your town? _____

9. Does your town have a town square in the traditional sense? Would you consider your town square or downtown the "heart" of town? If not, where is the "heart?" _____

10. Does your town have a Wal-Mart? _____

11. Does your town have its own locally owned newspaper? _____

12. Do you feel that your newspaper tells your community's story with its words and pictures, or is it merely a wrapper for advertising? _____

13. What's the major recreation in your town? If seasonal, explain. _____

14. If the people in your community go somewhere else for recreation, where? _____

15. In your opinion, are the citizens of your town proud to live there? _____

16. If the answer to #15 was no, explain why, in your opinion. _____

17. Where do you think most of the people in your community go for a (major) vacation? Where do you go? _____

18. Do you like visitors (tourists) to your community? _____

19. Would you like to see your community grow by 25 percent? 50 percent? More or less, over the next ten years? _____

20. What does your community need to be a really kick-ass place to live, work, and play? _____

21. Do you ever write to your local, county, or state officials with comments, suggestions, or complaints? Do you know many people in your town who do? _____

22. On a scale of 1-10 (1 being one and 10 being ten), how would you score your local leaders' performance? How would you score your elected officials at the state level? Did Lee Harvey Oswald act alone? _____

23. Is there a clock(s) on the town square? How many? Are they working? Correct time? Chimes?_____

24. Does your town square have brick streets? _____

25. Are there pecan trees in your downtown? (State tree) _____

26. How often do you see a mockingbird? (State bird) _____

27. What are the names of the theaters in your downtown? Do they have neat old neon signs? Indicate which ones are still in use as theaters. _____

28. Does your town have a "Texas" street, road, avenue, or lane? _____

29. Optional Extra Credit Question: Can you prove that your mayor is a crook? _____

30. Real Extra Credit Question: What, in your opinion, defines a town? _____

31. Is your town a ghost town? Be honest, no ghost writers, please. _____

Comments: Feel free to write your own chapter of the book if you wish. Within the boundaries of good taste, and just short of libel and slander, put it on paper. Trust me, you'll feel better whether you share it with anyone or not.

And finally: If you are a native born Texan, did you specifically request to be born here? After all the time I spent looking for Texas, that's what I'd still like to know...

Quod d'inferno

Imagine a world without hastily hand-scribbled notes on corners of restaurant placemats, with grease stains and coffee rings obscuring the message to the extent that the original thought can never be resurrected, and a translation resembles poorly written fiction but is published in a major newspaper anyway, resulting in several arrests on charges ranging from conspiracy to sabotage Hilary Clinton's campaign for senate to an alleged threat of violence against a public official in Mentone (Loving County, pop. 140).

Could ever there be those encounters, either chance or clandestine, in smoky, noisy, dark, and cozy environs that didn't involve some numbers hand-scrawled on damp cocktail napkins or matchbook covers? No way; one might just as well envision a truck stop men's room stall, sans a handful of opus dopus, social commentary, and artful whit *(sic)*.

Now, picture the walls of an elementary school classroom, devoid of the bright, yet litanous pages of practiced penmanship; those pages ablaze with energetic illustrations as diverse as the unfettered young minds, which have rendered them handily in pencil, crayon, or tempera; minds too soon

homogenized in practice or misdirected in theory.

Aside: I still cling stubbornly to a lot of old traditions, but I must admit that I have certainly embraced a whole bunch of new ones in the past few years. For instance, when I began looking for Texas in 1994, I was not on line. In fact, I counted myself lucky to be on time (a good percentage of the time), on target (for a client's budget), and on budget (for our clients' jobs). I tried desperately to be on my rocker as well—if indeed, that is the opposite of being off one's...

As electrons replace pen strokes around the globe, technology lends a fateful hand to making even the simple, handwritten grocery list obsolete; e-mail stamps out he-, she-, you and me-mail; if postcards are never touched by human hands, how sincere is the sentiment?

Begs the question, just how necessary is such communication?* Hold that thought...

Ain't it a byte?

Mile upon mile of shiny ribbons,
maze-like,
precisely ordering the flow of thoughts, words,
numbers, and symbols that were novels, contracts,
secrets, and grocery lists—
now electrons.
Moving through layer upon layer of plastic and paint;
man made, yet controlling, directing, sorting, starting, stopping;
almost God-like;
subtly or not so, influencing governments
and governing heartbeats;
almost God-like.
Creations to satisfy and simplify for whom, really?
Us? or "Them?"
Smaller, smarter, faster—always faster;
less expensively reducing effort, privacy,
touching and emotional involvement,
till bit by bit,
face to face most often is
now electrons...

Let's examine the scenarios expressed in the first four paragraphs (excluding the aside) of this story:

In the first place, any public official in Loving County is well armed and perfectly capable of defending herself. Secondly, they'll never prove that Bill had anything to do with sabotaging Hilary's campaign any more than they proved he sabotaged her real life—or mine. (Farfetched, you say? Perhaps, but nevertheless, once something has been written down and given even a shred of credibility, it cannot be ignored—look at the Bible. Just kidding, that's a literary twist on an old educator's trick to see if the class is really paying attention; I could have picked my nose, but it wouldn't have had the same effect.) Thirdly, what's a truck stop men's room stall without graffiti? We all can rest assured that truck stops aren't going to change much. As far as the scenario in the fourth paragraph, any day

now it may very well speak for itself. Coming to a monitor near you...

Think of the four paragraphs as holding hands. Note the reference to "hands" in each—the common thread, if you will. See it? The author is lamenting the decline of what? Say it with me, "epistolary." Yeah, I mispronounced it the first time too. Then I looked it up (that's an invitation). It's a neat word, but a far neater, far more popular custom, once upon a time...

"The demise of personal letter writing is considered by many to be a sad comment on the overall lack of civility in our society. Many people arrange their lives in such a way that they never need to write a letter outside of business situations. There are, however, several situations in which a note or letter is expected. And there are many other circumstances in which communications will delight the recipient."

The New York Public Library Desk Reference; page 317

Relating that sentiment to paragraph three; given numerous recent, highly publicized incidents among young school children across the nation, one might conclude that lacking any significant persuasion to the contrary, our youth may chose to express

themselves with a pistol over epistolary, often with tragic consequences.

Remember the thought I asked you to hold? The one above, with the * at the end of it? Communication is expression, and for all H. sapiens, some form of expression is necessary for existence. Of course no one has ever died from not receiving a handwritten note or letter from someone else (the oft-reported "broken-heart" related deaths notwithstanding; many of those private tragedies actually have been linked directly to the receipt of handwritten missives of the "Dear John" variety). But isn't it pleasant to think that all those generations of our forebears, who engaged in the practice of, try it again, this time with feeling, "epistolary," actually may have treated each other better as a result?

Already I can envision the (neatly typed or e-mailed) letter I'll soon receive, demanding an explanation for *"(blah, blah)... all those dreadful wars, (yammer, yammer)... if once upon a time, (ZZZzzzz) everyone was exchanging handwritten epistles (yak, yak)... and treating each other so civil-like!"* And to that I can only reply, *"sumus quod sumus."*

Having said all that, I offer the following as proof that I practice what I preach—unless it cuts into my time on the computer...

'nuff said
Never abbreviate Texas

After I beheld the hundredth gorgeously weathered and worn Tex.; the umpteenth hand-painted Tx. and TX, I decided to share the following sentiments with everyone who ever dared...

Never abbreviate Texas! Ever! It's like Xmas for Christmas, a punch line without the joke, or a kiss without the foil and that little ribbon thing. Not the same at all.

Some shortcuts should never be taken. The same people who would never dream of

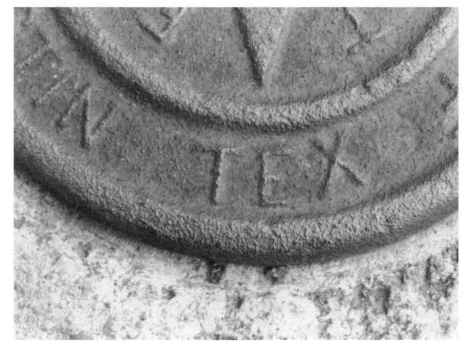

putting their unwrapped jelly beans in pockets or purses to become sticky lint bunnies behave as if they have no time to write all five letters in Texas. There are only five. And if it is a time thing, then perhaps all those folks who are in such a hurry should consider moving to Iowa, Ohio, or Utah. Tks....

Favorite things

Dr. Otha Spencer is a writer's writer. He's dedicated, focused, and disciplined. He is my favorite author and my role model when it comes to writing. He is a true teacher.

I asked him once for an exercise to help me get in the habit of writing regularly, and he suggested that I make a list of my favorite things and set aside one day a month to write about each of them in turn, adding that I needed to set aside a block of time to write each day. I took that to mean I should come up with a list of thirty favorite things, no, make that thirty-one; knowing Otha, I had better not assume I could take even one day off a month. So I began my list. He hadn't offered a clue how I should organize or prioritize it, so I decided on my own to arrange the items alphabetically, not wanting to go back to my mentor just yet. At least, not until I had written something I felt was worthy of seeking his formal critique. Day 1: Art... Day 2: Birdhouses...

Over four years have passed since he gave me those thoughts. My list underwent countless revisions and changes (Day 3: Cigars, Coffee, Cooking & Comfort), and it has been edited to two favorite things per day (Day 4: Discovery & Dogs). But with very few exceptions, the things I'd write each day were simply scores of starts, titles, and fragments in several journals [Get a grant to study...; How do cats know when they've licked themselves enough? Would two or fewer geese still attempt to fly in a 'V'?]. I had page after page of notes and observations on the road

[...reporter just mentioned on an NPR newscast that Africanized (killer) bees had now been found in 120 Texas counties—why had I not seen a single one in any Texas county? Were my powers of observation in need of a tune-up? How had the little buggers eluded me? Would I even recognize one if I saw one? Great, just what I needed, something else to look for...]. I also had several personal, jolt-a-person-awake-in-the-middle-of-the-night thoughts and ideas [...if I ever decide to enter politics, I'll run on the Birthday Party ticket; no, the Batchelor Party ticket; no, the Tupperware Party ticket, yes, definitely the one; slogan: "Who better to get America's stuff together?"].

I became publisher of *The Commerce Journal* on June 2, 1997. In addition to selling ads, handling the day-to-day business of a small town newspaper, and some photography, I'd occasionally write a story or column that I felt pretty good about and wait for Otha's comments. Sometimes they came—not exactly the rave reviews I hoped for—but acknowledgement at least, and I knew for a fact that he read each edition of the paper; from the most outlandish blooper or omission on the front page to the final typo on the back page. Nothing in the *Journal* escaped his purview. And if the slightest detail did manage to slip by, his ever-vigilant roommate, soul mate, and wife, Billie, never failed to bring it to his attention.

Then one day he said them—almost, at least—the words I had hoped to hear. "Rick,"

he said, "you are a good writer, but..." I didn't hear the rest of his sentence. I could tell he was about to offer some fatherly advice in the form of a not-so-mild rebuke, and I pushed my mental "replay" button to savor the, "Rick, you are a good writer..." part of his transmission.

When I quit the newspaper in June of 1999, after it sold to a profit-driven holding company in Birmingham, Alabama, I think Otha gave up on me as a writer, certainly as a journalist. And I don't mind it, I guess. The pressure's off at least. But I have done what he suggested. I have faithfully written something about one of my favorite things nearly every single day for the past four-plus years (Day 5: Eating & Education). And whether I really did disappoint him enough to give up on me, or whether

he's merely waiting for me to apologize for, in his opinion, wasting one more opportunity (to work 27½ hours a day for too little pay from a corporation and for a boss I despised) is moot. He's old enough and *father* enough to realize that our greatest pains in life derive from anger at our loved ones for not making the choices we think they should make—the choices we judge that we'd make in the same situation. He's also hardheaded himself; more than enough to understand when he's likely to get an apology from me. Besides, I'm way too busy. Day 6: Fishing & Friends. Day 7: Gardens & Geography.

In the end, I hope we're both right—he said that I'm a good writer and I give him a lot of the credit for my wanting to be. Most of the rest of the credit goes to another teacher...

Everyone should journal

"You were wrong, ma'am, I was a nitwit..." *

still a student

Miss Joan Vivion Henry will forever represent the classic spinster schoolmarm in my memory. She was very precise and very proper. She was stern, not threatening, and to every senior in her Honors English class at Kirkwood High School, she was ancient.

One day, as a pop quiz, she asked us to write an essay on a quote she had written on the blackboard (it was still black back then, not green), behind a large pull-down map. You could have heard an egg drop soup, as a couple dozen budding Pearl S. Bucks and Ernest Hemingways, with papers ready and pens poised, watched Miss Henry raise the map to reveal, "Little pitchers have big ears."

Two dozen pens remained poised as the same question formed in each of our minds, "Huh?" Oh, how we grappled with that obscure phrase. Some of us. Then the Muse arrived, and inspiration began filling those blank pages—for some of us. Others wrote in fitful spasms, frowning, looking up at the board in desperation, searching for meaning. All the while, Generalissimo Henry prowled the room, aisle by aisle, looking down at the casualties in her classroom-turned-field hospital, surveying no doubt the devastation, the unspeakable toll her orders had taken on these unseasoned troops.

An odd calm overtook me as I stared for a time at the quote, then out the window, then

back at the quote, and finally at my blank sheet of paper. To complete the battlefield metaphor, I was suffering from shellshock when three words came to me in one brilliant revelation. Smiling absently, as one might smile at an opponent who has just announced, "checkmate," I printed the words neatly on the clean white page, folded it lengthwise, signed my name, and lowered my weapon. The bell rang and we troops hurried off to another campaign, fully recovered from our wounds—some of us.

The next morning Miss Henry's large pull-down map was raised to reveal our chance at redemption. I like to imagine the carnage of the previous day had reviled her. What she expressed in words, however, was disappointment. She was not at all impressed by our musings and inspirations—those of us who had had any—and she returned the papers from the day before ungraded. I cannot for the life of me recall what the second quote was or the grade I received. And I have no idea what Miss Henry might have written on anyone else's "Little pitcher..." essay, but I will never forget her triumvirate in reply to mine. I had printed, "I'm a nitwit." Beneath my words, in her flawless, Spencerian script, she had written, "I believe otherwise."

Did you, when Peter asked so earnestly, utter the words, "I believe...," to save

Tinkerbell? I did. So long before Miss Henry believed in me, yet knowing that believing in someone was important. No one has said those words to me since, and even though I have felt the sentiment (or imagined it, perhaps), no one has actually expressed it in those words. I only mention it because, as I was working on the dedication for this book, I realized that Miss Henry was the first influence on me to write. With that thought, the urge came upon me to contact her, to thank her, then it dawned on me—she probably was no longer alive. She must have been at least in her fifties in 1966, and even though I remember her as very robust, with a sharp mind and a twinkle in her eyes when she smiled, she was already an old lady, thirty-plus years ago.

Miss Henry may not have been the cause of my desire or need to journal, but I will gladly give her credit for an above-average ability to put words together into fairly coherent sentences (some of them) and for contributing in no small way to the fertility of my imagination. Without my knowing it at the time, at least, Miss Henry definitely introduced me to the appreciation of writing. Thank goodness she knew what she was doing. Like the very best of true teachers (much different from many of today's "educators" who must be qualified to do so much more than merely teach), she shared new opportunities with her students. She showed us possibilities—possibilities that will continue to seduce me until I am no longer able to hold a pen or tap a keyboard.

Without waxing too philosophical and maudlin, I can't help but wonder how many other students have realized that she may have influenced them with her teaching and her caring. Forgive the trite sentiment, but if you can read this, thank a teacher.

*. . . for not saying this sooner; "Thank you, Miss Henry."

185

Zapata, Zavala, zymurgy

How many words do you know that begin with the letter "Z"? Zen, zenith, and zither jump to mind immediately, then one or two others after a bit of thought. I would have bet the farm the last word in need of definition was zygote but was pleased to find a new "z" word.

Texas only needs counties with names beginning with the letters "Q" and "X" to have the complete alphabet represented. Things like that usually bother me for some odd reason. But then there's Hawaii, with only the letters "H," "K," and "M" to begin its county names—all four of them; while Delaware, with three counties, has but "K," "N," and "S" to start their names.

To complete Texas's alphabet, how about some counties with really dull names exchange them for Quintessential or Xanthus? Or how about Quadrivium (a word well worth looking up) and Xeric (it's not like this one doesn't fit?) Last chance at Quixotic or Xenolith. Fine, keep your old names. Too many changes on maps anyway.

The way things start is important—almost as important as the way they end.

There are things that matter,
things that don't;
When you drop them, things that shatter,
things that won't...

I have this huge folder that I look in sometimes. It's actually a drawer with several folders. It's a couple of drawers, to be honest. Soon all the stuff in all the folders in all the drawers will be on a single disk, and that depresses me a bit. The stuff represents years of starts: a title in some cases, a line or two here, a page or two there. There are even a few entire finished pieces, or as finished as I can ever make them.

All that on one disk makes me feel like I haven't accomplished very much. Then I think, if I were foolish enough to dash back into our burning home, what would I most likely be able to grab before I snatched

up whatever was on the list that Judy and Jessica sent me back in the flames for—several drawers of folders, or a Zip disk? No contest.

"Starts," reads the tabs on all those folders. Vignettes, sketches, notes, bits and pieces, glimpses, and more than a few, "what on earth was I thinking?" Not all of which would make it out of the fire. But then, looking back, I was on fire at times when I wrote some of them...

Looking for Texas generated a bunch of starts. Some will never be more than that, others kindling, while others are not worthy of the bottom of a birdcage. As it turns out, those are the starts that I have chosen to end the book with and share with you here. And so, for those of you without parakeet, canary, parrot, or peach-faced lovebird—got a litter box?

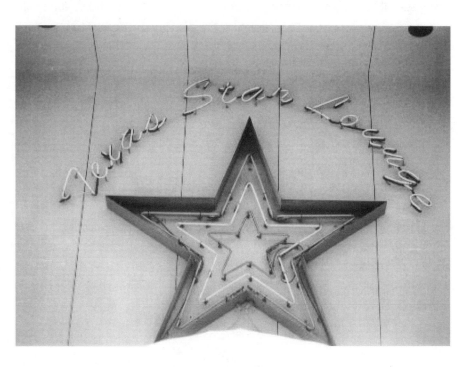

Hitting below the belt

Who began the absurd practice of placing anything to be read on belt buckles? How silly. I for one rarely would invite anyone to read anything so close to my, well, you know. On the other hand, staring at another person's, well, you know, is an activity to be engaged in from a respectable, albeit barely readable distance. On the other, other hand, what of those persons whose buckle has been swallowed by a waist that overflows their jeans and otherwise defies all efforts to contain it?

The only thing sillier would be to buckle one's britches behind one. While studying another person's backside is only slightly more accepted, and perhaps can be done without the person's knowledge, distance is still a problem...

I'm not certain where I was going with that piece. Or with this one:

Top this

It takes 686 Shiner Bock bottle caps to spell the word Texas in letters roughly six times the size of the top line of a standard eye chart. Nailing the entire assemblage to the side of an old barn takes seven people (who participated minimally in the original stage of the research) just over four hours—all for a photograph that took 1/250th of a second...

Now that I think about it, there are most likely people out there who might have been contemplating doing something just like that, and by sharing the above, I've saved them the time, effort, and brain cells, hopefully. Birdcage 1-Humanity 1.

This next start is, well, judge for yourself.

East Texas daytrip

The wooden cow lying on its side had obviously confused the circling buzzards; the only blemishes on a sky so empty and blue, it might have been part of a child's painting.

The magic of the day was unexpected. As novice alchemists might combine baser elements to concoct a precious mixture, though without benefit of formula or recipe, and to the pure delight of us four "children" who captured that perfect sky just as innocently—to remember.

After wine and cheese on a homemade table, we helped the cow resume her stiff-legged stance and watched as the embarrassed buzzards slowly widened their lazy spiral until it dissolved in the blueness.

Maybe I was a bit too hasty, that one might go on the disk. Sorry to have put you through a potential keeper. It won't happen again. Check out this crap:

A pattern here

In Dallas they pass the ball; in Austin they pass out our bucks (and laws); in the oil patch they pass gas; in San Antonio they "que pasa?"; in Victoria they honk, pass, and wave; in Commerce some of our leaders seem satisfied to let the world pass us by...

That was obviously written on one of those "down on my fellow human being" days when I tell my friends, "every time I meet a small-minded person in a position of alleged leadership, I am grateful that I know over 300 wildflowers on a first name basis." It was usually after such a day that I planned a trip, looking for some other part of Texas. Birdcage 2-Humanity 1.

In the "what on earth was I thinking?" category, there are these gems:

Time capsules

My notes contained something about all the stuff I've put in boxes and not opened for years; boxes of stuff I've moved across town at least three different times in Georgia and finally across the country—still tightly sealed, covered in dust, and saved for what...

A house divided

People who live in chicken houses should not throw noodles. People who live in doghouses should not throw cats or Frisbees. People who live in guesthouses should not throw up. People who live in safe houses should not throw safes. People who live in grass houses should not throw lawnmowers or herbicide. People who live in haunted houses should not throw their voices. People who live in pool houses should not throw anyone in the pool. People who live in dollhouses should not throw anything larger than Barbie's high heels. People who live in frat houses should not throw dull parties. And like the old saying goes, people who live in glass houses should not throw horseshoes.

Sometimes exercises like that are therapeutic. Often they can lead to some very creative outpourings. Then there are those other times...

Modern music

Generation X says, "Today's music is about us; it's for us, and mostly it's by us."

I could not agree more, as I find nearly all of it to be monoton*ous*, cacophon*ous*, ridicul*ous*, hein*ous*, venom*ous*, and sadly repetiti*ous*.

New twists

Little Miss Muffet sat on her tuffet—
> and grew a posterior to fill her house's interior...

Rub a dub dub, three men in a tub—
> and we act surprised at one or two in the closet...

Jack and Jill ran up the hill—
> every morning at 6:30 a.m. sharp, in matching jogging outfits...

Mary, Mary, quite contrary—
> but girl, we love you anyway...

Little Jack Horner sat in the corner—
> while the teacher spoke to his parents about the boy's attitude...

Wee Willie Winkie ran through the town—
> wishing all the while he lived somewhere without vicious dogs, broken
> glass, and muggers...

The boy stood on the burning deck—
> saw the steaks seared all to heck
> and wished he had listened to his wife and ordered pizza...

In 1492 Columbus sailed the ocean blue—
> found himself in a world brand new
> and conducted himself like any other sailor in a foreign port...

With all the negative hype and gloom and doom bombarding us hourly, as the year 2000 approached, I came up with a concept from a lighter perspective. Needless to say, the idea was precisely that—needless.

Birthdays bugging you?

Researchers in Anthony, Texas/New Mexico, the "Leap Year Capital of the World," have isolated and reprogrammed the dreaded Y2K bug to a positive end. A spokesperson released a brief statement to the effect that the scourge of the millennium now eats only data related to birthdays...

Just imagine, turning a menace into a blessing; software to add years to our lives—on paper, at least. It could have been the next Pet Rock, but I had no time (thank goodness, Judy said) to pursue it properly. In 25 words or more, my idea was to establish a high-profile "Y2K Bug Eats Birthdays" web site and get a huge Texas computer company

to supply Anthony with the necessary hardware and support. Then everyone on earth who wished to have four years subtracted from their birth date would supply the web site with all the necessary information, and for a nominal fee they would receive a very official-looking "revised" birth certificate and a document stating that "...due to Y2K-related problems," yadda, yadda, "...records lost," yadda, yadda; etc., etc. Maybe even bigger than the Pet Rock thing.

Back in 1996 I thought about getting Atlanta, Texas, to put on the "Po'lympics"; you know, for the rest of us. A buddy and I came up with a whole list of events, ranging from the hay bale snatch and stack, to the trotline tug and toss. We made up rules for each event and scoring guidelines for judges. For instance, in the high voltage vault, a contestant could gain extra style points for jumping over the electrified fence with a purloined chicken under both arms, and bonus style points for making the jump with a portable pig or small heifer. Another buddy or two looked at the event list and concluded that

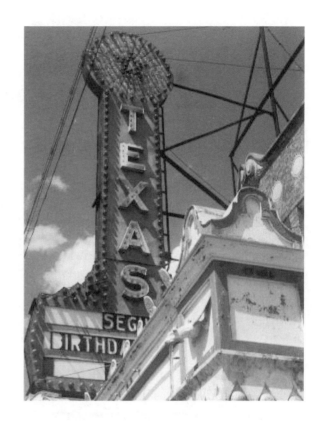

having such an event so close to Arkansas would bias the outcome of nearly every contest...

After some thought, I figured the next item goes without saying...

Get here as quickly as you can

Just about anyone who lives elsewhere and is more than five years old knows Texas. To anyone who lives elsewhere, Texas is that larger-than-life state—of mind, mostly—the state that is bigger even than Alaska, in all the ways that matter. What good are square miles if you can't get to them, even on a horse? For Texans, elsewhere is someplace wishing it could be like Texas. Texans understand this situation and are able to tolerate envy and imitation in many forms, some flattering and some not so. Texans also tolerate the myths about themselves and their state, knowing that the truth, even in small doses, is generally too much for non-Texans to handle.

...but I guess I said it anyway, huh? Then there's all of this to round out the collection:

Since you asked

Someone asked me the other day if I had ever been to Vanderpool, Texas. Well, right then and there, the Texas part of me took over as I spoke about my great-great-grandfather, the one who, after single-handedly slaying over 7,000 of Santa Gertrudis' soldiers at the Alamo, died right alongside David Bowie, John Wayne, Davy Crockett, and all those other brave volunteers. A genuine tear rolled down my cheek when I got to the part where grateful Texican peasants carried great-great-granddad's remains, guided by a pair each of golden eagles and mountain lions, to a quiet little spring-fed valley in what was to become Bandera County, just west of San Antonio, laid him to rest, and named the place Vanderpool—having read his name from his dog tags...

A conundrum in my wallet

I had planned to do a story on all the cool T-shirts I saw and/or purchased while looking for Texas. I had a particular favorite on my person one day, and a friend told another friend as she gestured in my direction, "How 'bout that conundrum on Rick's T-shirt?" I told them there was no such thing on my T-shirt and they laughed. Irritated, I showed them that it was right where it was supposed to be, and they laughed even harder.

Through tears and gasping for breath, they managed an explanation.

On second thought, I decided that the T-shirt story had not a shred of relevance...

A prettier girl I never metaphor

A story about stories seemed appropriate, but an editor suggested that might be another book. I certainly heard my share while looking for Texas, and hats off to all the storytellers out there. Hey, write your own books, why not? Grab the frog by the horns (you can actually do that in Texas, you know) and take the bull by the legs. Let the chips fall where they may. The only consequence to consider is where they may fall if a person actually does have a bull by the legs.

I lost count of all the "prettiest girl in Texas" entries in my journal...

Wood smoke smells the same all over Texas

I made this note in Quitman on March 30, 1996, but have no idea why...

A miled (sic) rebuke

Miles and years and sunshine fade things as surely as pure neglect. Some can be repainted, replanted, or repositioned, while others must be replaced.

I'll not be critical of much that I saw while looking for Texas, and it wouldn't be fair or reasonable to consider changing much at all—with one exception. Whether displayed in public places or on private grounds, I did notice too many faded and frayed flags throughout our state. Old Glory was too often not very glorious, while our Lone Star pride, obviously left alone and aloft for too long at the mercy of the harsher elements of Texas, waved shabbily to passing friends and strangers alike. 'nuff said...

If I weren't writing, I'd a-quilting be

I happen to like quilts. Saw them hanging on clotheslines all over the state. I plan to make one someday; have often referred to my life as a crazy quilt in progress...

Lights out

One of the great things about being on the road is catching up on lots of little things at night in cheap motel rooms. You know the type of accommodations I'm referring to—those little roadside dust mite and mildew factories; the ones without HBO or springs in the beds; the budget this or that, recently annexed by a Middle Eastern country.

Reading stacks of my junk mail occupied many a lonely night in those places while I was looking for Texas. At other times I discouraged roaches from taking up residence in my luggage, or took batting practice at mosquitoes until I passed out—either from those activities, road fatigue, or when it dawned on me that I was reading junk mail...

Welcome to the year of the wabbit

Believe it or not, I planned to write a piece celebrating 1999 as the year of a Texas icon—the jackrabbit. I even drafted a (tongue-in-cheek) letter to Texas legislators, requesting they downplay—just to mark the special year—the status of the state's official small mammal, the armadillo. Whose idea was that, anyway? To begin with, they're suicidal; secondly, Florida and Alabama probably have more armadillos than we have in Texas; and third, Florida and Alabama don't have jackrabbits.

Well, all that was moot when I discovered that the jackrabbit isn't even a rabbit at all—it's a dang hare; and not one worth splitting for the sake of a story...

Mouse this

We all make sacrifices. Had I suspected I was at risk of contracting carpal tunnel syndrome, tendonitis, tenosynovitis, and other musculoskeletal disorders by engaging in the activities involved in doing this book—simply from typing and "mousing"—I might have reconsidered the undertaking. Nevertheless, at the risk of becoming a "statistic," I plod on, pretending I am imagining that my write hand is number than my left. I even did this neat verse on statistics, but decided it wasn't that neat...

Millennium is toast

Something told me all the millennium hype was not worth all the paper it was printed on. My only written comment on the subject was this: If the world as we know it does end on December 31, 1999, I'd like to imagine that a new civilization might give some thought to starting each new year with a month other than cold, bleak January...

A thought just occurred to me—what if I simply wrote a whole book of started stories? I could title it:

Looking for Texas trivia, tripe, and twattle

...or maybe not.

Actually, there was one other start that never got much past the title:

How I came to write this book

One night, it was just Judy, me, and God. He spoke first; *"Well, Rick, now that you've got that out of your system for a while, why not ride all over Texas, journaling and taking pictures of all kinds of stuff? Maybe put it all in a book one day..."*

When I woke Judy to tell her what happened (the God speaking to me part, thank you very much!) she muttered something about waiting for the movie and wanting Meryl Streep to play her in it.

That's it. The book's over—well, almost. After all this time we've spent together, I have one little favor to ask; should you decide to set out looking for Texas: Travel safely and wave every chance you get. And thanks for sharing my journey. Adios...

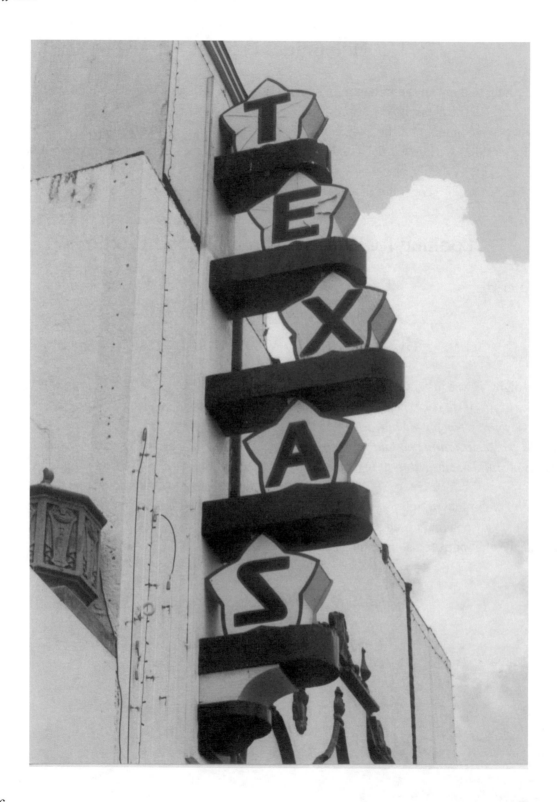

Bibliography

Liberal use was made of the *Texas Almanac*, Texas Handbook Online, *Texas State Travel Guide*, and *Texas State Directory* for any facts, figures and statistics I wasn't able to fabricate to suit my needs. Great reference resources, all!

Index

Order your own full-color "Looking for Texas" poster

19" x 26" color poster $24.95 plus $5 handling and postage
Order by mail, phone, or web site.

Rick Vanderpool traveled over 20,500 miles and spent 54 days on the road, photographing the word "Texas" in an infinite variety of sizes, shapes, angles, colors, and materials. He called the project "Looking for Texas" and incorporated many of the photos in this journal of his travels. Now these photos are available in this handsome fine art poster—the first in a series—printed by Padgett Printing Corporation of Dallas, Texas.

"Looking for Texas" poster finished size is 19" x 26". Each poster is signed by the artist. A Texas county identification key and biography is included. Cost: $24.95 each; add $5.00 each for handling and first-class postage.

"Looking for Texas" print portfolios and individual prints of any image on the poster, as well as other posters, note cards, and calendars are also available. See web site for details www.myprintstore.com.

Rick Vanderpool
drake@koyote.com
www.koyote.com/users/drake/Default.htm

Prairie Rose Studio
P.O. Box 1316
Commerce, Texas 75429
903-886-1633
See our work at **www.texasescapes.com**